G000075094

November 2017

Editor David Eggleton
Founding Editor Charles Brasch (1909–1973)

Cover: Jenna Packer, *The Market Rallies*, 2017, 1116 x 1527 mm.
Acrylic on canvas.

Published with the assistance of Creative New Zealand.

OTAGO UNIVERSITY PRESS

CONTENTS

4 Kathleen Grattan Award for Poetry 2017 Judge's Report, *Bill Manhire*

6 Landfall Essay Competition 2017 Judge's Report, *David Eggleton*

8 The Perfume Counter, *Laurence Fearnley*

14 Shitfight, *Alie Benge*

22 Gone Swimming, *Ingrid Horrocks*

32 Reaching Out for Hear, *Lynley Edmeades*

42 A Box of Bones, *Sue Wootton*

51 I Wet My Pants, *Kate Camp*

59 Trackside, *Mark Anthony Houlahan*

64 Tītipounamu Tapping the Beech Forest, *Rhian Gallagher*

65 The Illuminated Page, *Rhian Gallagher*

66 Huia's Song, *Medb Charleton*

67 The Swan Hunter, *H.E. Crampton*

73 Summers Were Longer Then, *Claire Orchard*

74 You've Been Having My Nightmares, *Ruby Solly*

75 i used 2b silver, *Carin Smeaton*

76 From the Tribe of Gad, *Ben Egerton*

77 Kate Sheppard Reads the *Weekly*, *Samantha Montgomerie*

78 An Outrageous Piece of Living Shit, *Sue Reidy*

80 Dropped Pin: Brooklyn, New York, *Michael Steven*

82 Kid and the Tiger, *Breton Dukes*

94 Bender, *Kiri Piahana-Wong*

95 Tongue, *Owen Bullock*

96 ART PORTFOLIO, *James Robinson*

105 Craft Market, *Rebecca Reader*

106 Slut, *Judith Lofley*

107 Locked In, *Sarah Shirley*

108 Cured, *René Harrison*

109 The Backyard Forms, *John Dennison*

112 Permission to Take Photographs, *Rachel J. Fenton*

113 Yes, *Phoebe Wright*

116 Kalene Hill 1948: The Baby Won't Turn, *Kerrin P. Sharpe*

117 Daybreak Again, *Marianne Bevan*

125 Bombed, *Ali Shakir*

126 One Long Puff, *Ali Shakir*

127 The Hotel Theresa, *Doc Drumheller*

128 Hoki Mai, *Tayi Tibble*

129 Tuvalu, *Rev. Mua Strickson-Pua*

130 Island Girl, *Sisilia Eteuati*

131 Discards, *Albert Wendt*

132 A Palm Tree in Freemans Bay, *Bob Orr*

134 poet in his castle, *Vaughan Rapatahana*

136 Rowley's Tangi—Down the Road, *Brian Potiki*

139 middle name, *Tony Beyer*

140 Thistledown Farewell, *Owen Marshall*

141 Town Planning *or* A Loose Roundelay in Answer to the People Who Keep Inviting Me to School Reunions, *Joanna Preston*

143 Volcano Country, *Riemke Ensing*

144 ART PORTFOLIO, *Jenna Packer*

153 Expectation, *Tom Weston*

155 A Personal Memoir of Dr Rosie Scott, *Stephanie Johnson*

160 Caselberg Trust International Poetry Prize 2017 Judge's Report, *Riemke Ensing*

LANDFALL REVIEW

162 LANDFALL REVIEW ONLINE: Books recently reviewed

166 MARTIN EDMOND on *Charles Brasch: Journals 1945–1957* ed. *Peter Simpson* / 171 IAIN SHARP on *Selected Poems* by Ian Wedde / 175 JENNY POWELL on *Die Bibel* and *Collected Poems 1981–2016* by Michael O'Leary / 179 JOHANNA EMENEY on *The Arrow that Missed* by Ted Jenner and *The Ones Who Keep Quiet* by David Howard / 183 DENIS HAROLD on *The New Animals* by Pip Adams / 186 CHARLOTTE GRAHAM on *The Suicide Club* by Sarah Quigley / 189 KATIE PICKLES on *The Great War for New Zealand: Waikato 1800–2000* by Vincent O'Malley / 192 EDMUND BOHAN on *The World, the Flesh and the Devil* by Andrew Sharp

202 Contributors

208 LANDFALL BACK PAGE: *Andrew McLeod*

BILL MANHIRE

Kathleen Grattan Award for Poetry 2017 Judge's Report

I was impressed by the quality of entries for this year's Kathleen Grattan Award. Quite a number were real book-length projects, not just convenient gatherings of well-made stand-alone poems. This was a little problematic for some manuscripts, in that a few weak sections made the larger structure feel a little shaky or—once or twice—brought it down altogether. Several entries, while they met the minimum page count, felt mildly underdone. A few others, full of fine things, went on a little too long and wore out their welcome.

Among a larger group I kept returning to, I particularly liked collections by **Scott Hamilton**, **Elizabeth Morton**, **Tracey Slaughter** and **Holly Frieda**, but in the end my four runners-up were as follows:

Nick Ascroft's 'Moral Sloth' is among other things a virtuoso display of formal skills. He does a particularly classy line in sonnets. He can rhyme as tellingly as Alexander Pope or the Byron of *Don Juan* – and can match those poets in quickness of thought and even (it seems to me) outstrip them in richness of diction.

I really liked 'ell yrs', **Tom McCone**'s manuscript of love poems, which is informed throughout (I think) by loneliness and loss. The poems' feelings—sometimes accepting, sometimes 'wild&/bewildered'—are often articulated through runs of beautifully sudden phrases.

Philip Armstrong's 'Orpheus in Pieces' is an impressive historical poem about the wreck of the *Orpheus* at Manukau Heads in 1863. The poem is done in steadily (indeed, relentlessly) advancing couplets, with skilful management of syntax to match the text's historical detail. The whole thing is watertight in terms of craft, as well as deeply researched and thoughtful.

James Norcliffe's 'Deadpan' is one of those collections that never puts a foot wrong—indeed, it's so well done that you sometimes want it to make a small mistake or two. The title points deftly to the way the text manages to

convey big emotions without cracking a smile or shedding a tear. I particularly enjoyed the *Hamlet* re-visioning sequence, 'Poor Yorick'.

But my winner was **Alison Glenny**'s Antarctic-focused 'The Farewell Tourist', which pushes against the boundaries of what poetry might be, yet seems far more like poetry than any of the standard prose genres it sometimes resembles. There is some beautiful writing, but—though there is sometimes talk of music and musical instruments —the text is not written primarily for the ear. More than most entries, it takes full advantage of the white pages on which the words appear. In particular it plays with ideas of erasure, as if all our words, like any evidence of human presence, can be extinguished by a fresh fall of snow. What remains are footnotes, a world composed of illegibilities and crossings-out and things-gone-missing, but still a place where men and women fall in love and drift apart yet still reflect (and reflect on) each other in ways that might get them from one page to the next.

The whole text is flavoured with a slightly held-back surrealism. Fog rolls down an Edwardian hallway, a glacier pushes through a bathroom wall. There are moments of collage, gestures and quotations from heroic-age narratives, deliberately affectless phrasings, real and cod dictionary definitions. (One definition of *erasure* is: 'The practice of concealing part of a poem by covering it with snow'.) The manuscript title implies an underlying critique of 'farewell tourism', which in one very specific instance involves a fashion for decadent luxury cruises to view what is going to vanish—in this case icebergs; but perhaps also this book.

Alison Glenny's manuscript makes the reader work, and gives in return a kind of droll melancholy. It is busy saying farewell as you turn the pages. This won't be enough for some readers, but 'The Farewell Tourist' was the manuscript I wanted to reread most often, each time getting refreshed pleasure from what was already familiar, and also finding new things to enjoy and admire.

DAVID EGGLETON

Landfall Essay Competition 2017 Judge's Report

The essay as a literary form defies strict definition. The verb 'essay' means to try out, to explore, to investigate; and the best essays therefore often contain within them a notion of failure: so far, and no further. The best kind of essayist, then, is surely sceptical, ironic, looking at a subject one way and then another, and is sometimes prepared to undermine the proposition they started out from as the essay proceeds. An essayist tries to tell the truth, be it ever so crafted, but knows truth is slippery, elusive, fugitive. Praising the *Essays* of Michel de Montaigne—generally agreed to be the originator of the modern personal essay—Ralph Waldo Emerson, another fine essayist, wrote: 'Cut these words and they would bleed; they are vascular and alive.'

There were 64 entries in the 2017 Landfall Essay Competition, and these expositions covered a wonderfully eclectic range of topics: from the melancholy of the graveyard of an old cargo ship; to the gravitas of Celtic poetry; to the poignancy of newspaper accounts of the end of World War I; to the incorporation of the presence of an active railway line running close to the family farm into a family narrative.

Some of the most astute observations, perhaps because they involved moments of self-observation, occurred in the many essays submitted which explored some aspect of the body, of the corporeal: of what happens when a sensate body is exposed to stress, or else just to immediate sensation. So, there is a swimmer's journey, nosing through the waters of various locales as a way of inhabiting the landscape; while another essayist outlines a personal comedy (though it didn't seem like it at the time) of 'illness anxiety', or episodes of hypochondria; and a third writes precisely and eloquently about the chastening effects of incontinence.

In the end, as I looked not for the literal but the figurative truth, not for the facts but the illustrated argument, not for the disinterred diary but the transcendent anecdote, the undeniable revelation, two finalist essays proved especially difficult to separate, though their topics and their strategies are

very different. Consequently, there are two first-placed essays in the 2017 Landfall Essay Competition: 'The Perfume Counter' by **Laurence Fearnley**, and 'Shitfight' by **Alie Benge**.

Smells are deeply linked to memory, we know, but Laurence Fearnley in her essay makes scents—at once treasurable, resonant, mysterious—synaesthetic emblems of how we perceive the world. She employs an ironic tone with a light touch to tease out just how intense a sensation smell is. As she truffles among odours and perfumes she encounters day to day, her assured and measured writing brings her surroundings alive with sharp, descriptive clarity.

Alie Benge's essay, 'Shitfight', which is about raw army recruits in Australia being prepared for a theatre of war in the Middle East, has a physicality and dynamic urgency to it that stopped me in my tracks and made me circle around it again and again. She traces out her gradually ebbing martial zeal, her loss of soldierly spirit, amid a culture of dread, anxiety and mindless obedience—albeit in a manner shot through with sardonic humour. She's dogged by both institutional sexism and the moral ambiguity implicit in being taught to kill an enemy where you do not discriminate between soldiers and civilians: all are hostile or potentially so. In her contrarian stance we see the essay being practised as a great and noble artform, where the essayist is, by turns, philosopher, raconteur, jester, devil's advocate, nay-sayer.

There are five shortlisted essays: 'Gone Swimming' by **Ingrid Horrocks**, 'Reaching Out for Hear' by **Lynley Edmeades**, 'A Box of Bones' by **Sue Wootton**, 'I Wet My Pants' by **Kate Camp** and 'Trackside' by **Mark Houlahan**.

The two winning essays and the five shortlisted essays are published on the following pages.

The Perfume Counter

When I walk through a city I pay attention to its smell. There's a lot to take in: plants and trees, food and cooking, the scent of rain on the pavement, the ocean and harbour, traffic fumes, construction sites, drains and body odours. Sometimes I focus on fragrance, hoping to detect a perfume on a passing pedestrian. I have only identified three or four scents in the fourteen years since moving to Dunedin. Three of these perfumes are in the gourmand tonka bean and vanilla style: Angel, Flowerbomb and, more recently, La Vie est Belle, while the fourth is the airy-aquatic-floral L'Eau d'Issey. My perfume encounters are so rare that I have concluded that most people dislike fragrance, or regard it as superfluous or shameful—either because smell is unimportant or because perfume defines the wearer as privileged and shallow.

Every morning I scan a perfume blog and am always surprised by how often commuters in big cities notice fragrance. The air of New York is apparently heavy with Le Labo Santal 33. It's a sandalwood perfume, created to suggest the American west, the smell of cowboys and campfires. I've not tested Santal 33, or many of the other perfumes listed by the regulars who post or comment on the perfume blog—the selection of perfumes in Dunedin is meagre by international standards. Because I am unfamiliar with the featured scents and don't expect to ever smell them, I am always surprised by how much attention I pay to the various descriptions, and how much pleasure I gain from reading about them.

No one in my family is obsessed with perfume and I've given a great deal of thought to why I care so much about fragrance reviews and individual reports, and the conclusion I've drawn is that perfume sparks my imagination in the way that fiction and travel writing does. As I read, my brain is active, drawing upon my limited scent memory and library in an attempt to understand the perfume object. I search the list of notes on the scent pyramid, read how they are blended and balanced, and I identify the nose and

the house behind the fragrance. Just as I have favourite authors or film directors, I have favourite perfumers, and once I'm familiar with an individual's style it's conceivable that I can guess how they might approach a rose, fruit, wood, incense, or green composition. When I factor in the source of the materials (whether the sandalwood is Indian or Australian, for example) and the house style of the company commissioning the perfume, I add more clues.

A couple of years ago, while reading my favourite American perfume site—a blog that regularly receives 300 comments—I came to suspect that two of the regular readers and contributors to the daily 'what I'm wearing' thread were New Zealanders. I can't remember what gave them away but it could have been the use of the word 'autumn' instead of 'fall', or a complaint about international shipping costs, or, more likely, something in the tone of their comment that drew my attention to an element of self-awareness and an undercurrent of humour that struck a chord and felt familiar.

Last year, at a launch for my novel, I arranged to meet one of these women. During the afternoon leading up to the event I worried about what perfume to wear, and, unable to decide, left my Auckland hotel empty handed. I spent the hour prior to the launch browsing in a couple of Ponsonby perfume shops, collecting testers of scents I had read about but hadn't tried. By the time I made it to the launch I was wearing eight or ten perfumes on my arms and carrying a fan of scented blotters. None of the testers was labelled, and those on my skin were muddled in my memory.

As the bookshop began to welcome guests I chatted to the few people I knew, all the while keeping a lookout for the perfume collector. I had formed an image of her in my imagination—a cross between actor Julie Walters and classist Mary Beard—but none of the people entering the shop fitted my impression. Falling back on my scant knowledge of her perfume tastes, I decided to trust my nose and sniff her out. However, the wad of samples in my pockets combined with the strips layered across my arms was so overpowering that I couldn't detect anything beyond my own cloud of fumes. A stylish woman arrived, wearing a dark coat and fedora. Her appearance put me in mind of Toulouse Lautrec's 1892 portrait of Aristide Bruant, the performer depicted in the lithograph *Ambassadeurs*. I caught her eye once or twice but hesitated before approaching her.

On that first meeting the woman in the fedora (I'll call her W) told me she was wearing Hermès' Ambre Narguilé. From descriptions I had read, I knew it was composed around amber (which is produced by combining vanillin and labdanum and has nothing to do with the fossilised tree resin), with a nod to the sweet-smokiness of a hookah (narguilé). It was created in 2004 by one of my favourite perfumers, Jean-Claude Ellena, and it is frequently referred to as a comfort scent—it is warm (rather than fresh), soft (in a textural sense) and sweet with a hint of fruit, honey and spice. It is a scent that stays close to the skin and is difficult to detect from afar.

Perfume, like clothing, contributes to a sense of identity but, equally, it can disrupt the image presented to the public. I had not met W before and now I discovered that her outward appearance and her scent were producing two distinctly different impressions in my mind. In other words I was battling with mixed messages. Her clothing was not exactly severe but it did convey an image of a high-end fashion or art-world type. The faint perfume, on the other hand, was homely. I could smell it when she moved or gestured and it reminded me of spicy apple pie.

Trying to figure out who W really was, I ran through a number of possibilities in my mind. Either the clothing or the fragrance was a façade, but which one? Then again, maybe the clothing was designed to keep strangers at bay, while the perfume was W's extension of friendship towards me. After all, we had established our relationship via scent and she would have known I would focus on how she smelt rather than how she looked. In that respect, perfume was our bond, our common language. The third possibility was that the clothing and perfume were perfectly matched. They were both carefully curated and stylish but I had missed the connection.

I spent most of the evening staring at her, searching her face and gestures for clues. It was embarrassing; I kept catching myself looking at her and felt exposed. And there was another problem. Before meeting W that night, I had never smelled Ambre Narguilé and I was desperate to study it up close. But how could I do that? Inhaling perfume off another's skin is an intimate act, akin to touching a pregnant woman's 'bump', or feeling the texture of someone's hair. To sniff a person without consent is transgressive. And asking for permission would be awkward.

In the end I didn't ask to smell the perfume but months later I met W

again, this time at the Auckland City Art Gallery. She turned up wearing a cap that reminded me of Barbra Streisand's character in the 1972 film *What's Up Doc?* I wore jeans and an army jacket. As we chatted, she placed some perfume samples on the table between us and there in a small vial was Ambre Narguilé. She offered it to me and, using the plastic dipper, I placed a tiny amount on the soft pad of my thumb and held it to my nose. She did the same. As we repeated the smelling process over the next few minutes, raising our hands, inhaling deeply, tilting our heads and gazing off into the middle distance, I began to feel self-conscious. Our short ritual brought to mind the courtship habits of bowerbirds or grebes. As often happens when I feel out of my depth, I began to giggle.

By why should smelling perfume samples in a café be more extraordinary that looking together at an image in an open book, sharing ear buds to listen to music, jointly touching a piece of fabric, or ordering a cake with two forks? Is smell so associated with bodily functions and sex that it is best kept for private? I sniffed the sample again and discovered that I was incapable of accurately describing the full range and movement of the odour. My sense of smell is so under-utilised that it was beyond my scent vocabulary. All that came to mind was, 'It's good, isn't it?' As I uttered those words I thought what a failure I would feel if my response to a painting, a piece of music, handling a pebble or tasting a ripe peach was reduced to: 'It's good.'

The next time we met was at the Chanel boutique in Britomart. From past experience I have learnt that perfume counters can be as emotionally and intellectually absorbing as any bookshop or library, gallery or museum. I also know that sales assistants who dislike perfume and don't wear it themselves are easy to spot because they almost always spray and sniff the blotting paper tester first, before 'binning it' by passing it across the counter to the customer. Perfume enthusiasts, on the other hand, spray the blotter and offer it to the customer unsniffed. Like a sommelier, they watch and wait for a reaction.

I had never tested any of the perfumes in the Les Exclusifs de Chanel collection and I was looking forward to the visit. Christopher Sheldrake (with Jacques Polge) created many of the scents in the line. Sheldrake's most famous creations, for Serge Lutens, tend to favour unusual combinations of stewed fruit, almond, vanilla, amber, resins, wood, leather and smoke. Most

mainstream fragrances follow a James Bond formula. They are linear, so feature an attention-grabbing opening (to capture the market of the shopper who sprays and buys) followed by hours of dull and predictable storyline (in perfume this is represented by a dry down of laundry-powder musk or synthetic wood). Sheldrake's perfumes are multi-layered and sometimes baffling. A film comparison might be Terrence Malick's *The Tree of Life*. I cannot make up my mind whether I like or dislike his scents, whether they are extraordinary or banal, but if I had to restrict myself to one perfumer for the rest of my life it would be him.

At Chanel, W is welcomed by name and we are invited to sit at a table. As we watch, the assistant lifts a white cube onto the counter and raises the lid. Inside are sixteen receptacles, each containing a ceramic rod. Around fifteen centimetres in length and the diameter of my index finger, each ceramic dowel is labelled with the name of a perfume from the exclusive collection. The ceramic surface is smooth and polished except for a centimetre at its tip. Here the surface is porous; it has been soaked in fragrance. To smell the perfume all we have to do is raise the wand to our noses and inhale.

The benefit of such a system becomes immediately obvious. Instead of filling the air with fumes or soaking card blotters and waiting for the scent to settle, we simply sniff the rods, which hold each scent in its entirety. The real advantage becomes clear when comparing one perfume to another. There is no muddle or confusion, as so often happens when testing on blotters or skin, and the assistant invites us to take our time.

W's knowledge of perfume is far greater than mine. Her personal collection is extensive and her nose is better trained than mine to recognise individual notes, and accords. Sniffing perfume is easy, describing it is not, and almost straight away it becomes clear that she and I interpret smell in different ways. Our responses are individual, personal, and the language we use to describe a scent doesn't always match. We tend to throw words around until we identify a common metaphor, and then we work forward, becoming more precise as we sniff and retest the perfume to create a scent object. What do we mean by wood, for example? Pine? Cedar? Sandalwood? Oak? Bark or sap? Resin? Or do we mean timber? Wood shavings? Dust? Old books? When I look out of my window I can see a garden full of trees that I can name: silver birch, maple, rātā, kōwhai, but how many could I identify by smell? None.

'Coromandel', created by Christopher Sheldrake and Jacques Polge, is named for the coromandel lacquer screens in Gabrielle Chanel's apartment. The perfume is an oriental with notes of benzoin (a resin), amber, frankincense, patchouli and jasmine. People who have worn and reviewed the scent mention wood and vanilla, patchouli, spice and an overall sensation of warmth and comfort. I wonder how my approach and perception of the scent would alter if I believed it was named after Coromandel on the east coast of the North Island? Would I trust my nose to guide me or would I allow my more fully developed visual sense and preference for story to take over and steer me towards what I imagined I smelled? It's more than likely I would exclaim that the perfume was a masterful rendition of a forest. If I didn't have access to the notes, I might picture the natural landscape of the Coromandel and create an imaginary blend of raupeka (a sweet-scented orchid), kauri, horopito, nīkau, fern and moss.

When I started work this morning I sprayed the back of my hand with Coromandel. To begin with, it smelled of amber, and then it became grassy, then woody—a mixture of sandalwood, cedar and freshly milled timber—but now, seven hours later, it smells of nutmeg and custard, and jute, with a hint of camphor and chai. The scent is not loud; all day I have had to hold my hand to my nose in order to detect the smell and its development. Does the scent create an image of either a coromandel screen or a Coromandel location? No.

Visual images and stories, analogies and metaphors help us to make sense of smell, and provide the language to describe it. But smell is not 'other' to sight, sound, touch and taste. If we learnt to identify smells, if we increased our scent vocabulary, we might have less need for all those comparisons, metaphors and stories and simply go straight to the scent object. When I wore Coromandel no image sprang to mind; it was purely abstract. As the hours passed I became more and more conscious of its temporal boundaries: the way it performed, shifted and developed throughout the day. It existed in time and had a life. I inhaled, allowed the scent to enter my body, and took notice. It was that simple.

Shitfight

The grenades aren't shaped like pineapples, as I'd thought they would be, but more like cans of Coke. My hands shake as I select one out of the tin box; it could be a cake tin, or a box of chocolates. The bombs are in ordered rows. The pins are more complicated than in the movies. You could never pull them out with your teeth. (This information is met with collective disappointment, akin to when we found out that shooting from the hip was not an approved firing position.) You pull the pin as far as it will go and then twist your wrist slightly further than is comfortable. Resist the compulsion to brace the grenade against your stomach to help you twist.

A grenade is three pieces. Pin, bomb, and lever. It's not the pin that activates the bomb. The pin releases the lever. The separation of the lever activates the bomb. I stand with a grenade in one hand and the pin in the other. There's a corporal next to me whose job it is to drag me around the trench wall and jump on me if I happen to drop the grenade and throw the pin. I stare at my hands and remember a time in school when I unwrapped my sandwich, threw the bread in the bin and raised the paper to my mouth.

I throw the grenade, and watch the lever fly away. The corporal and I duck below the trench. Sound pounds over us, no longer an abstract thing, impossible to touch. I could reach up and run my hands through this sound if it lasted long enough. When the sound that was living and solid and synesthetic dies back, there's a soft pattering of falling earth and shrapnel. The corporal lifts his head over the trench, swearing and holding his hand on his heart.

'Try throwing a little further this time.'

In the recruitment interview they ask if you could ever kill someone. The correct answer is, 'If they were a threat to Commonwealth people or property, then yes. Of course I could.' A boy in the year above me at school had trained for months to get into the army. When he was asked this question, he said no and was told he didn't need to wait around for the physical. For me, it was

easy to say the words, words being all they were. I was only signing up for the gap-year programme. I wouldn't be in the army long enough to have to decide. This was a temporary solution until I worked out what I really wanted to do. I wouldn't fall for the propaganda, I knew how these things worked, I'd read Wilfred Owen. I would play the game but I wouldn't buy in.

The bugle plays at 6am. We rip both sheets off our beds and stand in the hallway with the sheets over our shoulders. We yell our numbers in turn. One of the first things to get used to is hearing my own voice so loudly. The yelling bursts the capillaries in our noses and they bleed, off and on, for the first week. After the bugle and the ripping and the yelling we are given fifteen minutes to dress and make our beds, ruler in hand, measuring the part of the sheet that folds over the duvet, the placement of the pillow from the head of the bed and the extra rug that is folded on the end.

As we get further through training the fifteen minutes is reduced to eleven and then nine. The movement and the measuring and the obeying lead to a suspension of thought that leaves no room for anxiety or indecision. Thought is replaced by a narrow consciousness that focuses in on the pulling of laces through boots and the synchronised lifting of mattresses. We're being trained not to think. The point of this three months is to break us down and build us up again as soldiers. They don't want someone on the battlefield who will pause or question orders. They want soldiers who will obey. This suspension of thought is useful when I realise the showers don't have doors.

The platoon that lives above us is instructed to take all the furniture from their rooms, carry it down the stairs, and reassemble the rooms on the parade ground. They're given ten minutes but they take eleven. They're told to carry the furniture back to their rooms and start again. Each time they fail, the time limit is reduced. They repeat the exercise until a recruit drops his end of the bed on the stairs, curls his arms around his knees and rocks against the stairwell, saying, 'There's not enough time, there's not enough time.' His suitcase is returned to him and the other recruits help him pack it. Another recruit goes missing in the middle of night and is found marching down the highway in his pyjamas.

I get infringed twice in one week. The first is for not starching my slouch hat well enough; the second for leaving a piece of paper on my desk. When rust is found on my bayonet the infringement is upgraded to a charge. I want

to explain that it wasn't my bayonet, that all the bayonets in the armoury were redistributed at random before the inspection. But I'm standing on a white line being yelled at, forbidden to make eye contact. There's no designated time for explanation, and no point if there were. So I get up at 5am and march around the parade ground wearing a pack carefully measured to be one third of my weight. Corporal Steele, the only person I've ever truly hated, follows behind.

'You're a retard, aren't you, Recruit Benge?'

'Yes, Corporal.'

'What are you, Recruit?'

'A retard, Corporal.'

There's comfort in knowing he also had to get up at 5. Bombardier asks me why I'm such a shitfight (/ʃɪt faɪt/ noun: Someone who is bad at everything they do; everything they touch turns to shit). The name sticks. It attaches itself to me and I hear it when I fall through the netting on the obstacle course, when I realise I haven't seen my rifle since the last time we stopped, when I panic about running through an underground drain half full of water. 'Shitfight' is staccato. It's sung like a nursery rhyme, and whispered under a breath as I pass. My own name falls away and 'Shitfight' takes its place.

People ask me why I'm here, in this space where I so obviously don't fit. I tell them I thought I knew what I'd wanted after school: an internship, a desk that I could put framed photos on, a career in advertising. But it wasn't what I'd expected. I want basic training to be over, but not like I'd wanted those months to be over. My future had stretched out before me, the same day, the same bus ride, the same nine hours. I struggled for breath in the never-endingness of it all. Here, at least I don't wake up sad, count down the hours from nine, and cry behind my sunglasses on the ride home. Perhaps that's what keeps me here while people who aren't shitfights have breakdowns in stairwells. Perhaps they had a second option, something to return to. But I can shut out the insults and dull their edges in a way that I could never dull monotony. I may be a shitfight, but at least I'm not bored.

I can't remember what I'd imagined the army would be like. Whatever I dreamed about beforehand was quickly excised by the bright, dusty, out-of-breath reality. It was my friend Sophie who first dreamed up the plan. We would enlist in the gap-year programme together, get good Myspace photos,

save our money, and go travelling when it was all over. It was these prizes that kept me going as I performed the nightly jog around the block that was my training. I was dreamy, with no thought of war or politics, and I needed the hope of something different. Then Sophie didn't get in and I had to do it by myself.

Bombardier gives us this: 'You're on a mission in Iraq. You and three others. It's crucial that you aren't seen. On the last day of your mission, a young girl wanders into your camp. She starts to cry and run for home. What do you do?' We say, 'Bug out.' We say, 'Abandon the mission.' When he shakes his head, we say, 'Restrain her somehow until we're done and then let her go.' These are not allowed. Bombardier waits, but no one will say it. We're given a talk about hesitation.

I'm surprised by how much talking there is. I learn to yawn with my mouth closed and rest one eye at a time. We're given talks about honour and tradition. About sacred duties and administering justice. During the latter I dodge my eyes away from pictures of children in an Iraqi town, their skin bubbled away. The results of chemical weapons. They tell us about landmines, how they're designed not to kill but to maim. The lesson is on the Ottawa Treaty, which outlawed their use. On a PowerPoint slide is a list of non-signatories: the nations that ignored the treaty and continued to plant mines like seeds to bloom under children and farmers. China, Russia, Iran, North Korea, Pakistan, Saudi Arabia. Other lessons are on the Anzacs, the Rats of Tobruk, the Victoria Cross. The talks could be divided into 'Who is your enemy?' and 'Who are you?' The will to win is praised. A lack of aggression is shunned. We watch videos of tanks in formation driving down a road, soldiers running, all in slow motion with cinematic music.

In school I'd craved an opportunity for radicalisation. In primary school my friend and I would change our names to sound like hippies. One week I would only answer to Sunshine Daydream, the next Mountain Flower. We would play suffragists without any understanding of the concepts of voting or violence, having not yet identified oppression.

The radicalisation was an objective desire. It had no subject or direction. An end in itself, rather than a means to an end. Something about the stories I'm told during training get in my blood. They touch the part of myself that wants to fight for something, to belong to a wider community and be part of

their movement. Besides, there is shame in not believing their ideology, and I've had enough of being shamed. Soon I'm running my hands over my scalp as my hair floats to the ground. I'm standing on parade on Anzac Day. A swell of pride and a forgetfulness. *Dulce et decorum est, pro patria mori.* Lest we remember.

The lines on the targets are arranged in a disruptive pattern. Enough black against yellow to suggest a human form, but not so many lines that it's obviously a person. The hope is that in another context, another time, we'll see only this suggestion of a person through our cross-hairs.

There's a recruit named Cameron who, for some reason, is called Dick. His interest in death is awkward. His questions about it reveal something in himself that we're uncomfortable being near. He asks Bombardier if he's ever killed anybody. Bombardier sneers at him and says, 'There's something not right with you, Dick.' But as he walks away he says, 'I don't know. You drop a bomb from a plane. It explodes. What do you think?' I wonder what Bombardier sees on those strange nights when you wake in a half-dream state and things come back to you, larger than they are in the daylight. Does he see a door open in a plane and a flash of light and fire?

During basic training I can't imagine ever being out of here. How was it that once I could get in my car and drive somewhere? How did I govern my own time? The day we graduate there's a feeling in the air, like on the last day of school when we'd stack the chairs in towers and talk about holidays. As I get on the bus to leave, Corporal Steele yells over the crowd that he's going to call my next posting so they know to expect a shitfight.

The bus takes me to a holding platoon in Melbourne where I'll sort out everything I need for corps-specific training. The first job I'm given is to write my will. After that, I'm led to my new bedroom and I'm alone for the first time in three months. When the door closes I feel like the only oxygen is on the other side. I fold socks under my door so it won't close properly. I go to the shops to buy my dad a birthday present but I can't remember how to decide.

I finish my training in Melbourne and I'm sent to Townsville where the air is so hot it feels like hands around your throat. There are only two seasons here: the hot season and the wet season. They're both hot, it's just that one is also wet. A stranger tells me he once saw a bird die in mid-air and fall from

the sky. I live in a building with artillery boys and I sleep with a crowbar next to my bed. An email goes around telling us to watch out for the crocodile that lives in the river by the gym. Townsville is a garrison town. It was ready to be deserted before the base was built, and now the town's industry is geared towards catering to soldiers. The civilians here call us Army Jerks because we drink too much and start fights at The Strand on hot weekend nights. They don't smile at us. It's suggested we avoid public transport and travel in twos. Our shaved heads and strong arms give us away. I'm blasé about the warnings, over-confident, until something is slipped into my drink and I spend a night staring at taxis and telling people I have stars in my wrists. This is the fifth time I've changed cities this year and sometimes I look for landmarks to remind me where I am.

The eighth of March hovers in my mind as the day I enlisted and the day I can leave. Yet as March approaches I find I'm not ready to go. If I stay I could get a post in Brisbane, a deployment in June. A deployment means I could buy a house, or go to uni without a student loan. I have to decide.

There are hippies dancing and waving signs outside the base in Townsville. One shakes a sign at drivers that says, 'Honk if you want peace.' Another, 'Refuse to serve in Afghanistan.' I drive past on the way to Subway and think how almost a year ago I might have done something like that. The next month civilian protesters sneak into Talisman Sabre, a joint exercise between Australia and America. They try to take videos of our training but they're caught by the fenceline. People are getting angrier and security is tightened on base. We talk in groups about how civilians have no idea what's going on over there; how we're training the Afghan National Army, equipping them to look after themselves, and then we'll leave. We say war is the means by which peace is achieved. We bolster one another's opinions and they flourish. The eighth of March arrives and slides past. I'm posted out to Brisbane. I prepare for a war I don't understand and I wait as one after another, deployments are promised and then fall through.

In Brisbane I learn that if anyone was to invade Australia, it should be at 7pm when everyone on base is drunk. During one of these 7pms I meet Steve, a lance corporal in training. He likes me because I'm the only girl here and my hair is almost grown back. I like him because he has those muscles with the veins running along them, because he has a higher security clearance and

tells me national secrets, and because he'll be gone soon. He's off to Afghanistan as soon as his promotion comes through. He says cooks are safe over there. He'll get put on sentry and patrols, but it's a non-combat role. I tell Steve that a cook at training told me if insurgents get all the way to the kitchens, they've broken through every line of defence. The cook had said, 'Wait till they flood in, wait as long as you can, and then blow up the gas tanks. Get right up close and you won't feel a thing.'

Before Steve leaves, a cook from our battalion is killed. He was on sentry duty with a recruit of the Afghan National Army. The story gets through the cracks in security. Around base people pass the story back and forth. The recruit must have killed him because the shot was in his back, and because the recruit disappeared into the desert on the back of a waiting motorbike. I thought of those conversations in Townsville. How we'd believed one another about war bringing peace.

Men die in the Afghan spring, when insurgents come out from their winter hiding places. In the Book of Samuel it says, 'In spring, at the time when kings go off to war.' We call it the 'killing season'. We lack the poetry of the prophets. It's unnerving, how unchanged war is. Every killing season, smiling photos of dead soldiers appear in the papers. We get released from work to attend more talks to bolster us up again. We're shown more pictures of the Taliban's victims; more stories circulate, 'Look what the bad man did. Look how they treat their women.' We're fed a hero fantasy.

But it's a man in green who walks me home one night and tells a lie to our friends. He says I waited by the door, taking my time with my keys, and then invited him inside. Men in green send the texts that roll in like thunder: 'Steve deserves better than an ugly slut like you.' Steve doesn't believe the lie and I wait for him to defend me. I wait and I wait. He laughs when our friend runs up behind me and pulls my skirt into the air. 'Whore' is written on my door with little stick figure diagrams drawn all around it. The diagrams, or I suppose they're portraits, could be a disruptive pattern. The suggestion of a person. I stare at the sharpie marks against the blue paint and wonder, who is my enemy? Where does he live?

I drive to my parents' house and start looking up universities. I end up reading about the Ottawa Treaty and find the United States on the list of non-signatories. I am out of love with this. I should already be gone.

I read in my field notebook the notes I'd written from the grenade course, 'The F1 grenade has a kill radius of six metres. Casualty radius of fifteen metres. Contains 4000 ball bearings to maximise damage upon detonation.' I can't remember which lesson this is from, 'Who is your enemy?' or 'Who are you?'

I don't remember leaving. I remember starting university, and relearning how to buy groceries and be alone, but walking out of base that last time, handing in my resignation, doing final medicals, these memories are gone, in the same way that I wake in the morning with no memory of falling asleep. Three years later I find a box in my grandparents' cupboard. It's full of letters from my Nanna's uncle, who died in the war. The last letter says, 'Don't worry about me. Something seems to tell me that I will come through all right and all will be well.' He died on the ninth of September 1918, aged twenty-one. Dulce est, blah blah blah. War is like a card game that the elder teaches to the younger.

I heard that Steve came back from Afghanistan and started having panic attacks whenever he heard his name being called. He was diagnosed with an allergy to coffee.

INGRID HORROCKS

Gone Swimming

My family are swimmers. This last grey summer this meant checking the weather online whenever the temperature lifted and heading down to the Wellington beach least likely to be windy. Our regular spot is harbourside Hataitai, for its relatively warm waters, lack of undertow, and prime view of landing planes. We started going there when my daughters were toddlers and we've stayed loyal. Princess Bay on the south coast Taputeranga Marine Reserve, with its curve of rocks protecting a small bay and its view of the Kaikoura ranges, is a chillier but more spectacular favourite.

Toward the end of the summer I found myself also having lots of conversations about Nick Smith's '90 per cent of rivers swimmable by 2040' policy and the proposed new threshold for water health based on 'secondary contact' rather than 'immersion'. I kept coming back to the fact that the mechanistic adjective 'swimmable' just didn't evoke the immersive pleasures of swimming. And without that, what will make any of us care? It all made me want to reach for something more—and to throw myself into the water.

On what turned out to be the sunniest weekend in a long, wet summer, I decided to leave my family behind and swim my way up the island—in a manner of speaking. Ever since I'd read Roger Deakin's *Waterlog: A swimmer's journey through Britain* I'd been wanting to do something like this here, if on a much smaller scale. In preparation, I looked up the new Can I Swim Here? site just launched by Land, Air, Water Aotearoa (LAWA) and printed out maps from the Ministry of the Environment water quality website, with the waterways colour-coded from blue (excellent) to red (poor). I found myself reluctant, though, to actually look at these resources before I went, discovering a persistent desire not to know that I found was widely shared by people I met along the way. More pleasant to swim than to think about the shit we're swimming in. Why wouldn't it be? Before I thought more, I wanted to experience a spectrum of the pleasures of swimming.

I left work early on a Thursday in late March and by mid-afternoon was

swimming in the sea near Raumati, where my mother spent her summers as a girl. I paddled about in the small waves, Kapiti Island surfacing between me and the open sea. I stayed the first night with a childhood friend in the centre of the Manawatu Plains and in the morning, before school drop-off, we drove through the misty paddocks toward the hills for an early-morning swim. At Horseshoe Bend on the Tokomaru River, with my friends' kids as audience, we tottered over the grey riverstones, counted to three in unison, and dived into the deep freezing water. We were out almost before we were in, our skin singing with the rush of it.

I swam at Lake Dudding, near Marton, where my father-out-law used to go with his primary school in the 1940s. He remembered slightly murky water with a strip of yellow sand. It's now the site of a small motorcamp surrounded by farmland and, despite its boast to being 'Jewel of the Rangitikei', there was more evidence of mud than sand. I got changed in the concrete-block changing rooms, walked around the lake's perimeter, and swam back across, wanting to feel what it was like to swim with a destination. It's a small lake. When I say I'm a swimmer I don't mean I can really swim. I dreaded swimming sports days at high school and was one of those kids who was more drowning than swimming. But I loved being in the water and eventually I mastered a kind of basic breaststroke.

When I stepped into the water the lake-weed gathered around my legs and I had to clear weed away from my face at each stroke. It was heavy going and soon I was breathing hard, my limbs heavy. Eventually, though, I was through the weed and out drifting in the middle of the lake's still water, confident enough to pause and float on my back before swimming on. It was wonderful.

I had a quick sea swim at Turakina River mouth at Koitiata in the late morning and in the afternoon swam at Mosquito Point on the Whanganui River, which according to one website was one of New Zealand's 'Top 10 Summer Swimming Spots'. The Whanganui wasn't looking too great, even under blue skies, its thick brown waters moving slowly between wide banks. Everyone I spoke to in town seemed to think it had always been brown—that it was just a brown river—but I knew that once it was a green river with a stony bed. That week, in a unique Treaty of Waitangi settlement that was at the top of the radio news hour after hour as I drove, Te Āti Haunui-a-

Pāpārangi had been granted governance of the river in its entirety as a taonga central to their way of life—not just the water, but the river's bed, banks, fisheries, plants and taniwha. The settlement contained a reminder, too, that rivers were once, and continue to be, sources of kai. Most striking, though, was the fact that the river itself had been granted 'legal personhood', with the rights, duties and even liabilities that came with it.

I stood for a long time waist deep in the river with the thick brown waters running through my fingers and wondered what it might mean to want to swim in a person—and whether I should even be there. Perhaps the best-case scenario was to imagine it as an act of love, involving a complex, challenging, evolving relationship.

On that Friday afternoon there was no one else there, not even across on the east bank where there is a famous rope-swing. Then a Māori family arrived, a mother and three kids. They were new to the area and hadn't been to the spot before. The kids joined me in the water, calling me Miss. Is it cold, Miss? Are you going to put your head under, Miss? When I did finally dive in and let the current move me, Is the river taking you, Miss? Later a poet acquaintance would tell me there was thought to be a taniwha on this river bend, and that a swimmer drowned there last year. Only Pākehā go into the river at that spot, she said, I guess because they don't know.

The next morning I took a chilly dip in the hotel pool with its blue painted bottom and chlorine-clear water. I emerged wide awake, but it was nothing like the shock of the river swim of the morning before, nor the experience of drifting in the Whanganui. Later in the morning I turned off down a long gravel road and swam at the deserted nudist beach at Ototoka. I had to climb down a steep path from the clifftop carpark and cross a stream on a wooden footbridge to reach what turned out to be one of the most beautiful beaches I've ever seen. It is isolated by sandstone cliffs forged by the sea and is open to the ocean, giving an intense feeling of being on an island on the very edge of the land. I stripped off, becoming simply a small human figure looking out. It had been getting warmer as I travelled north. As I stepped in the water washed around and up my naked body. The waves weren't big but the undertow sucked back and forth at my legs, pulling me in so that I had no choice but to go under, plunging my head into a wall of water peaked with white.

As I dived I felt a childish Maurice Sendak rhyme running through me: *I am in the sea and the sea is in me.* It felt like a naïve, embodied version of the saying that was all over the airwaves following the Whanganui settlement: 'Ko au te awa, ko te awa ko au', 'I am the river and the river is me'. The water's health is the people's health. On my way back up the path I washed in the pounding waters of a small waterfall that gushed down the cliffs toward the sea.

After that I slowed down, turning off at Stratford and taking the Forgotten Highway north. I swam in a mountain stream beside the road near Damper Falls, from which I emerged refreshed but scratched from a scramble through the undergrowth. The landscape I drove through had begun to stream with potential swimming spots and I'd started dreaming about the potential for future family swimming trips.

I was now heading to Mokau, a tiny settlement on the west coast an hour north of New Plymouth. I drove through patches of bush among cleared hills in the long, golden afternoon shadows, remembering both the stark loveliness of the hills on the Wairarapa farm where I grew up, and what I now know about how it takes a century for the roots of big trees to rot. For a long time after the nineteenth-century clearances ghost roots held the skeletons of the hills in place. According to environmental historian Catherine Knight, we have only relatively recently begun to feel the full effects of hill-country felling and soil erosion, which now send 190 million tonnes of topsoil into waterways each year. This is silting up and raising riverbeds, making them susceptible to flooding and damaging their potential as homes for life.[1]

As I drove, I was listening to a podcast of Geoff Park talking through his classic 1990s ecology of New Zealand's coastal wetlands, *Ngā Uruora/The Groves of Life: Ecology & history in a New Zealand landscape.* In fact, I'd set it up when I headed out from Wellington and hadn't worked out how to turn it off so Park's voice started up every time I got into the car—*rapid deforestation, forest remnants, tapu, sacred places, unless we ...* There's something about his persistent lament that I find hard to take, but now I let him talk. Park has a chapter about a riverbend near Mokau where there's a small stand of giant

1 Catherine Knight, *New Zealand's Rivers*, Canterbury University Press, 2016.

kahikatea which for him is a sacred site. Once part of an ecosystem that would have been all along these waterways, astonishingly, according to Park, this stand is now the single remaining northern stand of original lowland bush that reaches to the edge of a river estuary.

I arrived at Mokau just before seven, as Mt Taranaki settled into silhouette against the sea and sky. From the Mokau Hotel the estuary looks like an inland lake, so that there is water everywhere, with bush visible toward the hills. When I'd read online that the median age in the town is thirty-nine I'd felt a flash of recognition, broken immediately when I saw the median income: $20,000.

I had to head down the road to the Awakino pub to get something to eat, and then I drove back along the road with an open beer and fish and chips, hoping to squeeze in a moment of kiwiana on the beach before the orange sphere of sun sank into the water in a blaze of west coast sunset. But the estuary was muddy (what did I expect?) and the way to the beach itself blocked by a two-metre-high security fence and danger signs warning of coastal erosion.

A young local couple fiddling with a tractor in the carpark pointed out where I could squeeze around the fence and perch on the rocks of the new sea wall. Later, I would read on the Waitomo District Council website (it had the byline 'Creating a better future with vibrant communities and thriving business') that anyone who chose to ignore these signs was liable to a fine of up to, yes, $20,000. But it was spectacularly beautiful down there in that moment as the sun sank and I was determined to enjoy my chips and great battered hunks of fish. As an arrival, it was a bewildering mixture of glorious and dismal.

Back at the hotel, prompted by Geoff Park, I finally made myself look at my printed maps and have a proper go at using the LAWA site. On the maps, rivers that are 'Excellent' or 'Good' appeared in blue and green, merging into the paper landscapes. They were the colours of water. Yellow, orange and red signalled fair to poor water quality, and stood out from my maps' surfaces like cancer cells, toxins threading through the land, pulsing with heat as the waters got further from the hills and began their journey through human country to the sea.

I started with the Manawatu–Wanganui region, where 45 per cent of rivers (by length) are 'swimmable' (that is blue, green, or yellow), meaning 55 per cent are not. I'd made myself think that Horseshoe Bend *must* be all right because my friend and I had driven toward the misty ranges to get there. But it was 'Code Red', as in 'Avoid Swimming'. There was an E. *coli* warning in place, which basically means animal or human faeces. The shit levels in Lake Dudding were okay, but there was an intermittent risk of toxic algae, with a traffic light coding of 'Could be a Health Risk'.

I quickly got confused moving between my paper copies and all the different online sites, shifting from smart phone to computer. It was a very different sensation from the heady rush of that first morning swim. At first I had thought the sea I'd been swimming in was clean, or at least clean again, since we have for the most part stopped dumping untreated sewage and industrial waste into it. The LAWA site had lots of 'thumbs up' icons based on the most recent readings. But when I looked at the Ministry of Environment site, which charts water health over time, I saw that where I'd swum at Raumati, as well as where I swim with my kids at Hataitai and Lyall Bay, all have a 'Moderate Risk' rating, as in 5–10 per cent risk of illness. Great. When the summer sun comes out, do we all need to start checking not just the wind direction on the Metservice site, but the toxicity levels on LAWA? It is a bleak thought.

So what about here, where I had not yet swum? At the service station where I'd filled up earlier the young woman had advised me to swim in the sea on the in-coming tide for cleaner, clearer water. She had a tide chart on the wall behind the counter and suggested I swim late morning the following day.

What about swimming in the Mokau itself? I'd asked.

Yeah, should be okay.

As I left she called after me, Anyway, enjoy!

According to the Ministry for the Environment site the Waikato region through which the Mokau flows has the highest percentage of highly polluted rivers of anywhere in the country. The whole length of the Mokau threaded its way across my online map in pulsing red. I was right to feel that it's an isolated region: the river's catchment area is home to just 2200 people. It's also home, though, to 440,000 sheep, 70,000 beef cattle and 20,000 dairy cattle.

The numbers were hard to take on board. Re-reading Knight's history of rivers the night before had filled me with the recentness and ongoingness of the impact of farming. The effects of agriculture on waterways today are different from that of nineteenth-century bush clearances. Cattle have gone from 2 million in 1975, to 4 million in the mid-1990s, to 6.7 million in 2014 as a result of the dairying boom. Huge expansions in irrigation, frequently subsidised by government, have drained rivers and streams and in turn intensified land use around then, leading to increasing waste. As Knight explains, even seemingly clear water running off farmland after rain is filled with damaging nutrients, bacteria and other chemicals. The pollutants have just become harder to see. She concludes that it is little use lamenting an ideal of pristine, pre-European settlement rivers; what we need is a shared language and set of values for finding a new baseline we consider acceptable. That is, rivers need to remain—or return to—whatever status we decide is appropriate for their functions, whether that be for generating electricity, for carrying away waste, for scenic value, or for hosting various forms of life, such as kanakana or native eels. In Knight's chilling account our collective lack of management of our rivers puts many of them in danger of becoming incapable of being 'working' rivers of any sort.

Swimming feels like such a small, trivial part of all this, but perhaps it serves as some kind of animal symbol of engagement and involvement—of necessary immersion—linking the life of waters with the lives of humans.

The next morning I dropped into the tiny visitor centre, filled with historical photographs of the early days of milling, and asked the woman at the counter about the river. She gestured in the direction of the bush just upriver, noting that I couldn't go there because you had to pass through farmland and she was sure I wouldn't be given permission. The upriver boats weren't running the usual cruises because of damaging flooding the previous week. But this woman, with her neat grey hair and cardy, seemed to be invoking the bush's presence as assurance of the health of the river.

When I murmured about the stats on the Ministry for the Environment site she looked puzzled, a little shocked maybe.

Shouldn't be …

I immediately felt like a rude outsider, coming in to complain about the cleanliness of the premises, and in a too-typical conflict-avoidance manoeuvre I somehow ended up agreeing it should be right. Right?

It was a gorgeous morning, completely still with a clear, pale blue sky. With nowhere very far to drive that day, I was in a holiday mood. There were a few families down on the beach, mainly with little kids in sunsuits. We have at least, for the most part, taken on board the dangers the sun poses to the human body on this spot on earth. The tide was coming in, hopefully bringing in new water from the ocean.

Yet it was the river I really wanted, despite what I now knew. On its southern bank there are caves where the cliffs meet the sea; the cliffs rise up from beside the water for hundreds of feet, forming a spectacular promontory out above the ocean, and I was drawn to the river's wide-open mouth. When I stepped into the water on the edge of what, according to Park, was one of our last working tidal estuaries, I felt the tug upriver.

At first I walked upstream with the tidal waters, waist deep and two metres from shore. The water was clear and fast moving. Then I lay on my back, toes poking out, hands fluttering like vestigial wings, and let myself drift. I'd never felt anything quite like this floating. For a while I closed my eyes, letting the water carry me. The minutes stretched, the water seeming to enter into my amphibian body.

Then at the bend, the current suddenly pulled me toward midstream. I flipped and reached for the bottom but it had dropped away and the water was moving fast and straight now, tugging at my legs as I tried to kick myself back toward the bank. My arms only just made headway against the pushback of the water, my panicked strokes almost useless against the water's pull. Then just before the rush to midstream a sandbar pushed up against my feet and I stood, breathing hard. River drownings were so common in the nineteenth century they used to call them the New Zealand death.

Back in the shallows there was a woman in gumboots fishing, her line stretching across my route. I waded carefully back to the shore and got out of the water.

The woman was catching kahawai mainly, she said, but sometimes she got trevally or snapper.

Does she swim?

Well, she prefers swimming pools. Besides, she added, I know what's in here.

Together we stood and looked across the moving water, undergoing its swift daily cleansing that is never enough.

When I looked back she was holding a flame up to a cigarette.

Two days later I would develop a bladder infection.

In the afternoon I headed on to Raglan, where my own life began. I was due on election day 1975 (back when there were only 2 million cattle in New Zealand) and my mother was a candidate for the Values Party. She is gloriously ripe in the campaign photos, embodying some kind of Earth Mother image the press was intent on associating with the party when they weren't depicting them as a bunch of radical, free-love, tree-hugging hippies, rabbiting on about things like pollution and the future. Muldoon was elected and I was late.

A week after the election my mother, my father and my elder brother, then three, drove along the winding roads from Cambridge to Raglan, where they went for a walk on the beach and ate an enormous mussel feast. By the end of the walk I was on my way.

I drove into Raglan in the early evening. I pitched my tent in the campground on the peninsula that juts out into the estuary, before walking over the small sand dune between the campground and the water. All I could think was, bloody hell, this magnificent island we live on. I was alone on a grey-sand beach by an inlet glazed gold by the sun. I thought of my small family here four decades ago, my mother's stomach swelling.

Was ever an evening this still and waiting, the sky this deep blue?

After dinner there was one more swim to be had, a night swim, which like a morning swim is all its own thing. I don't remember when I last swam at night, certainly not since my own children were born.

I'd been planning on skinny-dipping, which is an essential part of the night swim, but a man had called out after dinner as I left the restaurant and set off around the dark sand dunes offering to 'walk me home'. I was determined not to let the menace in that call take the night and thus the water from me, but I did go back to my tent for togs.

I headed down the short path from the campground without my torch. The

mixture of thrill and fear in the dark felt familiar, as did the sense that the real danger might be human.

The water had retreated and as soon as I put my feet in I felt mud. Again, of course. I could have predicted that one, as well as the low tide. I was a slow learner. Another 20 metres on it was still ankle deep, while way ahead of me sandbars rose above the water level. I walked on, not swimming this time, but moving in the water's terrain.

Above me the stars were extraordinary—more every minute, it seemed, although perhaps it was just my eyes adjusting. And then I saw, or at least thought I saw, the stars reflected on the water. Was that even possible? Could light be thrown down from the sky like that? In the sky the stars blurred into the arching haze of the Milky Way, but in the water just the brightest gleamed on the perfect black stillness. I breathed, breathed, feeling that rare sense of complete stillness settle. I could have been standing on the back of a whale swimming in the sky.

When I woke the next morning in my tent I would be filled with wonder at the memory of the size of the night and of those stars floating in a depth of black. And I would feel, then, the smallness of this planet, terrifyingly expendable with its seas and tributaries, and its rivers and lakes. And the brevity of the time we have.

LYNLEY EDMEADES

Reaching Out for Hear

Hearing is the sense most favoured by attention; it holds the frontier, so to speak, at the point where seeing fails. —Paul Valéry

Pin your ears back and go for it. —John Key

Every Friday afternoon I go to a small room in a building on a hill in Dunedin. This room is north facing, and being there in the early afternoon means I often catch the sun at its height. In the winter months the sun sashays at an acute angle, across the carpark to the wall opposite me. As I fiddle with my hands, picking at the dirt underneath my fingernails or rotating the ring on my right hand, the sun's shadows alter the beige tones of the ceiling.

 I don't know what happens in the room next door, but Friday afternoons are for some kind of administrative task. The walls are thin, and I can hear the methodical kerchunk of what sounds like an old stamp, sending me straight back to my primary school library. In a time of emails and electronic invoicing, I like to think that in the room next door they've stopped the clock: Friday afternoon is for folding up documents, licking envelopes, and stamping them with a return address. Or *courtesy of.*

 The stamping is usually replaced by a vacuum cleaner. I hear the plug being slotted into the wall between it and me before the vacuumer plots the carpeted floor, punting around under desk and between chair legs, up against the edges of a freestanding pot plant, perhaps. It only takes a few minutes, so I guess the room is pretty small. I know this place by hearing.

 I am often silent here. The man who sits with me calls it my quietude. Sometimes I struggle with it; sometimes it is exactly what I need. While there is doubt about what we are hearing, there is no doubt that we are both listening. He listens to me, listening.

The verb *to hear*, or its gerund form, *hearing*, has a couple of different meanings in contemporary usage. From the early thirteenth century we have the meaning that has endured today: to perceive of sound by ear. Several hundred years later the term came to be used in a legal context: *to receive a fair hearing*. In French, écouter is the common verb for the act of listening, while its counterpart, *entendre*, means, more broadly, to hear or pay attention to something or someone. *Entendre* comes from the Latin *intendere* or *intendo*, meaning, in a sisterly way perhaps, *I turn my attention to*, or *I hold out, stretch or strain* towards something or someone. In te reo Māori there are several different words used to describe both the act and the phenomenon. The common verbs *oko* and *whakarongo* both mean *to hear*, while several modified versions describe various kinds of hearing: *kātahi* signifies the listener likes what they are hearing, while *hāraurau* and *hakari* describe hearing a more or less indistinct sound. *Whakawā* refers to a judicial hearing, but can also mean the act of judgement or accusation.

'I got a right earbashing' is something people used to say after being in the school principal's office, or after a yak with a chatty aunty. 'I'm all ears' suggests you're open and ready for an ensuing conversation, but also where an air of condescension might mask good intentions. Children are often told to 'listen up', which means more than simply 'listen'—more like 'pay attention'. If I've been 'listening in', I've probably been overhearing something not intended for my ears.

> Listening In
> The mere presence of her was the necessary part.
> Overhearers, their large wafts of ears
> were, of course, listening in.
> Together, we could hear history
> painting a diagram of itself, and things began
> to form layers. My mother's hand
> upon the pillow, the pillow soft upon the bed.

My sisters and I were a typical bunch of girls, yelling 'it's my turn!' on the trampoline in our younger years, or telling each other to piss off and

slamming doors in our teens. As we grew up, the outdoors no longer held
such glittering appeal, and the house seemed to grow smaller. I recall the
volume of the television slowly creeping up as our tolerance for one another's
company diminished. If the phone rang, or if Mum was 'doing the accounts',
she would announce herself in the doorway with hands on hips. 'Turn that
bloody thing down,' she'd say. 'I can't hear myself think.'

In the eighties the phone was hot property in a family of three girls. We
couldn't all be on the phone at once, giggling coyly at boyfriends' jokes, or
gossiping about who was wearing what at mufti day. Dad would always need
to 'make some phone calls' after the news at six, while Mum was getting the
dinner on and asking us to turn the TV down. We had to wait in line for a turn
on the phone on a weeknight if everyone was home, and when you finally got
to use it, the receiver was always warm and a bit greasy.

I remember how revolutionary it was when Mum came home from The
Warehouse with a phone extension cord. Usually stationed on the wall
between one sister's room and mine, the spare phone could now be trundled
out and into the privacy of my own bedroom. It was one of those receivers
that had the numbers on it, so if you were balancing it on your shoulder while
fiddling with your ghetto blaster or trying on your sisters' earrings and you
pressed too hard, the person on the other end was assaulted by a prolonged
beep as you leaned on a button.

One advantage of a phone with multiple extensions was that you could
listen in on others' private conversations. As the youngest, I took my role as
chief eavesdropper very seriously. Soon after the arrival of the extension I
perfected the art of picking up the phone in the kitchen whenever an intimate
exchange was happening at the other end of the house. The trick, my peers
taught me, was to pick up the receiver while keeping the hang-up button
pressed down, preventing an audible click. The mute button was also a coup.
It meant I didn't have to mask my breathing any more, or could relay
everything to the friend beside me, who was, naturally, all ears.

My parents weren't big on talking about the birds and the bees. I was lucky
to have older sisters, and to be able to listen in on conversations as things
started happening to them, knowing that one day I too would have 'my friend
come to visit'. Why my mother insisted on calling menstruation a 'friend'
remains a mystery to us. She'd say to us younger two, 'Leave your sister alone,

will you? She has her friend.' What friend? I'd wonder. She'd be in her room, everyone else busy with whatever it was they did before the internet, and I'd go and stand in the hallway, carefully pressing my ear up to the cold wooden door. There's no one in there, I'd think to myself.

Some years later my listening curiosity led to to my first encounter with the mysterious world of sex. This time my sister had a real friend staying: Jason, captain of the first fifteen. When he'd come in, he'd address everyone individually, finding something to say to each of us. We all loved it; Mum would even giggle a little when he'd ask, 'And how was *your* day, Mrs E.?' When said sister turned sixteen, and because Jason was captain of the first fifteen, he was allowed to stay over at the weekends. I would listen with both fear and intent when the bed would gently and repetitively thud against the wall between her room and mine.

Recently I've been learning how to teach English to second-language learners. For the training we meet in a large, cold room on the second floor of an old school in the fluvial marshes of South Dunedin, where we discuss issues of acculturation, the dangers of generalisation, and the struggles of language acquisition. One day, in an effort to help us appreciate what it is like to hear a language we don't understand, our teacher calls upon one student, a native Chinese-speaker, to address us. In under twenty minutes he delivers Mandarin 101: the consonants, the vowel sounds, the compound vowel-consonant sounds, and the four variations in tone. The latter he expertly demonstrates by pretending to drive a car: flat terrain (mā), uphill terrain (má), downhill terrain (mà), falling-then-rising terrain (mǎ). We are all smiles and eyes.

About halfway through his presentation our teacher interrupts. 'What you're doing is great, Steven. But for the rest, just speak to us in Mandarin.' Steven pauses, smiles, and does what most of us will only ever imagine doing—he switches languages. Very quickly, our demeanours change. I sit back in my chair. I may have folded my arms. At one point, Steven slips back into English, says, 'for example', which I latch on to. I wonder if there is perhaps no equivalent in Mandarin, or if he's subconsciously falling back on to common ground after feeling our shift in attention. He starts gesticulating more, larger and bolder movements with his arms and hands, face and mouth. The volume of his voice goes up.

Later, the teacher tells us that she'd once done this same exercise with another group, without explaining it beforehand. The attendees came back from a tea break, she tells us, and sat down expecting the lesson to resume as normal. Instead, a fluent Spanish speaker stood up and began addressing them. In response, one woman stormed out. She was so discomforted by the experience that she left the room. For some, hearing a language they don't understand is like listening to white noise. For others, it's like music.

In one of his lesser-known works, American composer John Cage stripped language to its bare bones in an effort to encourage us to listen to the nuances and subtleties of sound. In 'Empty Words', Cage took a text from Henry James Thoreau and broke it down to five main elements: phrases, sentences, words, syllables and letters. Each unit builds from the previous: we make syllables from letters, words from syllables, sentences from words and so on. Over the course of the work Cage deconstructed the original text so that all that remains in the final section are letters. When he performed this piece, the effect was something like a *musication* of language: while the letters still symbolised something, they were closer to musical notation than written language. The letters stood for sound, 'emptied' of their meaning.

While Cage's work is intellectually intriguing, it is not readable in the traditional sense. It is hard to engage with at face value. What is fascinating about 'Empty Words' is that, like much of Cage's work, he took the concept to the extreme. He wasn't afraid of not making sense. In fact, at one particular performance of 'Empty Words' in Milan he was booed off the stage, had tomatoes thrown at him, and was shouted at for being a 'futurista'. He was happy to speak in a way that was not understood.

Calm and
In the distance he could hear
sound making a right go of it.
His lobes, with all their tucks
and echoes, were like a cat's footsteps
on a wooden floor.
Together, they would make a bay
of calm and almost-static:

the sound moving out to ear,
his ear reaching out for hear.

In Maslow's hierarchy of needs, basic physiological necessities form the foundations—food, shelter, warmth, safety and security. Above these sit psychological needs: belongingness, love and relationships, esteem and accomplishment. At the very top, as a kind of bonus tier if you can make it that far, is this thing called self-actualisation: achieving one's full potential. What isn't mentioned is listening, but I feel like this otherwise taken-for-granted act hovers in the background of the whole pyramid scheme, like an undercoat that gives the primary colours their lustre. To my mind, the elements in the top half are synonymous with a feeling of being mirrored, being held in mind and having a sense of self, of which listening is the bedrock. To have a foundation of listening is to trust that when you speak you will be heard; that when confronted with the noise of yourself you will learn to find words to speak about that noise; that those words will be picked up and heard by a devout listener.

Skilled, trained listeners are in high demand in New Zealand, where one in six adults are living with mental illness. If you're Māori, the odds are almost double. In June 2015 the country's largest counselling service, Relationships Aotearoa, was placed into liquidation after its main source of funding was cut. At that time the service had 7000 clients receiving counselling or therapy; in the years leading up to the closure, Relationships Aotearoa reported seeing up to 30,000 people per year. In the 2017 budget the National government announced what appeared to be a 'boost' to national health spending, the biggest increase the sector has seen since 2006. On closer examination it can be seen that funding additions for mental health since 2008 in fact represent a 28 per cent increase in spending to meet a massive 60 per cent increase in demand. Since its closure, Relationships Aotearoa clients have been forced to go private, upping the demand and wait-time for privately practising counsellors and psychotherapists.

The going rate for a fifty-minute session with a private practitioner ranges from about $60 to $120. While some people may be eligible to receive funding through Work and Income, this money is only available for those who meet the criteria for a 'serious mental illness'. You have to be in danger of harming

yourself or others. But even then the services aren't readily forthcoming. A friend told me recently that when he mentioned the word 'suicide' in his third session with a new therapist, the therapist responded by asking how he thought that made her feel. She then proceeded to tell him that his mention of suicide had made her feel scared. When he didn't turn up to the next session, the therapist never called.

A number of years after learning about sex through the wall of my family home, I gained my own first-hand experience of bed-against-wall-thud. I lost my virginity at the ripe age of fifteen, because that's what everyone was doing then. I was babysitting and, since my boyfriend lived just down the road, I decided this was 'the night'. My boyfriend waited down the street until the kids were in bed, and when he came over I told him we didn't have much time; I took him to the spare room. I was quite the young seductress, except I had no idea what I was doing. It was just a case of getting it done, my friends had told me.

Doing the washing the next day, my mother found blood spots on my underwear. I was listening to the Smashing Pumpkins in my bedroom when she knocked on the door and asked to speak to me. She never mentioned the word sex, and so our short conversation seemed to pass in platitudes. 'You know you can talk to me about anything, don't you?' she said. I wasn't sure if she was talking about menstrual issues or my recent sexual escapade. Again, I didn't know what I was doing. If they'd told us during the sexual reproduction module at intermediate school that losing your virginity might result in bleeding, I mustn't have been listening.

Once I got into the sex groove, and was old enough to be allowed to stay at my boyfriend's house, he and I spent a lot of time in the bedroom. His parents' room was next door, and in some unconscious and immensely embarrassing act of role-reversal I took my role as sexually active girlfriend very literally. There is no doubt in my somewhat more mature mind that his parents could hear us and, with the gift of retrospect, I realise my sonic exhibitionism was derived from a need to be heard. I wanted to be recognised as an adult female human being, and somehow, I felt that by giving my sexuality a soundtrack, I would come to be treated like one. Of course, that subconscious *intendo* was misplaced. I wanted to be heard because I hadn't

been, but I was making all the wrong sounds and reaching out to the wrong people. Thank fuck I don't have anything to do with him or his family any more.

In 2014 Eminem took the National Party to court for using a version of his song 'Lose Yourself' in their election lobbying. The song was used as backing for their campaign track, and Eminem's company, Eight Mile Style, alleged that the National Party had breached copyright law by using the chart-topping hit.

To testify in the case, lawyers brought in various expert listeners to prove that the song used by the National Party, although actually called 'Eminem Esque', was only partly derivative of the original. Various musicologists and academics were invited to express their opinion, as was Jeff Bass, the co-producer of the infamous rapper's song. Bass performed a version of the song on his acoustic guitar in front of the Wellington High Court.

Bass's performance, and other recordings of the hearing, are readily available online. One minute-long clip in particular shows a lawyer awkwardly poised in front of his laptop, plugged into the courtroom's sound system as the original song is played for the court. The lawyer is somewhat dishevelled, his legal regalia draped over his shoulders as if grabbed from the coat rack on his way out the door; his silvering hair is ruffled. He peers around the room with eyebrows raised quizzically, looking as if he might slip into a Dad-ish shuffle, not knowing where to put his hands. A woman dressed in corporate attire and with a regulation brown bob leaks out a small smirk and seems to only just suppress a snicker. She watches incredulously as the man seated next to her takes extensive notes. He looks up at the ceiling periodically, as if gazing at the sound system directly might reveal something that cannot be heard.

It's a laughable story: a rapper's song—aptly titled 'Lose Yourself'—being played in a wing of the Wellington High Court, which looks like some 1960s purpose-built university tutorial room. Quirks aside, what I find so compelling about this clip is the implied invitation to watch these lawyers and bureaucrats in the act of listening, and where this listening, or failure to listen, is both the point of great discomfort and the whole point of this court hearing. Eminem was suing the National Party for not listening to his song

properly to begin with. It is essentially a hearing about listening, or the failure to listen, and where the act of listening procures both inanity and discomfort.

In a 2014 interview, young entrepreneur Jake Millar asked John Key what advice he would give to his sixteen-year-old self. Key's response was to 'pin your ears back and go for it'. What did Key mean in this context? The phrase 'pin your ears back' has a confusing array (or mêlée) of meanings. Some say it refers to someone or something preparing for a skirmish. It is what a dog does before it attacks, enabling it to charge with full force and ferocity. Others argue that if a dog is pinning its ears back it is more likely to be behaving submissively in the face of a bigger dog or an authoritarian owner. Different again is the notion that if I am challenging someone in a fight and I pin my ears back, I have soundly defeated my opponent. Alternatively—and more specifically related to the idea of listening—if I am being chastised by my father, for example, he is likely to be pinning *my* ears back. At the same time, if he is punishing me, and I pin my ears back, I am probably listening very carefully.

Given that Key also said, 'It's not ability that's going to define how successful you are, it's attitude', my feeling is that his advice to his younger self was addressed to the attacking dog. He seems to be telling this young man to get ready, which implies, in this context: don't pay attention to others. All you'll need is attitude, that go-geddum outlook that our forebears had. You won't need your ears, or the ability to hear, and you certainly won't need to worry about listening.

My teenage sonic exhibitionism was problematic precisely because I pinned my ears back and went for it. I was making sound but didn't know where it was landing, and the sounds I made didn't fit with what I wanted to say. I wanted to be heard, but I failed to listen to myself or anyone else. I was straining, but not toward anyone that could really hear me.

A version of this went on for some years. I felt like I was yelling but no one was listening, or that, like my boyfriend's parents, no one could hear what I wanted them to hear. What I said and what was heard seemed to be different languages. Some of it was noise; some of it made no sense. This might be why, years later, I have come to find Cage's poetry so compelling—he

possesses the freedom to speak without having to make sense. As a teenager, when I felt like I wasn't making sense, I came to contain my yelling within the walls of my head. From there, I grew quiet and reserved. Into my twenties, I wound up severely depressed and needing help. My ears were pinned back, but I was getting nowhere.

In the small room on the hill, my listener does the *straining towards*. That's his job. He's trained to pay attention and he's really good at it. He listens to my noise, my silence, and my not making sense. He listens, and I listen, and we do that thing together. Here, we are submissive dogs. We don't need to get ready for attack. Instead of pinning our ears back, our ears reach out for hear.

There is no clock within my line of sight here. It is part of my listener's job to do the time-keeping. When my allotted fifty minutes has passed, he announces that 'it is time for us to stop for today', the emphasis falling on the *is*, as if it could be time for many other things. 'Sure,' I reply, and slowly come back to sitting.

As he writes out a receipt, I usually make some comment about the weather. Now that we're back in the hearing-and-seeing-world together, I feel the need to fill the silence. He replies to my pleasantries with a mild smile, without looking up from the task at hand. As I put on my coat, he stands to hand me my receipt. I thank him as he opens the door. 'See you next week,' he says. 'Sounds good,' I reply.

SUE WOOTTON

A Box of Bones

Searching recently for a good read-aloud children's story, I pulled from the bottom of the bookshelf *How Tom Beat Captain Najork and his Hired Sportsmen* by Russell Hoban. Young Tom lives with his aunt, Miss Fidget Wonkham-Strong. She's no soft-hearted dearest Auntie Fidge. She is aways, strictly, Aunt Fidget Wonkham-Strong, a woman who 'wore an iron hat, and took no nonsense from anyone'. In Quentin Blake's illustrations she's a big-beamed human battleship wearing a riveted-on grey dress and a high grey helmet. Tom—colourful, cheeky, cheerful—is clearly dancing circles around her. Readers naturally side with Tom. He's all risk and movement. He's teetering and testing, nimble, flexible, curious and persistent. He's full of life. Poor old Aunt Fidget Wonkham-Strong makes flowers droop and trees shiver. Ridiculous in her rigid posture, bound tight by her unbending rules, she represents a fatal stillness of the soul, a kind of living death.

When I was eighteen, I found myself in the presence of someone very like Aunt Fidget Wonkham-Strong. She taught anatomy at the school of physiotherapy where I was enrolled as a first-year student. Wide-hipped and waistless, with an imposing ledge of a bosom, whenever she walked into the room we tender blossoms drooped. She stomped, each footstep an insult to the floor. I would eventually learn to figure out where a person was hurting by watching them walk: lower back, tummy, ribcage, shoulder, neck, head, hip, knee, Achilles tendon—the site of pain always lends a signature adjustment to the gait. But even as-yet untrained, I could tell that Ms Anatomy Wonkham-Strong was through-and-through sore. Some long-ago irritation had lodged within her, spread through her entire body, and vibrated out into any environment through which she moved.

Her hair was set on her scalp in smooth grey whorls, the way ivy leaves in relief decorate a tombstone. She delivered loud, withering judgements when students weren't quick to respond or gave the wrong answer. Her temper simmered, battle-ready. In *How Tom Beat Captain Najork* young Tom is the bane

of Aunt Fidget Wonkham-Strong's life. He likes to fool around; she hates fooling around with a vengeance. She wants him to eat greasy bloaters and cabbage-and-potato sog and learn the *Nautical Almanac* by heart. Tom carries on fooling around. He fools around with barrels in alleys, and on high-up things that shake and wobble, and he fools around by dropping things in rivers and fishing them out. 'It looks very much like playing to me,' Aunt Fidget Wonkham-Strong tells him disapprovingly. Just so, our anatomy lecturer disapproved of us. She believed that if left to our own devices we'd fool around all day and half the night.

You bet. We were young and for many of us it was our first year living away from home. We were boisterous, a pack of puppies off the leash. Fooling around was a force within us; we were full to bursting with laughter and physicality. When we walked we had a tendency to romp, and if the flowers and trees shivered as we passed it was with a surge of delighted, sensual anticipation. We could, and did, giggle anywhere, those withering looks from Ms Anatomy Wonkham-Strong notwithstanding. Her *Nautical Almanac* was *Gray's Anatomy*. As physiotherapy students our main focus was the musculo-skeletal system: muscles, tendons, ligaments, bones, joints, nerves, arteries, veins, cartilage and fascia. If Ms Anatomy Wonkham-Strong said *deltoid* we thought *origin, insertion, nerve supply, actions*. If she said *scapula* we mentally murmured *spinous process, medial edge, lateral border, subscapular fossa, suprascapular notch*.

We spent hours in the medical school's anatomy library and dissection room. There we abandoned book learning and travelled, at first sometimes a bit queasily, through this new, strange territory of the dead body. Gray's was an excellent map but, like any migrant fresh off the boat, we took a while to recognise the actual landmarks and to confidently navigate between them, and longer still to become fluent in the unfamiliar language of this different place.

There was slang, expressions like 'See you in the bod room' to toss lightly into a conversation with a classmate; there was the secret pleasure of being in that gang, seeing the arts students' eyes widen with, what was that—fear? There was a whole new formal vocabulary to get our tongues around, words like *septum, fossa, zygoma, trochanter* and *trebaculae*—a lexicon that was sensual in its chewiness and shamanic in its power. 'A treasure trove of words!', as

neuro-surgeon Abraham Verghese puts it in his novel *Cutting for Stone*. The novel's narrator soon discovers that learning this 'special language' is a way of 'amassing a kind of force'. Like him, we learned, we amassed, and we felt the force accrue. *Radius, ulna, olecranon, epicondyle, bicipital groove.* Of course too much amassing counts as hoarding, and there is no one poorer than someone who does not know how to gift their gold, but there was no space in our student curriculum for reading novels like *Cutting for Stone* that might have reminded us of that.

Lectures always opened with a roll call, Ms Anatomy Wonkham-Strong calling our surnames in alphabetical order and each of us in turn responding 'Here' or 'Yes'. For me, someone who hated speaking out in classrooms at the best of times, this was an ordeal. Plus, it was like listening to the radio's weather forecast when you live in Dunedin. *Auckland, rain and 14 degrees … Hamilton, morning fog clears to a fine afternoon, 14 … Wellington gusty northerlies and 12 … Christchurch, 10 and sunny … Chatham Islands, cloudy, chance of rain.* My surname, near the end of the alphabet, was the Dunedin of roll calls. Too often I missed me. Someone would poke me and I'd startle awake to find all faces turned to me and a cavernous silence filling the room. 'Here!' I'd peep. But how long had Ms Anatomy Wonkham-Strong been standing there bellowing my name? Had she already said, in that iron voice, 'Are you available for this class or do you have better things to think about?'

I did tend to have better things to think about, or at least more intriguing things. For instance I thought about Ms Anatomy Wonkham-Strong. How old was she? Hard to tell, but old. Forty-five? Fifty? Was she married? The thought! And why so mean and mirthless? Was she born this way, or was she a cutie-pie baby turned sour? What sours people? Surely it was unpleasant being Ms Anatomy Wonkham-Strong. Could she smile? I mean *could* she? Or had her muscles grown too weak from lack of practice? (And what were smiling muscles called? I had never before thought of how a smile needed a muscle.) That hairdo … it had to be a salon wash and set.

I shuddered. One of my first after-school jobs had been helping at a hairdresser's, sweeping the floor, sterilising the combs and refreshing the towels, greeting customers and leading them to the basin or chair. Churchmouse shy, I was quaking in my sneakers most of the time, but I must have measured up because after a couple of weeks I was told I'd be allowed to

wash clients' hair. The prospect was terrifying. It seemed such an intimate thing to do to a stranger, to someone tipped backwards helplessly, throat exposed. When my very first hair-washing customer turned out to be the mother of a boy from my class I wanted to run out of the salon and not come back. I was scared to fasten the cape, scared to adjust her neck on the headrest, scared of getting shampoo in her eyes, of freezing (or scalding) her head. Mrs F ought to have got that haircut free—she worked so hard to reassure me while I tentatively wet her head and then massaged in the foam. Mrs F was a salon regular and after a few weeks I began to look forward to her appointment.

Ms Anatomy Wonkham-Strong was clearly also a salon regular … but how the heart would sink to see her approach. A pall would be cast. The salon's aviary-like chitter-chatter would thin and cease. I could all too well imagine draping the cape over her formidable torso, helping her lie back in the chair (that bookshelf bosom undeflated, pointing straight up), adjusting the nape of her neck on the basin's padding, testing the water temperature on the back of my hand and then running my fingers through the concrete swirls, loosening the strands, touching the pallid skin on her scalp. Oh, horrific! And worse—what if, instead of berating me, she closed her eyes and sighed with pleasure? I couldn't tell if that was hilarious or nauseating—it was right on the edge.

Most weekday evenings I studied in my hostel room with *Gray's* open on the desk. I pored over the illustrations and wrote notes listing each body part's essential features—which of course I understood to mean its examinable features (I was so *very* young.) I also kept on my desk a wooden box containing the right half of a human skeleton. Skeletons for students were usually sold as halves, it being the obvious way to add value to one body. It cost me more than the usual half skeleton because it still had the skull. The skull was quite a prize, and therefore I didn't leave it in the box. I placed it on my bookcase, which I felt made me seem both sophisticated and mysterious, like someone who actually belonged in this strange new world, this world of the peeled person. Meat, bone, gristle … was this what being human amounted to, in the end? My own body was becoming strange to me, both more and less marvellous, more and less mundane. I'd gaze at my warm, dexterous, feeling, touching hand, amazed and appalled in equal measure by

its structure and connections. By its cleverness, and by its limitations. The carpals, for example, two rows of Boggle-like bones snugged in at the base of the wrist: *trapezium, trapezoid, scaphoid, lunate, capitate* ...

Visitors to my room were drawn to the skull. 'Is it real?' they'd ask. 'Yes,' I'd say, and very often a reflex response, not quite a grimace, would flash across their faces. If a person happened to have a hand on the skull at that moment, the hand might jump away—but it would soon return, stroking the tight seams where the cranial bones zipped together or testing the teeth in their sockets. People liked to pick up the skull. They made a show of weighing it on an upturned palm and staring into the eye sockets. There was a fair bit of misquoting Shakespeare. *Alas poor Yorrick. To be or not to be. I knew him well. Hubble bubble toil and trouble.*

I said those same things myself from time to time, but mainly my relationship with the skull was low key and domestic. I usually said hello when I came in at the end of the day but otherwise the skull and I each kept our own counsel. Most of the time it just sat on the bookcase keeping me company while I studied, looking over me while I slept, there to greet me when I woke. But no, I didn't actually believe that. The skull was just bones. Surely otherwise I would have kept it in the box with the rest of its skeleton, and not allowed strangers to handle it like a stage prop. But my journey towards the bones themselves, towards their realness—towards, you might say, their marrow—was slow. I was still only capable of learning the simplest anatomy, the disarticulated version.

At some point most evenings I would put down my pen and pull the box of bones towards me. The lid had a small brass hook that fastened to a matching brass eye on the base. I tapped the hook edgeways and, as it fell free of the eye, I felt the box give, as if I'd just unbuttoned a tight corset. Apart from the foot and the hand, whose bones had been wired together, the bones lay separated and higgledy-piggledy. I might pick up whatever happened to be lying on the top—a rib perhaps, or the femur.

At other times I needed to look more closely at a specific part of the body so I would fish around for that particular bone. The knocking sound of bone on bone and bone on box comes back to me as I recall this. With practice I became good at fishing blind, my eyes on *Gray's Anatomy* and one hand in the box, delving. The scapula is like a large empty scallop shell. The humerus and

the fibula are long sticks, the humerus thicker, and knobbled top and bottom. The fibula is more like a giant's toothpick or knitting needle. A patella sits comfortably in the palm of the hand, and has a satisfying contoured shape, like a large limpet. I noticed, too, the patella's heft, its stone-like solidity. Most of the rest of the bones in the box didn't feel this way. They were very light in the hand, almost like holding sticks of chalk. Had they been buried, or cremated, of course, they would be less than chalk by now. They'd be dust. Perhaps beyond dust: loam, clay. Shakespeare has Hamlet imagine Alexander's bones fully recycled in the earth, becoming clay to stop a bunghole. *To what base uses we may return, Horatio.*

To this base use? To rattle in a wooden box from student to student; to live out the afterlife in a succession of Dunedin hostels and flats; to lie higgledy piggledy on a desk in Clyde Street, perhaps, or on a Queen Street windowsill with a view of the Green Belt, kererū and tūī swooping through the trees? I bought the box from a medical student who had pinned a 'For Sale' message on a notice board at my hostel. I went to his flat in Albany Street. I remember that he did not invite me in—we did the transaction on the doorstep. When he opened the box to prove nothing was missing, a frisson of fascination ran through me. Real bones! Whose bones?

I exclaimed. I touched. I questioned. I was caught up and passionate. He shifted uncomfortably, let me wind down to a halt. The bones, he told me, had probably come from India, but he didn't really know. He spoke coolly, dispassionately, a trifle disdainfully. I understood that I had transgressed. I needed to get cool with the bones. Ashamed of my rookie behaviour, I immediately suppressed my natural curiosity about the skeleton's origins. I saw how naïve I was, how childish, sentimental and unscientific. I would have to adopt a completely new approach to the human body if I were to be successful in my chosen career. I needed to detach my self. These were just bones. We are all just bones.

I walked back to the hostel with 'my' half skeleton in my arms. I'd like to think I was aware, even if fleetingly, of faint flipping or flapping sensations in my gut and my chest, like tiny wings, as if valves deep within me were fluttering shut. Not valves I would ever see in an anatomy atlas or on a dissection table, for which very reason it would soon become easy for me to spend many years denying their very existence. These were insubstantial,

ineffable and mysterious: the portals through which the subtle intelligence flows, mind to body, body to mind. If I did feel anything I doubt I knew what was happening. And anyway, I would have regarded it as a sign of progress. There were now two me's: me 'before the bones' and me 'after the bones'. Those valves were acting like shutters. What was shutting off was a way of seeing.

In his 1907 painting *The Head of the Medical Student* Picasso depicts a medical student with one eye open and one eye shut. The student bears medicine's doubled vision: an eye for dissociated observation, and an eye for connection and compassion. Open: the outward-looking, fact-discerning eye. Closed: the inward-directed eye of insight. An objective eye and a subjective eye. A cool eye and a warm eye. An eye for light and an eye for dark. A vigorous eye, purposeful and clear-eyed: the thinker's eye. A lazy eye: feeling, intuitive and dreaming. An eye for the part and an eye for the whole. An eye for categorising and diagnosing, a reductive eye, an eye for solutions—the scientist's gaze. A wondering, wandering eye: explorative, patient, curious, unfazed by paradox, ambiguity, complexity and confusion—the storyteller's gaze.

For the year that those bones were in my care, I refused to look at them as anything other than, well, bones. It was as if they and the box had come into existence—*abracadabra!*—solely for my edification. I did not imagine whose life they had once scaffolded, where that person had lived, or whether that life had been happy or sad. My daily chant was origin, insertion, nerve supply, actions, and my fingertips became as fluent on the bones as a blind person reading Braille: *transverse process, vertebral body, corocoid process, sternal notch*.

And yet, as I remember this, I also remember an event one day during that year that caused my other eye to fly briefly open. It was a rush of playfulness that did it—delicious, teetering, testing, curious playfulness. I won't go so far as to say nimble. We had finished with the upper limbs and were learning the legs, pelvis and spine. Ms Anatomy Wonkham-Strong stomped into the classroom, as usual, and we wilted, as usual. The first indication that things were out of order was when she bypassed the lectern, stomping instead to the corner of the classroom where the articulated skeleton was stored. She grasped the aluminium frame and hauled it to the centre of the room. The skeleton's feet swept along, six inches off the floor, and its legs and arms

48

rattled. Ms Anatomy Wonkham-Strong parked it next to the lectern and, with the skeleton still jiggling like a marionette, put a firm hand on the top of its skull. She gave it a twist and it pivoted neatly on the pin screwed through its cranium. Now the skeleton faced the whiteboard and we were staring at its back. Ms Anatomy Wonkham-Strong silenced and withered us with her usual pre-lecture stare. She took up her position behind the lectern. 'Latissimus dorsi,' she said.

She paused. She stared into the middle distance and seemed miles away, seeing not us but some other scene entirely. 'La-tiss-i-mus D.' She spoke tenderly, giving 'Latissimus' time on her tongue and lips, as if Latissimus D. were an Italian lover, and we braced for the sarcasm that would follow. She stepped out from behind the podium. Then she threw the whole room a big flirtatious wink and hitched up a hip. 'If you can rhumba,' she announced thunderously, 'you can walk.' To our astonishment she began, very dramatically, very sensuously, to hip-hitch her way across the floor. That bosom! Those buttocks! You would swear she'd shucked off starched undergarments, popped the buttons on a straitjacket, the way she shimmied. Slowly, sexily, she rhumba-ed the width of the classroom. Whatever song was pulsing gorgeous in her memory was pulsing gorgeous now through her limbs and pelvis. Fooling around or what! When she came to a halt, there was a micro-moment of silence. Then the entire classroom exploded with laughter and applause.

She bowed and straightened up, puffing but beaming. Leaning an elbow on the lectern like a drunk in a bar, she began to tell us a story. The outer carapace we knew as Ms Anatomy Wonkham-Strong had dissolved and someone else had emerged in our classroom. Not quite Bundlejoy Cosysweet, chosen by Tom to be his new aunt at the end of Hoban's story, but nevertheless, Ms Wonkham-Strong's hair had almost bounced, and smiles kept breaking through on her face. Zygomaticus superior and inferior, levator labii superior, risorious—strong and vigorous, there they were! She had worked in a polio rehabilitation centre in London during one of the postwar polio epidemics. A young woman—about our age, she said, scanning our faces, really looking at each of us—was paralysed in both legs. Ms Anatomy Wonkham-Strong reached out to touch the skeleton's nearest femur. It swung, a pendulum weight.

'Nothing,' she said, 'in the quads. Nothing in the hamstrings. No *tibialis anterior*, no peroneals, not a flicker in the calves. But what she did have was *latissimus dorsi*. Thoracodorsal nerve, C6, 7 and 8. It means "broad back".'

We watched her hand trace the muscle's wide domain, not bony landmark to bony landmark, but as if caressing the contours of someone's skin. Spine, ribs, humerus, shoulder blades … her palm came to rest on the superior posterior crest of the pelvis. With *latissimus dorsi* intact, she explained, a person can learn to hitch the pelvis and swing a callipered leg forward. 'The rhumba muscle.' Once again she was miles away from us, reminiscing. 'So that's how we taught Evelyn' (again she looked swiftly but intently at each of us) 'to walk.'

She had said too much. The spell broke, her carapace snapped into place. Ms Anatomy Wonkham-Strong glared. She stomped back to her usual position behind the lectern. She examined her lecture notes and cleared her throat. She looked at us, but not in that *seeing* way she had just moments before. We were once again that silly class of callow, comfortable kids. What did we know of paralysis or pain? We'd never seen polio, and most likely we never would. We were still only playing. *Latissimus dorsi*, she said, witheringly. *Origins, insertions, nerve supply, action.*

It would be nice to be able to say that when I returned to my hostel room that evening I picked up the skull and, looking into its eye sockets, declaimed: '… a fellow of infinite jest, of most excellent fancy … Your flashes of merriment that were wont to set the table on a roar …' Naturally I did not. I sat down after dinner with *Gray's* open on the desk, studied images of the human back, dug around in the box of bones for the pelvis. It's always been with me though, that glimpse: a young physiotherapist lit up with music and knowledge, teaching Evelyn the hip-hitch and leg-swing of callipers and crutches, dancing her out of the parallel bars and across the gymnasium floor.

I Wet My Pants

When we were growing up there were hardly any clothes shops for children. The only one I recall was Susan and Samuel, which had a sister store called Edward and Emma. I can't remember which one of them was in the Khandallah village, but I wet my pants in whichever one it was. The details are hazy, just my mother's exasperation— *the toilets are right there!*—and that feeling of wet pants and trousers, how it's warm at first, and it's a relief to stop holding on, but then it goes cold and clammy almost right away. Clothes shopping itself was a humiliating activity, fraught with self-consciousness and things left unsaid. Tall and gawky with short hair and glasses, I was always being mistaken for a boy, which I hated so much that I couldn't admit I hated it, and so could never suggest growing my hair, or wearing more girly clothes. I expect that contributed to the pants wetting; I was out of my element, and in front of a strange adult, a clothes shop woman, a type I always found made me feel even more awkward than usual.

To wet your pants at six or seven is one thing, but in the next memory I have I was definitely too old, perhaps just turned eleven. We went away on a sports trip to Hawke's Bay and were billeted. I used to stay at my Grandma's all the time, and occasionally at the houses of friends I knew well, but staying at the house of a strange family was another level of social challenge. I send love to the mother of that family for the dinner she made. The table was set with bread, hard-boiled eggs, grated carrot, cheese, ham, all in separate bowls for us to help ourselves. None of the dreaded unfamiliar foods that can be served up, in huge portions, at the houses of people you don't know. I remember a meal of 'fish pie' that was served up by one of our neighbours, which had the consistency and colour of porridge; it was pie in name only, with no pastry, just the blob of grey-white filling. They were an old-fashioned family, a *strict* family, and I picture the mother with a scarf on her head, though I may be making up that detail to accord with the wartime austerity of the meal.

So the mother of my billet family was obviously lovely, and I'm sure the girl I was billeted with was too. I even have a vague memory of them showing me the toilet, and it being like a public toilet, with a silver door that only went two-thirds of the way down, but that detail doesn't make any sense. Anyway, I was in the girl's room, *busting to go loo* as we would say, but too shy to ask, until from under the stool I was sitting on there was the pattering sound of wee hitting the carpet. Even then, when it was so obvious, I said something like, 'Oh, I must have spilled my drink bottle ...' I can't remember what happened next—I've no doubt my billet mother dealt with it in a very no-fuss way. But today, at forty-five, it is still hard for me to write that line about the drink bottle. The cover-up may not be worse than the crime but it is, somehow, even more humiliating.

Our own mother was an absolute terror on urination. Like any sensible mother of the time she always made us go before we went anywhere—'and squeeze out every last drop!' But she loved to torment us when we were on our way home in the car. If you told Mum to hurry because you needed to go to the loo she'd say, 'Niagara Falls! Niagara Falls! Great gushing rivers!' and go 'pssssssssss' all the way home. Then you'd be at the front door, bent over double, trying to get the key in the lock while behind you she'd be invoking rivers, lakes and waterfalls. There was a toilet just inside the door, the red toilet, so-called because the seat was red, along with the red wallpaper with baskets of black and white daisies. You'd always wee your pants a little bit while trying to get the sliding door open.

The next time I pissed myself I was twenty-five. It was some months after my friend Mark had killed himself, and I was spending a weeknight at home with a friend in the usual way, sitting in front of the fireplace in the bedroom of my flat, smoking joints, chain-smoking Port Royal roll-your-owns, and drinking instant coffee. I'd never been a huge drinker but I'd taken to keeping a hip flask in my room and having capfuls of brandy along with the dope, which I was finding was not as effective as usual at taking the edge off my emotions.

I got up to make a coffee, walked into the kitchen. The only sensation I had was of a microsecond passing, like a blink of the eyes, but suddenly I was in another world. I looked around the unfamiliar landscape, mystified. Where the hell was I? In front of me was a vast plain, like the Serengeti at dawn, pale

pink and utterly flat. In the distance were undefined shapes—maybe bison or wildebeest? Then I looked beyond them and saw sheer, dramatic cliffs, dark brown and shining, rising up precisely vertically from the plain. I was filled with a sense of wonder rather than panic, a David Attenborough-esque awe at the majesty of nature. Then I became aware of a dull ache in my left cheek. Looking harder at the cliffs, I realised they were the legs of a 1970s wood and basket-weave armchair, the African plain was the pastel carpet, the wildebeest balls of fluff and dog hair. I had passed out on the living-room floor.

I got up, went into my bedroom and told my friend she had to go. The next day I looked up drug and alcohol counselling in the phone book and made an appointment to see someone at NSAD, the National Society of Alcohol and Drug something. The counsellor I got was called Marta; she was from somewhere like Bulgaria and had a flat, pretty face, with a hare lip. It made her look a bit like a moon in a book of nursery rhymes, and I remember thinking, I don't think this woman's going to be able to help me. She did though, and I successfully stopped smoking dope for a while.

But fast forward some months and I'm out with a group, including the brother of my dead friend. We'd been corresponding since the funeral—by letter, how quaint!—and I think we both knew we were going to get together, although it was a terrible idea for all the obvious reasons and some less obvious ones too. But anyway, we're out with a group, and I'm smoking dope again after months on the wagon, and I'm drinking heavily and then we're back at my place, and I suppose I pass out for a moment while he's out of the room, and when he comes back in I find I've wet the bed. I tried to pass it off as a spilled glass of water. We both knew it wasn't, but we kind of played along to keep the peace. We just flipped the mattress over and slept on the other side.

I remember when I moved out of that flat, how I looked at that room from the doorway once it was empty. It was a great flat, far nicer than anywhere a student would normally live. Dad had bought it when I went back to university after dropping out, the kind of gold-plated second chances I would continue to benefit from through my life. The flat occupied the middle storey of a rambling arts and crafts house, and my room was huge, with oak-panelled walls painted cream, polished wood floors, tiny-paned windows looking down the valley onto greenery, and a working fireplace with a purple

tiled surround. The house was built below street level, and sometimes, on a still night, you'd hear voices coming down the chimney from people walking past outside. I used to scavenge firewood from building sites on my way home from university, carrying offcuts of four-by-two in a bag on my back like an insect as I laboured my way up the hill on my bike. I wrote my first book in that flat, sitting up late at my desk, smoking and writing with the reflected room in the windows in front of me. I wrote my university essays there and came home with exciting As and occasional annoying Bs. And I made affirmations for myself—I remember on the door having a sign that said: 1995 *a year to thrive a year to drive a year to enjoy just being alive.* I didn't actually start driving until 1996, but, you know.

Looking at the room when it was empty, I realised how much sadness I'd felt in it. There was so much going on at the time when Mark killed himself. I was angry and guilty, yes, but I was also full of bravado. I was pedalling as fast as I could to keep ahead of how I was feeling, I was succeeding like I never had before, but I was ashamed and greedy and ugly and needy and, as they say in the Bible, like a dog returning to its vomit, I was a fool returning to my folly, going back to my dope, and back to my messed-up bully of a boyfriend to get the dope, time and time again. It was a surprise to feel the simple sadness of the empty room, a feeling of a different order, almost noble. And I registered something like compassion for myself, which was in short supply in those days. I felt sad for what that girl had gone through, the girl who picked up the phone in the office of her first real job to hear a woman she didn't know say, 'I'm afraid I've got some terrible news.' And so even the fireplace, with its purple tiles and magical voices, I was glad to put behind me.

When I moved to Johnsonville in my thirties, to be near my sister and her new baby, it was the first time I'd lived within sight of the golden arches. You could tell yourself the flat was okay—it had good sun, polished floors, it was upstairs so you could see McDonald's or the suburbia around you on one side or Johnsonville Mall on the other. The smell of meat fat, of the white residue of chops cooked and the pan left out overnight in the minuscule kitchen, was the kind of thing not everyone would notice, but I am particularly sensitive to smells, and of all the awful things about that place it is that meat fat smell that I remember the most. If I tell you the other three things that were terrible I won't need to explain them: I was living above two seventeen-year-olds; I had

recently suffered a break-up; and I couldn't get the internet going: 'We are experiencing unusually high call volumes and the average waiting time is two hours and forty five minutes.'

I don't recall the night as having been anything particularly outlandish. After a function with an open bar, a work friend and I had headed to Courtenay Place. I was drunk enough to buy cigarettes though I wasn't smoking at the time—who knows how long a stretch I destroyed on that night out. We sat outside in the cold so I could smoke, drinking red wine by the glass and talking shit. I remember being drunk enough to need to concentrate when ordering every second two glasses of pinot noir; that moment of performance as you make studied eye contact, articulate your order, and manage your card and the eftpos machine. I would have taxied home, again, enunciating my address with careful concentration. By this stage I had moved from the spacious front bedroom because of the noise from my downstairs neighbours. I was sleeping in the back room, which was barely big enough for my double bed, and on that bed I had an extraordinary blanket which I'd bought at Pauanesia in Auckland, consisting of knitted peggy squares made from unravelled jerseys. It is really too heavy to sleep under—so heavy that your feet can't stay upright but are squashed to one side or the other. At some point I must have put on the electric blanket—like all New Zealand flats it was freezing in winter. When I woke I'd wet the bed and the electric blanket was still on full. I had the kind of head you get from red wine, cigarettes, and hours of overheating.

It was a beautiful sunny winter's day, extravagantly bright. I dragged the mattress into the living room, poured vinegar on the piss in some kind of recovered household hints memory. I drank some water and had some Panadol and made a cup of tea. And I sat there at the kitchen table, in my dressing gown and sunglasses, shaking with hangover, and cried. That kind of shame—the shame that comes when you are not coping and you can't tell anyone—is so inexplicable when you're not feeling it. I think I would have been more willing to tell my friends, my family, that I had wet the bed than that I had sat and cried at my table. Of course I didn't do either; I let my mattress dry out in the sun and it didn't seem to suffer many after-effects. I showered in the bathroom with its mouldy trim and its odd, mysterious smell, a bit plastic bag-gy.

That afternoon I was supposed to be going along to a singing group that I'd heard about. I was already part of the Wellington Community Choir, which had upwards of 100 people, singing in parts, and that had given me the confidence to try out this other group, which met on Sundays sometimes and was run by Bryan Crump. I didn't really know Bryan, he was the friend of a friend, but he'd said if I liked singing I should come along sometime. It would have been so easy not to go; I had every reason. I remember looking at the glass-fronted bookcase that had come from my father's office. It was made of dark wood, and the glass door on each shelf opened upwards with two round silver knobs, and slid back, like the compartments for cakes and sandwiches in an old-fashioned coffee lounge.

When you think about hitting rock bottom it sounds like a one-time thing, but in my experience it's a place you end up going to over and over again. If you're lucky, you learn something each time you visit. At this rock bottom I sensed that the singing group could be an important thing for me, a way of keeping faith, perhaps, with my childhood self, who loved more than anything to sing. As sick and ashamed as I was feeling, I knew that if I didn't go, I would feel even worse.

I don't remember what we sang, but it was the first time I'd ever experienced the kind of a capella arrangements where you just go *ooh ooh la la la* in all different places, instead of singing the words all together. That whole concept was new to me, and it was pretty terrifying. But when I think about that day in Bryan's living room in Graymor Flats I feel such a sense of gratitude. No one there knew me, or knew that I'd woken that morning on the fringes of Johnsonville's suburban shopping centre with a mouth like some Dantean cavern, trapped under the world's heaviest blanket in an overheated bed soaked in my own piss. I told Bryan later it was nice of him to ask me to join the group; he must have known through our mutual friend that I had been through a tough break-up and thought it might do me good. 'No,' he said, 'I just needed another alto.'

I've just remembered the one other time I wet my pants as an adult. Given it happened in the middle of the morning, in the central business district, with no alcohol involved, I'm surprised it had slipped my mind. I've always been prone to urinary tract infections, the main symptom of which is an irresistible, overwhelming urge to urinate. The sense of urgency is impossible

to convey if you haven't experienced it—that feeling of being right on the precipice of pissing yourself at any second makes you so panicky it's like being an adrenaline-charged prey animal. In this state I left my work in Bowen Street for an external meeting at a café on The Terrace. I can't recall who with or what about; all I remember is that I drank a lot of water, couldn't concentrate, and went to the toilet three times in the half-hour I was there. The meeting ended and I decided I couldn't go back to the office, I'd have to get a taxi and go home. I walked gingerly towards the cab stand at the top of Woodward Street, but all that water I'd drunk was catching up with me again and suddenly I knew I wouldn't make it home, or back to the office. I wouldn't even make it to the taxi. It was a crisp autumn day on The Terrace, I was the Director of Communications for the Ministry of Economic Development, and I was about to wet my pants like a three-year-old.

I turned into the nearest office building, looking for a stairwell that might, god willing, contain a toilet. By some miracle I found the door unlocked, but even as I put my hand on the handle I felt the piss soak down my grey woollen tights, and as I ran up the stairs I could hear the *pat pat pat* as drops hit the lino. There was, thank god, a women's toilet off the stairwell's first floor and I got myself into a cubicle, but there was no way I could get my tights down in time. I should have been horrified, but you know, the body is a powerful thing, and instead I was almost elated with relief as the urine ran down my legs and onto the cubicle floor.

Assessing my options, I decided the situation was better than I could have imagined. I'd left the office without my jacket, wearing an airforce-blue, needle-cord shirt-dress, tights, and khaki patent leather heels. The tights were soaked but the dress was unscathed, and once I'd tipped out the shoes (!) they looked fine. Mopping up the floor with toilet paper, and leaving my tights and underwear in the rubbish bin, I strode out of the building with purpose. With bare legs, the outfit was actually quite glamorous, and the two waiting taxi drivers gave each other a look as I hopped into the front car.

Sometimes I feel like humiliation is the most powerful force in the universe. Years, decades, lifetimes later you can still bring it to mind, and go red, and sweat and feel shame. Where other emotions can fade away, even disappear, so that no matter how hard you try you can't feel them any more, and sometimes can't even remember how it felt to feel them, humiliation

seems to survive. Maybe it's protected by its very privacy and secrecy; it never fades because it's kept from the light.

My grandfather was ten years old when his mother died. She'd had cancer, I think, but no one talked about cancer then, and he hadn't known it was coming. He just came home from school one day and it had happened, and he was sent round to an aunt and uncle's. The day of the funeral he was wearing an outfit he'd never worn before, he told me. It had trousers with an elaborate button fly, and afterwards, at the wake, he wet his pants. 'I didn't know how to manage the buttons,' he said. 'Mum wasn't there, and I didn't know who else to ask.' His voice got rough and he hit his chest with a fist in a gesture that I somehow knew was what he did when he was trying to stop himself crying, even though I'd never seen him cry before. 'There weren't anyone else I could ask.' He pronounced 'ask' the Yorkshire way, even though it was more than sixty years since he moved to New Zealand, and more than eighty since he ruined his good trousers on the day of his mother's funeral.

Trackside

There's a sound men make when their horse (or team) is winning. If you stand on any suburban street, or live beside a pub as I used to, you hear the sound when the game is tight, and after a slick, dipping pass, a wing is heading for the try line: 'Go, go, go, you beauty.' That's a deep unleashed sound, a full bark that swells from the base of the diaphragm, up the throat and out the mouth, for once fully extended, habitually tight New Zealand jaws loosened by passion and, yes, alcohol. You hear the same sound 200 metres from home as the final act of a horse race unfolds. If your horse has any chance, it's go, go, go, you beauty. Only racing insiders—trainers, stable hands—watch clinically, unmoved. The rest bellow shouts of joy, emissions of ecstatic release that, from the outside, sound like anger.

My father worked at racetracks most Saturdays of his adult life, until months before he died, so mostly you would hear him roar this way at the TV or the radio when, midweek, he was betting from home. On rare occasions we'd be in the stand together and once, just once I recall, we stood and cheered a horse called Bahrain winning the Waikato Cup at Te Rapa racecourse in 1979. Hands extend, fists pump up and down as knee shunts back and forth like a traction engine. It's a race-day haka, or a large betting man's imitation of a jockey's action, urging their mount onward. Bahrain won that day, all right, though only just. If you'd been standing beside us, you would think our dollar-each-way bets had won us several thousand bucks. Bahrain broke down in his next race, at the top of the straight in the Avondale Cup, and was put down—shot out of the hearing of the crowd, with screens preventing them from seeing the horse's death. Dad was working that day. We drove home disconsolate after the last race.

In the mid-1970s my father tried to make a living at the track. Not by betting, but by working for as many racing clubs as would hire him. He travelled

hundreds of miles from Auckland, to Whangarei and Paeroa, Te Aroha and Tauranga, Te Awamutu, Rotorua. Weekdays I would often join him. Mum would sign the absence note for school and we'd be off. We'd drive, he'd work through the day. I didn't know anyone at the track so I'd read, keep to myself, bet on each race. After the last race we'd convene at pubs on the main highway, with low-slung roofs and carparks covered in metal stones, all the better for utes and large cars to park and slide away on. I was too young to drink but publicans serving thirsty cashed-up racegoers in those days never requested proof of ID. I learned what racing men talked about, and how. I learnt how to drink too much and still make your point.

Hours later we'd set off home. On the road Dad would decide he needed to nap so he'd pull over. I'd sit in the passenger seat listening to the night, willing him to start the car and hit the road again. Of course we know now he'd need a clean twelve hours for alcohol to leave his system. When we drove home only a few hours later, slowly, erratically, he was still an only-just-awake drunk.

Two miracles stalked my father's life. One, he was never charged with drink-driving offences, though he would usually have been over the blood alcohol limit. How did his luck hold? Two (as he crowed down the phone to me, just weeks before his quadruple bypass in 1997), Guess what, son? Guess what the blood test showed? What, Dad? No liver damage. Given how much alcohol his liver had been required to purify for so long, he was rightly incredulous that it had not been blemished after some fifty years of wilful excess.

He was not, though, a reckless bettor. Only small amounts and only in cash. He lived thirty years into our bankcard, cash from the streetside hole-in-the-wall economy, but did not partake. Money, real money, would pile up on the lounge table, coins sorted in piles of twenty and fifty cent pieces, one and two dollar units. These would be counted with skills learnt from watching old-style cashiers. Besides the monies would be clippings from newspapers, Best Bets and other form guides for each week. He'd consider his race-day options, use the landline for learned discussions with betting associates, fill in his betting slips, drive in slow pomp to the TAB, and return home. All bets were

carefully recorded in old-style ledger books, wins and losses marked down. Never won much; never lost much. The betting pile was constant. It was still in place weeks after his death.

It's November 2006, the day after the Melbourne Cup. I'm visiting my father in hospital, in the final ward he'd live in. He's sitting up, staring ahead.

'Did you have a bet yesterday, Dad?'

...

'Did you watch the race?'

...

'You know you could have called Michael or Shaun … they'd have put a bet on for you.'

'Oh son', he finally says, 'it's not the same.' He spreads his left arm wide, palm open, like a Shakespearean king dismissing his retinue. Without the form guides and the newspapers, the sweep charts for the big races, and the chatter of TV and radio pundits on race-day morning; without betting slips and his coin hoard counted out with such exquisite care; without the rattle of car keys as he scooped them in his fist, prior to driving himself to the TAB beside the Cobb and Co on the far side of the Galleria where he could place his own bets: without all this panoply his former racing life had dissolved, and with it any desire to bet. All those mornings dressing up in shirt, tie and well-creased trousers for race day, all those decades of equine speculation and grass inspection, discovering with his own fingers what kind of racing surface a track manager really had prepared; all those race cups, trophies and plates he had witnessed: these too were all now part of his former self. With that single scythe of his hand I knew that he knew he would soon be dead. I told nobody this secret while watching the last five weeks of his life unfold.

I was probably eight or nine when I placed my first bet. Too young to peer over a betting counter and bet in person (once I was a teenager this was quite easy), yet old enough to save pocket money, read the racebook and the racing sections of the newspapers and make my own selection. We'd listen to the radio broadcast of the races in the back yard. In summer we'd picnic under the fruit trees while waiting for the big race. The gloating dance of triumph when your horse won. You were right and your brothers, as usual, wrong.

Hours later Dad would come home. From the bedroom you'd hear the click as the car key turned the motor off. From the lounge you'd hear the jingle of change in his right trouser pocket. 'Mark Anthony Patrick I've got something for you.' The bet with its dividend would be counted out carefully, handed back and tucked away. When you're eight, every win is big. The money was safely stowed under the bottom bunk for the next 'investment' opportunity.

My mother always bet small. A dollar on the favourite and she was happy— the smallest dividend would suffice. She'd place her tickets in the same pocket inside her purse and then snap it shut. If the horse did not come in, she would keep the ticket and then place the next bet carefully facing away from the previous—losing—ticket so that bad luck did not bleed from one to the next. After each race she'd carefully enter monies bet, monies won and lost at the back of the racebook; in the car, after the last race, each column would be added. I see her now, entering and adding the figures by hand with as much scrupulous clarity as a mass-market ballpoint pen allows, just like the old-style double-ledger book-filling accountant her father had been.

Are you winning? racegoers always ask. The totalisator, which began as an ingenious twentieth-century machine and is now, of course, a computer-driven algorithm, divides the total pool of bets by the number of winning tickets. But first the government, the racing clubs and the TAB claim their allotted share of every dollar bet; the truth then is that in the end the punters can't win. Yet you can take pleasure in the slow and careful process of loss. The iron-clad lesson from both my parents was that you could only bet with spare cash—money you did not quite need. Pay the mortgage, fill the cupboards and the fridge; then you can bet. When workers were still paid cash in brown envelopes my father might be given a dollar from his weekly pay. That was all he could bet with until, seven days later, the next brown envelope arrived. He knew how to eke out his race-day pleasures, small bet by small bet.

I go racing now with my brother and his son, my nephew. Last winter we went to Matamata and stood by the rail on a bright cold day. We saw a rowing Olympian, a gold medallist who owns shares in a horse or two (the track is less than an hour from Lake Karapiro where they train). The nephew could

touch the nose of the clerk of the course's horse, hear the drumming as the horses passed by on the puggy, yielding winter grass. Down by the rails the horses were stretched out long, as they are in those celebrated paintings by Edgar Dégas of racing at Longchamps, the Parisian racecourse inside the Bois de Boulogne. The motion of the horses thrilled the three-year-old—he could feel the hoofbeats pulsing through the rails. Now he can yell 'Go horsey!' loud and clear. He doesn't know about betting yet, nor why you have to pay attention and not ask questions of grownups as a horse race reaches its climax, but he also knows that any racetrack zens out his dada and his uncle; he knows too that the horsies are a site of many little-boy pleasures: escalators to ride up and down on (and once, thrillingly, to make stop by pushing the red emergency button at just the right height); salty fat chips drizzled with sweet tomato sauce; lolly scrambles; bouncy castles.

Racetracks are sad places now; the crowd has long moved on. Oh yes, there are dress-up days in summer, party frocks and corporate Christmas functions, hen parties and stag do's, fashions in the field and complimentary glasses of thin, harsh, local 'champagne'. These are not my favourite race days. Too much noise and distraction. Too many people who have no business being there. Midweek race days, on small-town racetracks, always on the edge of town, are somehow perfect, peaceful, empty. Just enough to do to keep awake. Have a bet, watch the next race. Maybe invest in a dried ham sandwich (a racetrack is the last place to take a vegan on a date). Wash this down with a $3 instant coffee in a styrofoam cup. Delicious.

Near the winning post you'll find owners, trainers, jockeys and stable hands. They cluster together for comfort as close as possible to the winning post. Far away, in the empty public stands, you can see broken-down seats, rusting gates; behind are unused buildings awaiting demolition, the unkempt grass. It's like spending a day inside a slowly expiring balloon. On late summer afternoons there's a heat haze floating above the back straight, or in May around four it might be the tendrils of a late-descending mist. If I look hard enough through the gloom maybe I'll spot his natty race-day blazer, so proudly worn, see the oversize tie from Hugh Wrights, hear him in full cry once more, barracking his favourite all the way down the home straight.

RHIAN GALLAGHER

Tītipounamu Tapping the Beech Forest

for Laurence

The smallest bird in the forest
—first entry in Moncrieff's book,
taking measure, as she does, of our avian tribe:
from tip of bill to tip of tail

choice spot to the heartbeat bird, a visionary speck
in the cool, calm, cathedral quiet of the beech forest;
the thick moss deck where I lie down
in yogi corpse pose

hearing a million tiny rhizoid voices,
the high-up canopy consorting with the sun, light
falling through a found gap
makes music with the moist green: jewel to jewel, gem

to gem. Above my eye comes tītipounamu
on the trunk that hasn't opened yet—
once more she works her way up the bark
tap-tap, wing flick, tap-tap-tap she looks up

to see what's happened in the last 3 seconds
then back to the tree: *bow, swivel, tap-tap-tap*
as if she will find the key one day—open
and open—all of the secrets of the beech forest
 bursting free.

The Illuminated Page

The afternoon released last class freed
from the sentence of a sentence to dawdle out
along a shingle verge the heady scent
of gum trees in the gully changing pace
as magpies swooped down from their watchtower

to outrun time and enter space
—the unsupervised, unscripted primer—
dry grasses a dust-caked hum
the riddle of the creek-bed dragonflies and reeds
a wilding apple sharp upon your tongue.

Before home and the night descending
to rhyme your way across a wheat field floating
on a deck of sky inland gulls like envoys
their telegraphic cries that said *not far to go* ...
not far to go became a day a moment

in a single hour as if some magic stardust
fell and broke the code words
woke upon the page sense with sense
converged to suffer the illumination gain
set on the scales with loss the world forever after
 in translation.

MEDB CHARLETON

Huia's Song

Stirred mid-morning
in the museum's reverent gloom,
I hear the choicest rain:

> *clear air*
> *have you seen seen seen*
> *my slender queen*
> *quee-een quee-een quee-een quee-een quee-een?*
> *where where where where where*

What I find is encased in glass:
mere bones, light
as hollow twigs

and ghost feathers,
the colour of night
before dawn.

Spirit notes,
sharp as air
in hooded forest,

under your spell
I hear love calling
from that jewellery box

in the chest, holding memory
by its folded dancer,
locked between wings breathing.

The Swan Hunter

The swan took off from the lagoon at dusk, the first of a pair. Truby Dean could scarcely believe it was heading for his hide in the bulrushes. He had been waiting for ducks, not swans. He had been trying not to scratch the sandfly bite on his neck and be still like the dog. He was mulling over whether to take a plucked fowl to Alethea and flattening hair over the exposed nape between his beanie and camo-down jacket, when the swan flew off.

Piko noticed it first, jowl bristles quivering as she turned towards the flap and whistle of wings. Then the bird bugled. Truby forgot about his neck and raised the gun barrel out of the rushes to track it. Although it seemed slow, the swan was flying quickly, each wingbeat broad and deep. Truby aimed at air in front of the breast, where he calculated the heart would be on the arrival of the pellets.

The swan flew directly over the bulrushes, its neck and red bill pointing to shore. Truby pulled the trigger just after the bird passed. A few tufts of feathers spat into the sky but the swan flew on. He should have put more shot out front.

Swans were difficult to shoot at a distance, the head small and body mostly feathers and air. Pellets often passed straight through. Hunters could forget about the neck.

He hit the second one, though. The pellets cracked a wing and the swan fell from the sky, plummeting until it hit the water. Truby heard the splash rather than saw it; he was already scanning the sky for the first bird again but it had reached the macrocarpas and was now out of range.

Piko leapt into the water on command. The black labrador half-carried and half-dragged the swan as she swam back to the bulrushes where Truby hid. The clouds were shot-pink above the lagoon by the time the dog had dropped the bird in the shallows. Piko needed a new grip, her jaws a rest, before grabbing the limp body again. She hauled it ashore with its neck and head drooping underwater all the way. By the time the dog had dropped the swan at

Truby's feet it was already dead. Long, floppy and young, not much past a cygnet.

Truby left the carcass on the bank of the estuary and the pair squatted down. There was enough light to keep hunting if the first two shots hadn't spooked other fowl. While Truby hid and waited, his bones chilling down, he thought about taking the swan to Alethea in the morning. A plump bird with soft meat.

Three ducks dropped before it was too dim to spot anything in the sky. Piko sniffed out the mallard and the paradise pair in the dark, fetching them while Truby packed up.

The hunter drove into town with the dog, his waders and a row of limp fowls in the back of the ute. He cruised past the tavern and stopped at the dairy to buy milk and a loaf of bread before heading home to pluck and gut the birds.

'Get anything?' called George over the hedge, scalp pale in the porch light.
'A few ducks and a swan.'

George nodded. 'Need a hand?' He ambled through the sawn arch in the corokia hedge with two bottles of beer without waiting for a reply.

The men sat outside to dress the birds despite the cold. There was the gamey smell; slithering entrails and feathers wisped blood about. They sat at the formica table with an ale while each plucked one of the paradise pair. George chose the drake; Truby took the hen. George's breath misted in the light from the garage as he talked about the fisherman who lived down by the pier who had hooked a gannet on the beach that morning. George and Margot had been sitting on the verandah next door with a pot of tea and a plate of scones when they saw the boil-up, probably a run of kahawai, less than twenty metres offshore. The fisherman had spotted the commotion too and sprinted along the beach to cast his line. At the same time the gannet dived the man cast his lure.

'Happened in a flash,' George said. 'Both of them thinking of fish for dinner. But the line got tangled in the wing of the gannet in mid-air. What are the chances of that?'

Truby shook his head as he laid the bald duck down and began on the swan. He snapped off the broken wing and chopped through the undamaged one too, throwing the pieced limbs in the bucket of feathers and gunk. Piko

sat keenly, watching every move. Now and then she sniffed in the direction of the bucket.

Would Alethea want a swan? Perhaps she would prefer a duck.

'What did the fellow do?' Truby asked. The angler couldn't sever his line and abandon the bird; gannets were protected.

'He pulled the line ashore, along with the flapping bird. The line wound tighter and tighter as he tugged it out of the sky. By the time he got the bird to the beach it was all trussed up.

'When he tried to set it free, the gannet attacked him. Imagine the thrashing of that six-foot wingspan, even if there's only one loose wing. That beak. I didn't think about trying to help. I'd only have made the ruddy thing flap more.'

The dead swan lay on the table in front of Truby. He should have started on it first like he usually did. There were so many feathers—charcoal plumes and white flight ones too. He would forget the head and neck; they were more bone than meat and his feet were numb. Truby waggled his toes as he snapped and chopped bits off the body, lobbing pieces into the pail.

George had finished the mallard and was now watching Truby pluck the swan while he drained his bottle of beer.

'There's more in the fridge,' said Truby, nudging his head towards the garage.

George stood, stretched out his shoulder blades then washed his hands under the tap by the camellia before heading into the shed. He squeezed between the stacked wood and the ute, edging past tools to the old Fisher & Paykel humming at the back of the shed. 'Do you want one?' he called.

'May as well,' said Truby, picturing a hot cup of tea. The cold had now seeped into his ankles.

As George handed him an open bottle, Truby asked, 'Do you think I should give Alethea the swan?'

George looked down at the three-quarters-plucked bird on the table—the pale skin and ivory fat. A near mature pen.

'Should be tender,' Truby added.

George nodded. He stared at the oval body then frowned. 'I wouldn't,' he said, and started to shake his head.

'It'll be tastier than old mallard. Near enough to goose.'

'It's a swan, Trubes.'

'I already gave her a duck. A few weeks back.'

'I'll ask Margot what she thinks. She's inside watching the box.'

'No, I wouldn't bother Margot,' said Truby, shaking his head. 'Could be one of her shows. What's she got to do with Alethea anyway? They're nothing alike.'

George nodded. 'Just a thought …'

They sat in silence for a few minutes while Truby kept plucking. Finally George spoke again. 'Who'd lump a kid with a mouthful of a name like that?'

'Her mother probably wanted to jazz up the boring surname. Anyway it suits her with that long silver hair.'

'Grey, you mean.' George looked up and smiled.

Truby did not shift his eyes from the swan. His fingers were in a rhythm of tugging out quills. 'Swans are pests.'

'You don't have to tell me that. It's whether Alethea knows. Whether she agrees.'

'Surely she'd know by now. She's been here long enough.'

Truby thought back to the day Alethea Smith arrived in her old stationwagon towing a double horse float, tyres bald and bulging. It must be a year now since she had bought the green bungalow on Jollies Lane with its sagging rusted roof, and the paddock next door riddled with thistles and dock. Hadn't she planted sunflowers and nasturtiums in her front garden and already seen them bloom? Dried seeds for sowing and crocheted blanket squares through a winter?

'Being noxious means nothing to some folk. You'd be safer giving her a duck.'

Truby nodded. It was true Alethea was fond of animals. She hadn't been here more than a few months before she rescued a retired sheepdog from the upper valley. He could also remember her puttering into town. He had been standing in the main street catching up with John McFarland about pegging day when she drove past, hand out the window adjusting the side mirror. Maybe taking a second glance. The roof rack of her wagon was stacked with bikes, a double kayak, paddles and rods. An assortment of nets. She was alone.

Alethea had strong views on possum traps, 1080 and organic courgettes. She defended absent lesbian friends under attack. When he visited her villa she

was often reading on her sinking verandah. She was aware of the world—and not just the benign. She knew about North Korean missiles, Yemeni famines and sarin gas in Syria. More often than not he didn't get her jokes, but if he did happen to catch on, her eyes would crinkle until they almost closed.

Truby looked up at George. 'What happened to the gannet?'

'It kept pecking his head and hand. Even drew blood. But somehow the bloke untangled the line and the bird was finally free. Then it flapped off. Veered sideways out over the sea, back to the colony no doubt. Both wings were beating, though.

'The gannet left the boil-up of kahawai behind. The bloke did too. After checking the pecks on his arm he wound up his line and shot off. Poor sod looked a bit shocked. Don't blame him. I was almost put off my scone and raspberry jam just watching … He walked along the beach towards the pier even though the kahawai were still on the boil.' George shook his head. 'Even closer to shore.'

'Tinny bugger, though.'

George nodded. 'It's a bit nippy. I might head in.'

'Take one of these with you,' said Truby, pushing a duck towards George.

'Thanks. Have you decided what you're going to give Alethea?'

Truby had finished plucking. The stippled carcass lay on the table—plump, limbless and glistening. 'Call me a fool,' he said, 'but I'm going to give her the swan.'

George shook his head and went to say something but stopped. He stood up, picked up the duck and wandered off.

'What?'

'Nothing, Trubes. Nothing,' said George, without turning around.

Truby shrugged and smiled. He reached into the bucket and trimmed a flap of skin off a wing. Fed it to Piko, who gulped it down without chewing.

As George wandered towards the hole in the hedge he called out, 'Don't say I didn't tell you.' He lifted the duck by the stump of its neck and gave it a slight shake before passing through the arch.

'Wouldn't dream of it,' said Truby. But George had already disappeared. The porch light next door flicked off.

Truby staggered to his feet to hose everything down in the dark. As he carried the pail of waste down to the beach he thought about a hot shower

and a cup of strong milky tea. It was a good night for soup. He relented before chucking all the scraps in the sea and kept back a few more pieces to take up to the house for the dog.

Back on the windless dunes, the stars glassy above, he put everything away in the garage except for the swan. It was too big to fit in the fridge so he put it in a rubbish bag, balanced slicker pads against the insides of the largest chilly bin and laid the carcass on a bed of ice. He pushed the lid shut and balanced a wedge of firewood on top to hold the seal.

'What do you reckon, Piko?' he said, carrying the scraps from the beach inside. 'Is the swan too big? Maybe Alethea would prefer a duck. She could pop a mallard straight in the fridge.'

The dog padded into the house behind him. When they got to the kitchen she sat down, looked up at him and silently begged. Although the lino was brown and littered with decorative whorls, the mud of her tracks was distinct.

Truby ran his fingers over the bite on his neck as he peered at the clock. It was late, his hunger sharp. The mopping could wait till morning. He looked down at the dog.

Piko was sitting, still and intense, eyes switching between him and the scraps on the table. Sighing, Truby tossed her a chunk of broken wing. The dog's jaws snapped and crunched.

'Nothing wrong with swan, is there?' said Truby, forcing his fingers not to scratch the nape of his neck.

CLAIRE ORCHARD

Summers Were Longer Then

This firebreak we're scaling
is dry and grit-slippery, just like
the one behind the side door
of the primer three classroom,
the one Mr Davis
of the wispy moustache
would have us clamber up
every fine morning
of the late summer term.

Some could manage two legs
but I was always on all fours,
feeling my way and the fear
of losing my grip, always
imagining myself
slow-motion tumbling,
collecting classmates
along the way

or just free-falling
between them, and them
stopping, open-mouthed,
to watch me plummeting,
the warm, rough concrete
of the netball court
rising up to kiss me hard.

RUBY SOLLY

You've Been Having My Nightmares

We are standing in a pool
with thousands of dead bees resting
on top of the water,
each time we move
the bees eddy and swirl
in a wet swarm.

A boy stands on the edge of a nearby cliff.
He smiles at us, then jumps.
The bees fly in a spiral towards the clouds,
the hum of them is intolerable,
translucence spills from our ears.

I awake first and find your hand clenched
around what you believe is a small handful of bees.
Your grip tightens as each breath
becomes smaller than the last.

CARIN SMEATON

i used 2b silver

and i was bigger back then a junior kiwi showt real
promise breaking thru my stingray skin early i
carried hape across da deep blu sea all by myself
in the days before aunty broke my heart & my
lumbar draping her after-match thighs over mine in
lov sique approval i was her first-prize korowai her
dogskin cloak her touchdown sorrow calling me
bub telling me hush she'd give me a son pluggin me
deep into da sockets of the wide-eyed sky lighting me
up wit the yet-to-be-discovered glo-stick-colour of
electrikk & it was an ultra-violet shade dat
day darkening my face tho my moko still stayd it
only blinded me for a bit but the madness was permanent
slippin outta sight straight into the pysch ward sneakin
the stillborns from the maternity ward there i callt 4 da
rays like how tangaroa did too snuck dem lil babes
east to the ūrupā we flew bye-bye baby blu under
hammrheads restaurant (best seafood n town said 1 of da
night nurses) unless the orderlies got to em first n
smoked dem poor nameless bubbas clean soot n
embers out into the air losing them in the tāmaki winds
(to the domain's despair) but not if i cud help it not on
my watch as i'd given them names great names 4 dem
too cos an unnamed child of da sky i
knew weren't good enuf

BEN EGERTON

From the Tribe of Gad

Offered his pick of the rooms he takes the attic.
Pulls up the ladder, disappears into pitch,
beds down between boxes, crockery, clothes. Fashions
someone's old garish coat for a pillow—unsightly stain
folded inward. Removes tiles to drink
from the guttering, coaxes blackbirds (he has time
on his side) to bring crusts, fruit, early-season berries.

It's not long before they forget he's up there—creaks blamed
on poor pipework, thumps explained away as weather
or ghosts—so they move on. Others move in. Install
doubling glazing, fix the plumbing, mend the roof. Yet still
they stir in the night, unsure what the small noise is.

Kate Sheppard Reads the *Weekly*

How would she feel—time-travel worn, teacup in hand,
settling to read after the long fight for equality—
all that petition rolling and politicking, to see sultry lips parted
and long hair flicking, as the wafer-thin goddesses pout and pose, teetering
forward on their stilettoed toes?

Would her teacup clatter and spoil, as a Kardashian bottom,
sand sprinkled and oiled, makes headline news, while Helen Clark's
views and Catton's muse don't worthy a mention? Would she shake her head
and sigh, pondering why, as she flicks past tales of weddings, marital woes,
the best foundation to powder one's nose?

Would she worry and fret as the girls walking by, with lipsticked
mouths and school skirts hitched high, spy lingered limbs, all arching and
bare,
the billboard stares trailing them like heavy-lidded peers?
While they study and swot and read on the sly, they know how they wield their
frame will get them by in this world where selfies and ball frocks matter
more than views on the world and political chatter.

SUE REIDY

An Outrageous Piece of Living Shit

It's as if his blonde daughter, you know the one he would fuck if she wasn't
his daughter by a Czech-American former model, and herself a former
fashion model,
socialite, converted Orthodox Jew, mother and entrepreneur, with her
namesake collection of ruffled blouses, shifts and wedges, is now an official
unpaid
special assistant, someone who has automatic entry anywhere
to offer her personal brand of window dressing.
It's as if no door is closed to her, no high-level meeting too private,
no material too sensitive that she can't offer an opinion with perfect candour.
It's as if her cosmetics, jewellery, leather handbags, luggage, clothes, shoes,
eyewear, cookie jars, retail, spa and beauty services are heading
for world domination.
It's as if any rule can be rewritten and there's no conflict of interest
that cannot be reframed, cannot be blended seamlessly with politics.
Her brand performance and revenue continue their upward trajectory.
She loves the Chinese and they love her trademarks.
Her personal, political and business lives are entwined like a tricephalic snake
supported by a single torso, kissing and hissing
in a profane triadic depiction of normality, or maybe a spookily beautiful,
long-haired vixen in a glittery designer gown luring suckers
with her beauty, before she digs her sharp talons into your brain
to confuse and unhinge you with fake news.
She is a trademark as much as a person as a brand as a driven creature
without a soul.

It's as if she is now the most famous woman on the planet,
even more famous than her multilingual ex-model stepmother,
who looks more like a Russian gangster's moll than a FLOTUS,

glimpsed in white wide-legged palazzo pants with a knee-grazing dark coat,
another time in a $9590 sequined suit,
inappropriate to wear for her appearance in Congress.
She who was never really an escort, more of a companion, a sexy withholding
attendant, she who steadfastly hides in her New York tower
far from her husband in Washington.
She who views the world from behind glass, behind oversized Gucci
sunglasses
(is she a member of the secret service?), behind her flashy diamond ring,
safe and secure at a cost of $145,000 per day, her pussy
maybe groped, maybe not. Her boy at school where he will be treated
as the innocent, blond, privileged son of a reality TV star,
now self-styled demi-god, but in reality an outrageous piece of living shit.

Oh ladies of the handbags, patronesses of malls, beauticians
and hairdressers, to thee do we cry, poor children of Eve,
to thee do we send up our sighs, mourning and weeping in this valley of tears.
Pity our sorrows, calm our fears, turn, then, most gracious advocates, thine
eyes
of mercy toward us, protect all women, defend the right to abortion,
to free speech, while to him who reigns above, bestower of life or death,
health or wealth, hasty dispatcher of cruise missiles, heedless of
consequences,
who tweets late at night, needy, greedy, outraged, seeking
the approval of the masses, to him, homage I will not pay,
you'd have to kill me first.

MICHAEL STEVEN

Dropped Pin: Brooklyn, New York

Chucking silver-blue clouds of indica smoke
El-P studies screens of scrolling sinewaves:

drum loops he's chopped into more pieces
than sides of pork in Chinese butcheries;

guitar riffs, mutated by so many oscillators,
no one can ever guess the songs or players

they were boosted from—Eddie Van Halen,
K.K. Downing, Slash, or Richie Blackmore?

And those synth lines: are they fall-out sirens
or God wailing in a TB-303 or Yamaha DX-7?

A foul-mouthed, frenetic, bar-cutting prophet.
Nostradamus in Air Max 90s and Yankee cap

scribbling down verses on yellow legal pads—
dictations delivered while dosing psilocybin

or seeking counsel in DMT's domed cathedrals
from metallic, Gaia-minded, mechanical elves.

Over hectically patterned battle rhyme schemes
inherited from Kool Moe Dee and Eric Sermon

he raps about Pentagon drone strike rehearsals
conducted above inner-city neighbourhoods,

about spambots siphoning off private details
to further interests of shadowy corporations.

Calling out the racists and the woman-beaters,
the arms brokers, the hate-dealing propagandists,

the liberty usurpers and Golden Owl worshippers.
He's giving them all the verbal middle finger—

a rum-sipping skunk hound, a wrecker of speakers.

Kid and the Tiger

Kid feels amazing, like angels'—nah, bats'—wings are folded away in his hoodie. Swooping's what he'll do, swooping up and down over the zoo on this blue-sky day—ever since they opened their lives to Jesus he's had all this ... this—

'VROOM,' he says, gripping his hands like he's got the handles of a Harley, blatting towards Vanessa and Abraham, waving the tickets, saying, 'So, let's go look at what God made' in a loud voice, sharing, in this way, His word with some of the other families getting themselves organised near the ticket kiosks.

Kid's twenty-four and Vanessa's eighteen. Vanessa does long hours at Subway, while Kid looks after two-year-old Abraham. Kid and Vanessa met leading a party lifestyle in Hamilton—Vanessa had left high school, Kid was just out of prison—and over that time, Abraham happened. Then, three Saturdays back, Vanessa got talking to a man she was preparing a big order for. The next morning the man came to their unit and took them all to church. Since then, they've cut the drugs and drinking (mostly), married at the registry office (the fastest way), made application to change their son's name (Shawn to Abraham), and switched to a Christian lifestyle that, last night, included an all-night prayer festival at a huge church in Mt Wellington.

And now, right on opening, with money he nicked from his dad—it's where Abe slept last night, and where they were this morning—Kid's got them a family pass to Auckland Zoo.

He bends to check Abraham, who's already straining at the straps of the new stroller their church gave them when they committed to the congregation.

'Up!' says Abraham, 'Get! Up!' The boy's eyes are bulgy and the skin around them is red like the material the stroller's made of.

'He looks thirsty,' says Kid, working on not talking too fast. 'He's thirsty, do you think?'

'How would I know?' goes Vanessa, distracted by the zoo map she's holding.

Her tone threatens Kid's buzz.

'You thirsty, mate?' asks Kid.

'Up!' goes the boy, 'Out!'

'An ice-cream?' says Kid. 'See the animals, eh? Then we'll get a Trumpet.'

Nodding seriously—Kid likes his son's serious reaction to treats—the boy goes, 'Hmm,' and then sits back a little so Kid can fit one of the straps over his shoulder.

'We have to watch too much sugar,' says Vanessa.

'That's from Trudy, is it?' goes Kid, and then, as he does when he's pissed off with his wife, when he wants her to see how well he knows his son, he devotes himself to entertaining Abraham with a series of animal sounds and faces.

That first Sunday, Church assigned them each a mentor. Trudy wouldn't be a lot older than Vanessa but she has a girl and twin boys, and her ex-cop, polished-head husband owns two late-night dairies in Taupo. Mostly, she tells Vanessa how to parent, which is stupid, fucking stupid, because Kid does all the looking after of Shawn … Abraham. And sorry, God, sorry about the f-word. Edgar, that's Kid's mentor, says becoming Christian comes down to changing your thought patterns. That words stem from thoughts and actions stem from words, and Edgar's got a super-long fringe combed back over a bald spot—do all serious Christians wear their hair weirdly?—and he likes to look around at them in church, smiling, as if that'll help what the preacher's saying sink in better, or maybe, and this is what Vanessa thinks, he grins so much because he's got a hard-on for Kid.

Kid who, queuing for the zoo tickets, took 20mg of Ritalin he bought at the festival from a guy who also sold him a can of high-strength beer and a joint laced (apparently) with MDMA, all of which Kid consumed/smoked last night without telling Vanessa. But Church always talks about being true to yourself, so, though Kid would normally pretend the money he stole was his—that he'd come by it in some cool/mysterious way—he now says, neutralising the drug-lie with a stealing truth, 'I pinched money from Dad— but he would have just spent it on smokes. If he didn't want me taking it, why leave his wallet out?'

All he gets for his confession from Vanessa is a bored look. 'So, are we going in?'

Bouncing out of his crouch, Kid gets into position behind the stroller, making more revving noises, and starting them towards where zoo staff are scanning people's tickets as they enter. 'Where's first?' he goes, trying to keep everything upbeat.

But lately, Vanessa won't even answer when he asks her something. Won't even look at him, will just sit there gaping at Abe, or her phone, or whatever. Like ... like Kid might as well not even be there. He's used to it, but still it pisses him off, and he speeds up, getting well ahead of her.

African Plains, says a sign with an arrow. Tiger Country, says another.

'Tiger Country!' goes Kid, talking forward to Abe and taking aim with the stroller.

There's a glass enclosure, but all you see are big-leafed shrubs and areas of thick deep-green grass and stuff.

'Any tigers?' goes Kid, stopping, getting back down to Abe's level and showing the boy how to scan the glass.

The boy jerks forward against the straps and Kid does another animal, this time a tiger, with wild eyes and his hands as its claws. '*Tigers*, mate,' he says, like they're Australians.

The boy smiles, but jerks forward and back again, and Kid gets back behind the stroller. When it comes to Abe, what's he's found, is that to avoid meltdowns, the best approach is to keep everything high energy and fast moving.

Vanessa's at a hip-height concrete fence. Stood there with the crumpled map, looking at her phone.

'Any tigers?' says Kid, pulling in beside her.

This one's more pit than enclosure. Sort of—what's the word? Medieval. Rock walls, dead pushed-over trees with planks between them, a banked-off area of shallow water, all of it sloping down from a low, prison-looking sort of building where all the tigers probably are.

It hasn't really come on yet but Kid feels guilty he's taken a pill and she hasn't, so, and though he knows it's try-hard, he attempts to get something back from Vanessa by saying, 'Wouldn't want to fall in, eh? What was it? Them lions and us Christians?'

Fast, like she was waiting for him to say it, like he's retarded, she says, 'It's tigers in here, not lions,' and even before she then, in a slightly nicer way, says, 'The elephants and whatever are that way' he's already left her and is headed in that direction, pedalling his feet, swooping in on the African Plains sign, the sign that points to a boardwalk, from where, spread beneath them, you see a pale dirt paddock, fences, and, once your eyes figure them out, giraffes and zebras.

'And ooh, what's that?' Kid says, and, moving fast, wanting to be the one who does the showing, he gets to the front of the stroller, unclips, hoists Abraham up, and points, 'Look at that big bird!'

The boy looks for a moment and then says, 'Ice. Cream!' putting his hand into Kid's mouth.

Through the soft bunch of fingers Kid says, 'Emu.'

'Meerkats are next,' goes Vanessa, coming along the boardwalk.

'Being nice now, are you?'

'Shut up, *Kid*,' she says.

'We're married now, *Vanessa*.'

'So?'

'So?' he parrots.

Abraham goes dead still when they fight—really taking it in. It always makes Kid feel guilty so he joggles his son and smiles, like it's more like a joke Mum and Dad are having with each other, and then he keeps walking along the boardwalk, towards where other people are standing, all faced in the same direction.

According to Vanessa, they're in a hurry. Twice this morning already she's said they have to leave no later than 11am in order to drive back, drop the car, walk to their unit where she'll change, and then, *fuckin' joy*, go to her shitty sandwich job.

At the meerkat enclosure it's 9.40am. A short man is made taller by the daughter on his shoulders. An old man sets up a tripod. Christian jokes aside, Kid likes the support Church provides. That and the Sunday routine of getting ready and going. Vanessa's habit, when she's not doing the breakfast shift, is to sit around until the last possible minute, change out of her pyjamas in a hurry and rush to work. Lazy, bloody lazy—always being in pyjamas means she always has an excuse for not taking Shawn outside to play.

Little big-eyed creatures with paws are zipping around trails they've made with their zipping around. Abraham's getting heavy and Kid puts him back in the stroller.

'Meerkats, eh?' he says, shaping his hand into one of the animals, having it stop and look in front of the boy's face.

More and more, Vanessa gets on his nerves. Is it worse since they stopped all the partying? Who knows? But her eating noises, and God, the sounds coming through the toilet walls ... whatever, a fart's a fart, and everyone farts when they shit. Jesus farted when he shat. Trudy farts. And shits. Probably Trudy's shit comes out dressed in Gucci. Anyway, Church is somewhere to be on Sunday and because church people 'drop in' all the time, embarrassed-at-the-mess Vanessa actually helps with the tidying—which is good but also irritating. Why doesn't she tidy for him? They don't run out of milk. Or biscuits. Overall, since going to church, Kid's more fed up with Vanessa, but his life's easier and that's made life better for Abraham.

He steers towards the end of the enclosure where signs point to the elephants. Kid's body's is starting to feel tired, they were up all night after all, but his brain's doing all this sharp thinking and looking at tall Vanessa—up there on her long legs. Wanting to acknowledge the slight improvement in their life with something kind, he goes close, looking at her out of the corner of his eye, and says, 'I want to lie down with you.'

It must come out louder than he'd planned, because a meerkat-watching woman wearing shiny exercise pants and carrying her child in a backpack looks around.

'Got that from the Bible, did you?' says Vanessa, but he's almost got a smile.

'Sex shouldn't be something you just do,' whispers Kid, which was something Edgar said to him, and was now a thing they both liked to say when they were feeling close, when they weren't arguing about who did what around the place in terms of earning money, cleaning the toilet or changing nappies.

Abraham thrusts forward again and this time, quick as, Kid tips the stroller back, causing Abraham a fast reverse.

'Careful,' says Vanessa.

'I got it,' says Kid.

'You're high,' says Vanessa, pouncing.

Kid ignores her. 'Let's just carry him,' he says. 'We're going to have to lift him in and out all the way around.'

Sighing—she's always bloody sighing—she looks at him and then at the stroller. 'What about that?'

'I'll run back to the car—meet you at the elephants.'

'Whatever,' says Vanessa, 'but you're high. I'm telling Edgar.'

Forgetting kind, Kid uses his hard, sarcastic, I'm-way-more-intelligent-than-you tone. 'Don't just rush around, you know? Let him look, try to teach him some things.'

Vanessa bends at the front of the stroller and picks Abraham up. When she stands, her face is red from gravity and the lift. 'I have been to a zoo before, you know.'

Ignoring her again to look at Abraham, Kid says, in a softer way, 'See you soon, mate,' but when he ducks in to kiss his son Vanessa swivels fast, so all he ends up kissing is the air where his son's cheek had been.

'Hey, fuck,' Kid says, and to make it worse, when he says that, because of the way she's got him, it's only Shawn who sees his angry face, and worse still, as he's trying to smile and make a happy pose for his son, Vanessa swivels again, so he's wide open and grinning for his tall wife, who takes the opportunity, in victory, to give him the finger.

It burns. Freaky giraffe wife! Right there she's wiped all the good he's done for them this morning.

The 'up' buzz of Ritalin switches to blood pouring to the surface of his skin, to sweat, soaking undies he wore all day yesterday, and all night, and kept on this morning, and that are now slime, while the tighter parts—the waistband, the bands around his thighs—those parts start to itch and, and …

Forgiveness. Forgiveness is a big word at church. Love, mercy. Christ and God, obviously, but forgiveness comes up a lot, but she treats him like her slave, her 'little Kid' she calls him. If she's put on the nappy, Shawn's shit always ends up in his shorts. Can't she do one thing properly?

And there they go, disappearing under a sign that says Watering Hole. Is Shawn looking? In case he is, Kid's waving, waving one hand and scratching with the other, but the boy doesn't see. They had bed bugs at Waikeria once, little fuckers that hook their jaws in, and the itching at what the jaws are

doing brings on these volcano skin things that itch even worse, and right now, around his waist and thighs, the itching's way worse than that, so, standing with legs crossed, like a girl desperate to piddle, he decides there's only one thing left to do:

Run. Sprint the boardwalk with the stroller. And, ah—Yes, Jesus—that feels better. Wind up the legs of his Lakers shorts cools sweat, easing the itch. So he runs faster, zigging and zagging, passing people who stare into the stroller as if he'd be stupid enough to do this sort of speed with Shawn aboard.

Looking after Shawn all the time, Kid sometimes feels old and past it. Way past the point where there was still the possibility of being someone, but running with this weight ahead makes him feel strong and young and now here, in front of him on the boardwalk, is one of those older families with the pretty mum and neatly bearded dad and two kids with zoo T-shirts—them with their sensible fucking shoes, and organisation—and Kid's high-speed dash has brought on a good destructive feeling, so he aims right into the middle, scattering them like a water-blaster, and, and ... and what Kid would never admit, to anyone, is the almost 24/7 terror he feels at the prospect of losing his son.

He loves Shawn so much. He doesn't know about Vanessa. When they drank all the time he experienced what he'd have called love, but maybe that was just a good feeling off the booze, combined with actual post-prison female company, but the thing between him and Shawn, that's pure. Even holy, if holy means clean and sort of unbreakable, like a wide white roll of NASA-strength plastic, rolling on and on, without all the usual crap you have littering relationships with friends, and parents, and wives ...

Tight left at the sign for the savannah. Still moving, still getting wind up around his grots. Past two staff members still scanning tickets.

Not that love was there right away. Love came in little leaps: like when he stayed up all night holding his boy's tiny body as it went stiff and vomited, holding the tiny, hot body as it went as limp as a flannel, wiping his face and hands and feet with a cloth he kept cool in another container of ice. Or the time Kid turned on the telly when Shawn was what—ten months? The snooker was on, and somehow coloured balls going this way and that got the wee man laughing and pointing and wanting to climb into the TV, onto that big green table. Or just the wee parcel of him, bathed and swaddled in a clean towel,

rocking him to sleep night after night in those first few months when Vanessa had gone back to work.

'Sacrifice,' Kid now says, remembering another church word.

He's left the itch way back on the boardwalk, and now, no doubt, the Ritalin's in. His thoughts are clear and positive, but his body's tired and his brain's stressed from duelling with Vanessa. The other name she uses on him is Jailbird, sometimes sweetly, other times real mean, and ... hold on, what's this? There, by the gift shop, three hire-strollers, and why not save his energy and leave their stroller here?

'In camouflage,' Kid says, wiping his face, which shines in the glass, from where three huge warthogs stare.

Vanessa'll be amazed he was so fast, and, when she sees their stroller here in plain sight, when she sees the simplicity of it, she'll accept he's at least worth something.

'In the meantime,' he goes—In the meantime, surprise them at the elephants with elephant-sized ice-creams. Be the steady hand Edgar talks about, be that rock.

So, still sweating, Kid takes time making the stroller seem like all the other strollers, making it seem 'ready' for hire, before resetting his Chiefs cap and sunglasses and swaggering back in the direction of his son and wife, swaggering, because what's building here (forget Edgar's steady-hand shit), what is the obvious outcome of this no-sleep-drug-morning, of this getting wrung out by Vanessa, getting worked up about life in general and Shawn specifically, is the urge—the same basic sequence that led Kid to do the thing that put him in prison—to draw attention to himself, probably not by doing a good thing, because getting good attention takes time: making the Warriors, gaining like awesome success through music or business.

Past the ticket scanners again, waving his ticket like it's a bundle of cash, and here, what's this? Lots of people at the tiger enclosure—with more people hurrying—and a voice, over a speaker, announcing, 'Breakfast time in tiger territory,' and what's best right now? Run around getting ice-creams and having the stupid things drip all over his hands while trying to find Vanessa who'll be zooming Shawn past polar bears and monkeys and whatever else—guaranteeing he learns nothing about anything—or falling in behind this excited crowd? Falling into a situation where at least the possibility exists for

him to show Church, Vanessa and that rich-arse boardwalking family precisely—that's *his* word, not God's—precisely the man they're expecting when they see an ex-con, unemployed druggie in basketball shorts and a crooked cap.

And so Kid's running again, this time towards the tigers, where the female, Molek—over a speaker a zookeeper's saying she's the most unpredictable of their tigers—is, apparently, about to feed.

Kid stops at the crowd's fringe and, with the overly polite voice he learnt in prison—excuse me sir, ma'am, excuse me—he works his way to the concrete wall and looks down at the zookeeper, a couple of metres below.

'Today's menu includes freshly killed chook, though of course they prefer live prey,' goes the keeper, who is standing on a narrow circular walkway six or seven metres above the enclosure.

'Fully extended,' goes the zookeeper, 'an adult tiger's claws are thirteen centimetres long, while their canines are longer than your middle finger.'

The keeper is further around the walkway in his jungle-green uniform, safari hat and mirror sunglasses, holding a sack which, by its shape, looks like it's holding more feathery crooked-legged carcasses that match the one he has by the head and is dangling well above Molek, who's stood there, sipping with her nostrils—and yeah, bro—actually licking her lips, staring up at the man, the man's hand, and the chicken in it.

What if Shawn fell in? You see it on the news and shit—a kid ends up in an enclosure getting batted around and half eaten. Or someone jumps in. The parent goes in as a distraction to the gorilla, or the lion, or the tiger. Being that person, that would be something major in a man's life. Dropping into the enclosure, making your body a shield for the child.

Kid tips forward off his feet so he's half over the railing, and looks. From this position he'd roll forward and down onto the walkway, and then … jump from the walkway down onto that springy-looking grass. You'd have to go hard to clear that knifey-looking tree branch—hitting that would cost skin, and what else you'd be risking, at the least, would be leg injuries: a dislocated knee, a broken ankle … but any of that would be minor compared to what would be next—facing off against old Molek.

He tilts back. The zookeeper's saying something, but where Kid is, is Shawn's twenty-first, and he, Shawn, is making a speech about the time his

dad jumped into the tiger enclosure at Auckland Zoo and 'faced off against old Molek', and now Dad, him, Kid, limps forward on lush carpet with a glass of champagne and kisses his son, holds him and hands him two thousand in fifties, and says …

Kid tips forward again, staring down at the walkway, concentrating, trying to find the right thing to say. 'Kia ora, son. God loves you, but not like I do—'

'Excuse me? Hey!'

It's the zookeeper. His sunglasses are on one of those fluoro neckband things, and he's taken them down and set them around his neck, below the wee wearable speaker thing, and now, like it's a gun, he's aiming the chicken at Kid, 'Back from there, please.'

Kid looks at Molek, who looks at the chicken's changed position, and then at the zookeeper who's smiling, but in a serious way, and still dangling her dinner. Kid looks behind him and then he comes away from the wall, turns, and stands, because the people who before were right up close have moved back, so there's a stage-like, half-moon of bare concrete, and he's on the stage, and isn't this more than damp washing hanging in different parts of their unit, melting ice-creams, and arguing with Vanessa all the way back to Hamilton?

Maybe it's the quiet—they're all staring at him like he's one of the animals—or the way Kid's holding his upper half, because the zookeeper, still worried, says, 'Sir?'

It's hot. Suddenly horribly hot, and when Kid strips off his hoodie his bat's wings flip free and fly up, so now Kid's standing on the narrow ridge of that high wall, facing his crowd, and if it's good enough for the preacher at church to go around raising his arms, pointing his palms at heaven, then it's good enough for Kid.

'Sir,' he hears again.

'My God!' he hears.

To savour this—now he's someone—to slow it down, Kid turns carefully and then stands tall, arms still wide, like instead of a jump it's a dive at the Olympics he's going to make. And down there, made smaller by the height, Molek edges in his direction because the zookeeper's removed his microphone thing and laid down the sack and the chicken, and, his bare eyes on Kid, is speaking in a hard voice into a walkie-talkie.

See? Kid matters. People are talking, people are worried—look at Crocodile Dundee there all stiff-necked and scared. Soon the whole country will hear—a man jumping into a tiger enclosure, a young man and a tiger. Edgar, Trudy and Trudy's bald-arsed husband will be shut up for a second or two. Nothing matters, nothing, not even God makes any difference—that's what they'll have to swallow. And how it looks now is that Kid's going to land on Molek, because she's come across to him and now she backs up a little and sits, waiting, her head and narrow eyes and wet, just-open mouth, all of it a satellite dish aimed up at Kid.

'Fuck God,' goes Kid, making his feet firm and wide, and though he's primed for this, and therefore calm, he starts crying—for Shawn of course—which is just the sort of weak-arsed shit that's always causes him to finally do whatever it is he's threatening, and so, keeping his arms wide for balance, he squats and fill his wings, and—

'Kid?' he hears.

Straightaway he's angry. It's Vanessa, and how fast must she have rushed Shawn through all the other enclosures to be back here now? But that doesn't last, because the other sound, the sound cutting through the Ritalin and his need to DO something other than pulling plastic toys out of the toilet's S-bend, is Shawn crying.

Shawn, his son, is behind him, crying. The rare kind. The crying the boy gets to when something's overwhelmed him. The crying he sometimes does at night when he wakes from a bad dream. Or when he's overtired. Hiccupping and hyperventilating with snot and tears. But isn't it better for the boy to know that Kid did something? That he acted, at least once? That isn't suicide, it's—what do you call it? Martyrdom. His son would always have that—Dad doing rodeo on a tiger.

But Shawn's here now—his twenty-first's miles off—and he's Shawn's dad and Kid doesn't know what's better—jumping, or being a sort of tit-useless man who's standing around waiting for life and God and Edgar and Vanessa and Trudy, all of them just to steamroll over the top of him every few days.

'Kid?' It's Vanessa again, and maybe it's the fact of him being up here, with a tiger waiting to eat him, but does it sound like she needs him? And wanting to check in her face for this, and really needing to see his boy, Kid turns back around. His legs are shaky and rubbery but he manages—for his son—to

stand straight, and there they are, and right away he can see what's wrong with Shawn.

He's shat himself and she hasn't got the stroller with the nappies and wipes and stuff. That's all back in the undercarriage of the thing. Vanessa looks scared and angry and desperate, and she's holding the boy low down, around her waist, and he's got a wet, scrunched-up face, and the other thing Shawn has got is shit dripping from the back of his shoes—sometimes he does these nuclear shits that end up from the soles of his feet to his neck. It's a choice now between martyrdom and getting down to help clear up his son, to get him clean and dry and back in the car, heading home, and really, it's Kid's legs that decide for him; they've gone from shaky to spaghetti, and instead of a graceful dive, what he does is fall, away from the tiger, and onto the concrete, hard onto his hands and knees on the concrete, and then, bleeding, he gets up and starts towards his son, towards his little family.

Bender

When Matilda leaves to go to
her mum's we go on a 3-day
bender. Stefan buys brandy
that he warms up with ginger
ale in the microwave, in the
morning the bottle sits empty.
Everyone in the building
takes a drug called *methedrone*
(not methadone), that is
supposed to be E but ends
up being cheaper while
doing almost the same thing.
No one is happy when
Jamie, who lives at No. 2,
is busted for dealing it
but we are all fascinated
to hear the results of the
police lab test which
proves it is methedrone
once and for all. Good
for Jamie, too, as
methedrone is Class C
compared to Ecstasy,
Class B. He gets
community service. I
wish I could tell you
what we did while
under the influence of
this drug but I can't
remember any of it. All
I can remember is how
my nose would burn.

OWEN BULLOCK

Tongue

Masonic lodges aren't noted for their indoor outdoor flow

a lot of linen suits in the Canberra poetry scene

my dreams aren't good enough
I dreamed I was boiling pasta

I don't know why I'm exerting pressure

as soon as you get a boyfriend
you stress

can mung beans go so wrong?

my kids are trying to kill me

he even argued under water

life's too short for a dollar coin in the trolley

the missing chunks of god

not all my zombies are carnivores

I still want to go to the footy and have fun

my boyfriend
not my boyfriend . . .

I get it

you're invited by the way
there's gonna be like a dance

a drop dead date

JAMES ROBINSON

Studio Diary

Sketches and drawings in preparation for *Doors (Hyper Objects of the Cthulucene)*,
Te Manawa Museum of Art, Science and History, Palmerston North,
forthcoming (December 2017 – June 2018).

Details for all works on the following eight pages:
Untitled notebook page, 2017, 105 x 148 mm. Mixed media on paper.

*If you've ever been inside or seen photographs of James Robinson's studios, you will know
that he likes to work in the midst of indoor chaos and industrial mess, out of which he
generates the raw materials of his paintings. Actually, his paintings are built up out of so
many found objects and recycled substances that they often seem as much fabricated as
painted. They're put together with a little bit of this and a little bit of that, and you don't
feel like enquiring too closely exactly what those little bits are.*

*Moreover, with their stitched-together gouges and rips, their lumps and bumps, their
dried-up trickles and pours of liquids, they almost take on an organic life. And they have
a raw quality. It's as if they hang on the wall festering like wounds that won't heal, or
seething like psychotic states of mind. He portrays an alienated sensibility. Yet if
Robinson's work displays morbid tendencies, it's done with a certain amount of wit and
humour, as if he's laughing a bit at his own excesses.*

*James Robinson's work is about powerlessness, and feelings of menace and threat. He
makes these feelings seem like a universal condition, typical of today's media-saturated
world in which we so often feel not in control, and even control is illusory: we are offered
so many choices by globalisation and consumerism we feel paralysed. His is art as
antidote to shopping-mall anxieties, to branding, to the anxieties engendered by non-stop
marketing: the anxieties you sometimes feel when you look past the billboards at the
waste ground beyond.* —David Eggleton

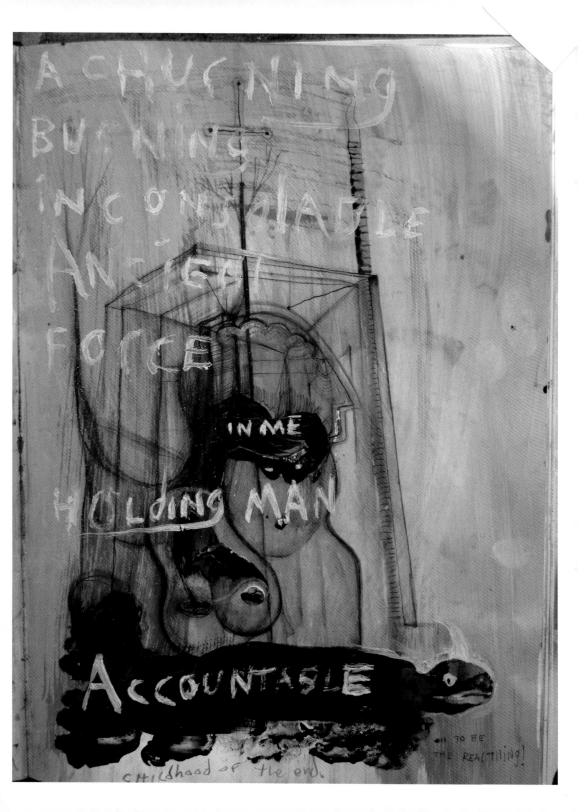

A CHURNING
BURNING
INCONSOLABLE
ANCIENT
FORCE

IN ME

HOLDING MAN

ACCOUNTABLE

OH TO BE
THE REAL THING!

childhood of the owl.

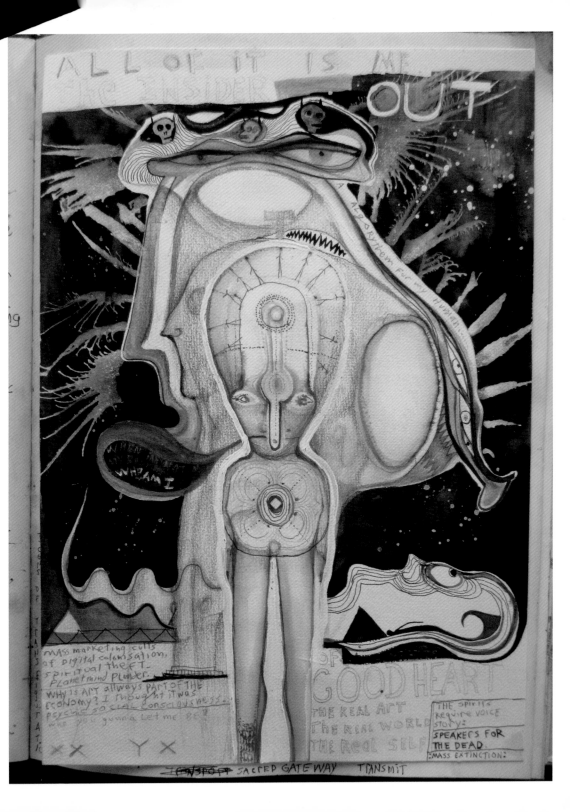

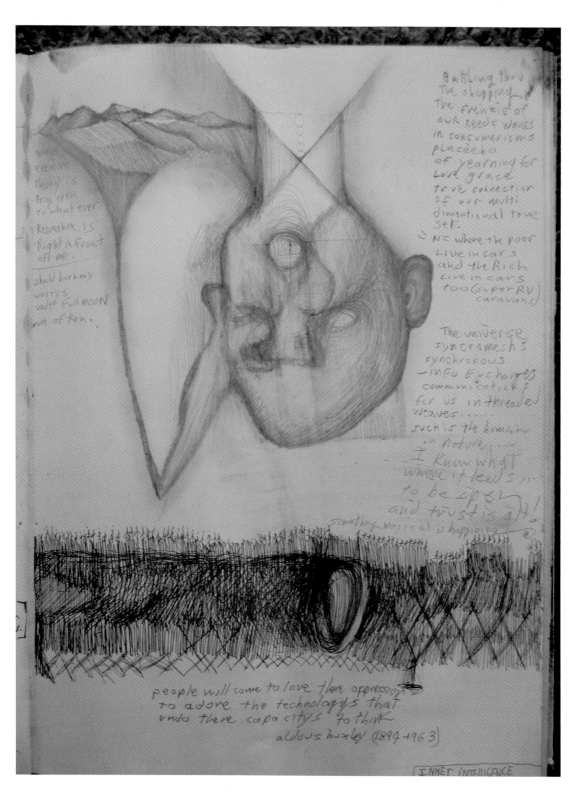

Battling thru
the shopping +
the frenzie of
our needs waves
in consumerisms
placeebo
of yearning for
Love grace
true connection
of our multi
dimentional true
self.

← NZ where the poor
Live in cars
and the Rich
live in cars
too (super RV
caravans)

The universe
syncromeshs
synchronous
— info Exchanges
communications
for us in threaded
weaves......
such is the branch
in nature.....
— I know what
where it leads ...
to be open
and trust is all!
something magical is happening

world
creative
theory is
being open
to whatever
resonace is
Right in front
off me.

should i worry my
worrys
under full moon
not often.

people will come to love there oppression
to adore the technologys that
undo there capacitys to think.
aldous huxley (1894–1963)

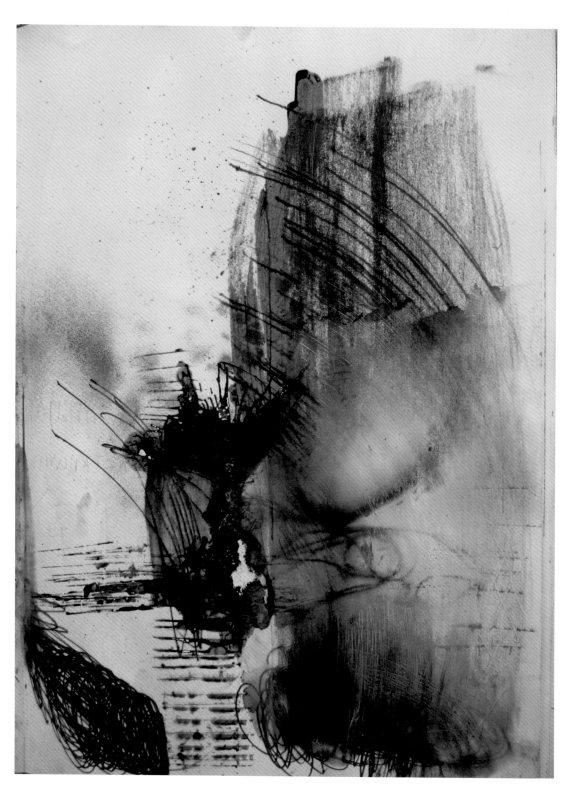

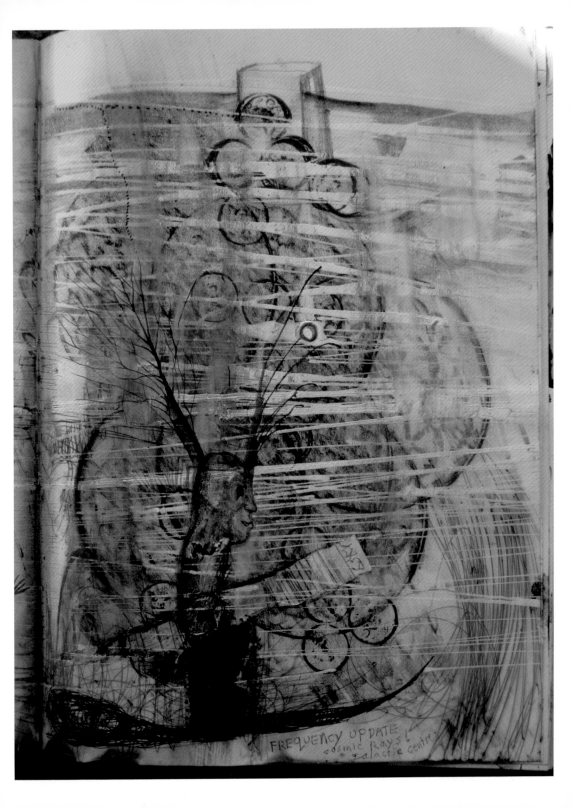

FREQUENCY UPDATE
cosmic Rays!
Galactic Centre

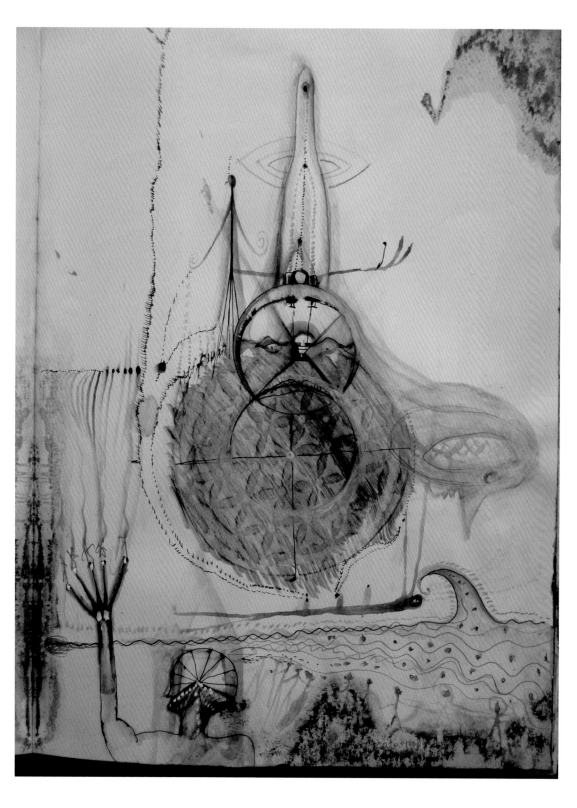

PHASE TRANSITION

 as the old collapses.

WARECONOMY. / nz asleap Bitch / safe haven possessed
 disempowerd
 sheeple

Craft Market

Piece of brownie?
> Thanks but gluten-free.

Oil of jasmine?
> Thanks but allergy.

Anti-aging cream?
> Thanks but already old.

Chilli jam?
> Thanks but not that bold.

Hand-carved doll?
> Thanks but creepy.

Camomile tea?
> ... already sleepy.

Limoncello?
> ... teetotal.

Amethyst charm?
> ... prefer opal.

Blood sausage?
> ... vegan.

Local poet's poetry?
> ... plebeian.

Fertility amulet?
> ... womb removed a while back.

Dreamcatcher?
> ... insomniac.

Marriage?
> ... but taken.

Early grave?
> ... Me? You're mistaken.

Eco coffin?
> ... still running.

It takes cunning to get three score and ten.

Slut

A prayer for the sluts amongst us
for our lives and desires
the fluttered lashes
and high heels
For the right to wear
short skirts and lacy tights
to prance or pose
with sex on our sleeve
and our hearts askance
all for the asking
or telling.
A blessing for the daring and departed
who bare their wretched bones,
and for the bleeding
and breeding witches
for the wanting and wanton
bless them all
in the howling wind
beneath the bridges
as we strut or skulk
in shadow and light.

SARAH SHIRLEY

Locked In

I've been lurking here in my hospital gown,
just waiting for a face like yours
to turn this septic frown upside down,
you know? I'm kidding honey, I know
you can't fix me, but a man's gotta smile
sometime. To be honest, it's been a while
since this mouth moved at all. They call
me locked in. They know I'm still here,
but my body's blocked out from my brain.
So you all breeze past me, checking what you can:

Breathing—check
Heartbeat—check

Checking the monitors, avoiding my gaze,
and I probably would too, darling, I understand
it's not all that easy to witness a man who
is trapped behind his own eyes. Not much
to do here but have imagined conversations,
these dreamed-up interactions where I think
of words I'd never say aloud, but in the quiet
moments I lean back into a net of hope
I wove for myself out of the thought that one of you
will be able to reach in, and pull me back out from my brain.

But until then, I'm looking for a face like yours.
Hey baby, give me a smile.

RENÉ HARRISON

Cured

I am the student of myself
and I'm failing.
Kill me or cure me
I walk on three legs, grotesque
as a gargoyle in the rain
fitting in to the railings
in the graveyard, where water rusts my stories,
glazing that memory that never fits.

JOHN DENNISON

The Backyard Forms

I'd find them in the gutters beside the road—
wheel-balancing weights cast in lead
that had flicked off the wheels of passing cars;
most were small, but some were a decent size,
a hand-width or more, warming in your palm,
and grimy. I'm not sure why I collected them—
flotsam of the road, discarded somethings
unthought of, gutter-cast lumps
rewarding my pocketing squiz of the road to school;
there was always the thought they might prove useful,
a selective sense of thrift, of tidiness,
but mostly of wealth. I'd bring out the stash to impress
visitors, heft the ice-cream container
down, let them feel the weight, turn the
finds over, share a happy fossick:
rim-sprung lead slugs, eccentric
balancing acts already dull with history,
my accumulating treasury.

When at the holiday camp I found the air-gun
range and its tiny smeared slugs, I began
to think elementally—of lead
itself, especially of how someone had said
you could melt it over a backyard fire,
could work real metal. That was the lure
which got me hauling down the heavy tub
with its finders-keepers history of leady nub,
and taking it out back to where we'd set
into the clay a brick-lined fire pit.

For a crucible I cleaned out
a catfood tin can and pinched a spout,
found gardening gloves and some pliers,
and set the loaded can in the embers.

Nothing at first: glue from the can label
burning off; then it was possible
to see, with quick, breath-held glances, a glow
about the tips of the weights, some show
of pooling silver at the bottom. The finds—
my picked-over hopes, pile of discards
set aside just in case, waste
of A-to-B, and of kids getting a taste
for firearms, trigger therapy—
resolved into now, lumps all swimmy
in themselves, becoming what they are
in any case, pure under a layer
of what is also there, peppery dross.

In remembering there is a gloss
that floats like the scum on the surface of a pond,
so that what is collected and weighed up in the mind
needs freeing up, redemptive fire, and a hand
to tilt the tin and see the promised end,
the remembering form running down the clay
face of things, answering the sky
in its brightness, answering the earth
in its fall, telling the story of both.

We had already thumbed and pugged holes in the dirt,
some simple sinkers, others more ornate—
coinage with a hole in the centre,
rough long swords in miniature—
small negatives of our imagination
that, when it came to it, couldn't contain

that bright heaviness, the shimmering flux
reaching for a livelier form to touch
with its quick clay-borne tongue the now.
I'm satisfied. Then, look—see how
oxides blooming on the new-cast mirror
fix its surface with a sharp intake of air.

RACHEL J. FENTON

Permission to Take Photographs

Hours from now I will pinpoint the difference between undulate and pivotal when referring to tassels twisted from lucky threads to titillate six or five old men while a woman takes pictures with her phone for her husband who has his back to the stage. He is turning red. A jazz band plays old-time hits making much of a trombone. Lederhosen-wearing wait-staff compete for our service. My friend knows the barkeep and introduces me. I say: You look like my grandfather, when he was alive, obviously. My friend decants a pitcher into the two large glasses we have drained. It's my fault. I had instructed: tea, food, beer, in that order. We are here via a French café and Korea Town. The burlesque dancer has beautiful breasts, has never fed children; her nipples will respond to giving the way a stoic hardens to loss. Of course I would say that after a tankard and a half in Bierhaus NYC. But this is Monday morning. I am in The Morgan and I have permission to take photographs of Mary Taylor's letters to her best friend Charlotte Brontë. The only stipulation, I must sign, they are for my private research use, must not be shared. The Berg has its own rules.

Yes

The first time she saw him, he was wearing a kaftan, playing croquet on someone's lawn, at someone's bach in Wainui. Hair down to his shoulders, beard full.

That summer, she watched him set off homemade fireworks on northwest nights, and hypnotise geckos by rubbing their sun-warmed bellies. Less is known about her—no photos from that time—she was camera shy. But there is that very small stripey bikini found in the attic, which indicates that she was not other types of shy.

He never told her he disliked the bikini.

They protested against the Springbok tour, sitting arm in arm on the concrete, and arm in arm in the police van when they were arrested.

They were married in a garden. She wore a lemon yellow dress. He wore a pale green silk suit and a pink tie. It was the eighties. A verse from *The Prophet* was read—about two trees growing close together but not in each other's shade. She never told him that she wasn't sure about *The Prophet*.

They were saving for their pilgrimage to India when they got pregnant. Instead of international flights, they bought a small hundred-year-old cottage on a large overgrown piece of land in Riccarton. Bought it for a song.

She never told him how she disliked his family's pseudo-intellectual snobbery.

Their daughter was born with dark eyes, dark hair and an early laugh. With her seeds and spade, his hammer and nails and timber from the buy-sell and his dreams, the little house grew and grew. It grew a spiral staircase to

a second storey. It grew a heavy door of polished wood, with stained glass windows, a magnolia tree, brick archways and meandering paths, swings and hammocks from the walnut tree, corn, pumpkins, wisteria and two small raised beds for children to learn to garden in.

He made no effort to tell her why he sometimes became depressed, and for silent days would not even look at her.

A second daughter was born, with blonde hair, blue eyes and a perpetually worried expression.

And there were fairy wings and clay pinch pots, hair ties and small shoes and lunchboxes.

There were Christmas crackers and birthday cakes, mumps, snow, sunflowers, cat funerals, another coat of paint, tramping trips.

She never told him how she hated it when he talked to her like one of his students.

She was promoted, cut her hair short, dressed sharp—in fitted jackets and lipstick, abandoning the elephant-print pants and dangly earrings.

Their daughters started high school and swam into new worlds of malls, friends and parties.

She travelled for work, and his depression moved into her side of the bed. He didn't tell her he'd had a premonition that she wouldn't come back, but he told his daughters.

They loaded the dishwasher in silence.

She left a book in the bathroom called *Too Good to Go, Too Bad to Stay*, and she never told him about the lives she'd dreamed of living, though maybe she would have if she had been brought up to believe her dreams were important.

He split more kindling than was necessary, washed the windows, and drove his daughters to music lessons, scholarship exams and university open days.

He told her they would grow old together, and that he could change.

She did what she had decided to do years before, and left.

He scattered his parents' ashes, quit his job and bought some goats.

Before long, four people who had once been one another's entire worlds had the width of the earth between them, talking via satellite, never to be all in the same place again.

But no one ever told them the last secret: that time is nothing. So they didn't know that in the world to come, in the singular, humming, eternal moment, in the wink of the gaping universe he was always and is always twenty years old, playing croquet in a kaftan, and she is always running into the sea in a striped bikini.

They are always sitting in the sun in the street under a protest banner, and holding laughing babies up in the air. Their hearts are always breaking, the fire is always just about to catch, the magnolias are opening. He is always saying, crying, will you marry me, and she is always smiling, and saying

Yes.

KERRIN P. SHARPE

Kalene Hill 1948: The Baby Won't Turn

Nurse McGregor fills the cylinder
with nitrous oxide and oxygen

and the mother soon forgets
the spotted hyena will find

the roast she hid in the tree
Nurse McGregor knows about

malpresentation and the breech baby's legs
extend like an antelope's

when she manipulates the two blunt blades
of the obstetrical forceps

outside a hooded cobra
crosses the red earth road

and the baby's father cycles faster
towards the brick mission station

then faster when he hears a lion's cough
which is when Nurse McGregor

hears the baby's lungs
fill with Africa

MARIANNE BEVAN

Daybreak Again

I travelled mostly to come home. From Ghana to Wellington, thirty-six hours by the most direct route. Two hundred and fifty hours over the two years. I would always board the plane in Accra at sunset, the sun a hazy orange behind the pollution. At this part of the journey it was mostly West Africans boarding, although on the last trip home I found a New Zealander and, jittery with escape, I nearly cried.

I had travelled to Togo, then Ghana, to make a new home. The night before I left Wellington I sat on the front step of the pink Wilson Street house and said to Hannah I was worried that when I came back, everything would be different. Hannah pointed inside at the rest of them playing ping-pong with cookbooks in the kitchen and said change seemed a while away. It was 1am and one of them had just broken the spine of a book.

When I left in the morning it was still dark, and it felt like I was getting out before the sun could come up and show me what I would be missing. I slipped silently in and out of airports. I crossed time zones and lost the sun. It came up as I arrived in Paris and a man at the airport asked if I would take a plastic bag with unknown contents to his family in Lomé, Togo. I said no and boarded the plane. The sun went down when I arrived in Lomé and there I was, twelve hours behind, this new country darkening, just as the one I had left would have been coming into light.

It was perhaps an odd time to leave. After six years Wellington was just starting to feel like home. I knew the people at the parties and I had things to talk to them about. You shouldn't underestimate what this means for a shy girl from a farm in Whakatane. And yet I was twenty-three and needed to leave.

Several years earlier I had travelled alone for the first time, to Timor-Leste. The country was in transition; they had become independent in 1999 after decades of occupation by Indonesia, but a small conflict in the capital in 2006

had sent the United Nations back in. The UN still ran the police and it was policing, men and violence that I was there to research.

When I arrived it was green. Rainy season had just ended and children roamed around the leafy streets. There was a DVD of *The Devil Wears Prada* at the backpackers, and for the first weeks I ate sweet bread rolls and watched the movie on repeat.

I started being invited to the ex-pat parties. I went to a jacuzzi party on the roof of an apartment block. It was thirty-five degrees and most people didn't have clean water, but here we were splashing warm water across the floor. The alcohol was free and I vomited over the side of the pool.

I joined a women's soccer team made up mostly of women working for the UN. Our coach was in the Portuguese military police and we practised at their compound. He half-heartedly yelled directions at us while wearing a gun at his thigh. The only teams that would play us were groups of thirteen-year-old boys, who always won. Amid all the local frustration with the continued presence and opulence of the United Nations, losing to this team of children felt like one of the few humble things the UN had done.

The world opened up in those few months. I could get on a bike with the Australian architect, wearing a straw hat for a helmet, and know that nothing would go wrong. I could kiss the Timorese artist and the Finnish researcher, and read it as a sign of things to come. Set loose in that strange city, I could survive in the chaos.

When a group of Timorese boys chased and cornered and groped me against a corrugated iron fence one evening, I didn't respond the way I'd always thought I would. I crumpled and cried. People asked if I would tell the police, which had never crossed my mind. They were just children after all.

The next week I travelled to one of the districts with the UN police to collect a teenager who was accused of rape. The Australian military were playing soccer with children on a nearby field, and the UN policeman I was with stopped and handed out balloons. A small boy sat on the fence outside a bubblegum-blue house, swinging his legs and refusing the balloon offerings. The police brought the teenager out in handcuffs. He was sixteen but looked much younger and I couldn't breathe. On the way back to the police station I sat in the back with him and his family, so that the mother of the girl could sit

in the front and not have to look at the accused. The small boy got in—he was the teenager's brother—and when we arrived at the station and the teenager—the accused—was taken away, the boy could no longer hold it in, and cried.

I caught a ride back to Dili with the commander of the Timorese police in an eight-car convoy, on an eight-hour winding road. Back in Dili I told José[1] about this. José ran an NGO and let me hang out at his office and do my work. We would eat lunch each day—tempeh, meat and rice—at the same small restaurant next door, where he would always make the same joke: 'I am a vegetarian, tomorrow.' He once laughed as he showed me the torture scars on his arms from the occupation, and he would grin as he looked around the restaurant to see who was there before saying anything about the government, his laughter a survival skill.

When I told him about my trip home with the commander he was furious. He had been trying to get a meeting with the commander for months and this white girl had been able to get eight hours of his time easily. The city was full of us—white girls who would get the meetings we needed in the morning and then get groped and chased by men and boys on motorbikes in the afternoon. Boys learning to play out the postwar frustrations of their fathers on the wealthy bodies walking the streets. Boys who could easily be forgiven because even though they hurt me, they were hurt too, by a system in which foreign women arrived in their country showing wealth and opportunities these boys would struggle to find access to. And so they tried to show themselves to be men by chasing, groping, and laughing as they ran away.

Later on I would realise that the artist had a girlfriend and the Australian wanted someone else and the researcher was fifteen years too old. Much later I would find that being assaulted is not felt so much in the moment, but in tiny ways that unfold over the years. But at the time, nothing made any sense and it felt like travelling not just in a new country but in a whole new emotional landscape. I came to love the chaos and absurdity, the promise that it held.

At nearly twenty-four I wanted that promise again, so I moved to Togo.

Togo was a lonely place. I was friends with an unhappily married American couple who didn't believe in abortion or gay marriage. I started smoking for

1 Not his real name.

something to do but was embarrassed and tried to hide it. We went to a West African dance class until the drummer started harassing my flatmate and we had to stop.

Most people outside of West Africa don't know where Togo is. It has no strategic importance, no natural resources to attract anyone, no wars or natural disasters. It has been ruled for decades by the same oppressive family. I worked with a man who used to work for the government. For decades he went through the same pattern, where he would work as a lawyer for the government for several years until they did something particularly offensive, and then he would quit and do something else. When enough time had passed and he had convinced himself again that he could change it from the inside, he would return. He always made sure to translate for me in meetings, my French still lacking, except that mostly he just translated his anger at the UN agency we worked for. Local staff like him were not allowed UN passports, which to him was another small injustice in a country of many.

I lived in a half-deserted mansion with bats in the ceilings, in a neighbourhood of dusty streets. There was a woman employed to clean the house but she eventually moved to Côte d'Ivoire. When she left I was selfishly relieved to no longer have the guilt that went along with being able to afford a cleaner on an intern salary. But then she offered up the services of her sixteen-year-old daughter, to which we couldn't really say no. Every Saturday the daughter would come along with her two younger siblings, whom she was responsible for looking after. When left alone the youngest child would run around the house, going through our drawers, bags and the fridge. So every Saturday we would stay home babysitting the youngest girl while the teenager nervously cleaned around us, none of us likely liking who we were in the situation, but none of us knowing what else to do.

Your experience of a place relies in some part on the story you create of it as it unfolds: the development of a theme around which to assign the various actions and actors. Living away from home is supposed to be a way to grow, to expand horizons, but in Togo I became smaller, more timid. Towards the end of my six months there I got a job with a women's organisation in Ghana and spent days trying to get a visa. Every day the rules changed at the whim of the Ghanaian woman who worked at the embassy: I had the wrong ID, the wrong letter, the wrong address, the wrong change. One day on the

motorbike ride home from the embassy I was crying so much I had to stop so I could buy a milk ice block to calm myself down. A strange self emerged from the isolation, the awkward, unequal situations. By the end the sky was too hazy to even see the horizon any more.

There were constant power outages when I first moved to Ghana. They were orderly at the start; my area would lose power every third day, from approximately 6pm to 10.30pm. There was a schedule online. But over time the cuts became more unpredictable. It would be three days of cuts in a row rather than every third day, and the cuts became longer. No one seemed to know why they were happening: they had accidentally sold all their power to Togo, or the pipeline had been broken, or the government had used too much during the election and we only felt the effects of it months later.

A friend overheard a conversation between co-workers, two young Ghanaian men who were frustrated with the power situation. They were not used to this, as Ghana usually had a reliable power supply, one of the most reliable in the region. They grew up being told they were the hope for the region and were promised an alluring future, but the government had taken away the light.

The power cuts ended. There was an optimism to Ghana, an anticipation. The skyline changed monthly as new buildings rose, a city gorging itself on concrete. For the first time in my life I felt like I was living in a city at the centre of something. I loved the language, the way that English was used. 'Daybreak again'. 'To be bitten by the rain'. 'I am coming,' to mean you'll arrive anytime from this afternoon to three days away.

I loved the barely contained chaos and the rules that governed it, which I did not understand. I once went to a town called Nkwanta where friends were working. We stayed for the weekend and had to leave on a 4.30am bus. It took hours to be let on because a woman had convinced some men to smuggle on a huge load of yams. They filled the undercarriage and the aisles, and after hours of sitting among them we were covered in dirt and frustration. The journey was rough and many yams were broken. The woman confronted the driver about this at a rest stop and gradually the whole bus became involved. What did she expect, they said, when she illegally brought yams on a

commuter bus? She eventually sat down. When we got to her stop hours later we all had to pass yams out of the windows, one by one.

One night I got too drunk and lay dizzy on the floor of the half-finished house we were in. Chewing gum was stuck to my skirt. We went to get fried chicken but I was too sick to eat and sat with my head between my legs gripping a bottle of water. A Fulani girl with the bluest eyes sat beside me, under the fluorescent lights. I had once seen her reach up, smiling, at the window of the bus I was on. No one gave her any money and as she turned away her face was blank; the smile had been one of heartbreak. She sat next to me and asked for my water and I had to think about it because in that moment I genuinely believed I needed it more.

I became addicted to the emotion of it, to the drama, to the way it twisted me. I wasn't sure what I would feel if I wasn't there. Everything was charged: the highs were higher, the lows lower, the boredom amplified tenfold.

I loved arguing with taxi drivers. Every day had a rawer edge, but there came a point where there were no more surprises. A man arrived at the gate asking if I had any machetes to clean and I calmly declined. A taxi driver stopped the car so I could drive and I did. Another goat in the gutter, another preacher on the bus, another knife attack down the road. The absurd became hollow; I'd seen it all before.

There is a reason, a specific reason, that I tell people when they ask me why I left Ghana after a year and a half: my boss disliked young women and had gradually worn us all down. This is true in a sense, although more than that, I could never figure out how to be myself away from home.

In Togo I'd read *Open City*. It follows Julius, a Nigerian-German man, around New York as he takes it all in, part of it but not part of it, the distance between his inner life and the outer world starkly exposed. Julius made sense to me. But then toward the end of the book he tells of how, the morning after a party, a childhood friend from Nigeria told Julius how he raped her when she was fourteen, of which he claimed no memory, no conscious awareness. 'Each person must, on some level take himself as the calibration point for normalcy ...' he says. 'Whatever our self-admitted eccentricities might be, we are not the villains of our own stories ... and so what does it mean when, in someone else's version, I am the villain?' Victims and perpetrators, heroes

and villains. To see yourself as one makes it harder to see yourself as another.

Early on, for work, I was sent with two older women, one from Mali and one from Côte d'Ivoire, to a small town in Ghana called Ho where they would observe the national elections. Neither spoke any English although one tried once, calling 'Small boy!' to the horrified teenager working in a restaurant where we were eating lunch. I was there to translate because I was the only one who spoke any French, although it was very little. In the morning an attempt to gently coax one woman to wear the T-shirt they were required to wear came out as a command: 'Vous devez le porter—you must wear it.' I was stung by a bee in a school field and dazed from the allergy pills; my French became even more choppy and slow. At lunch, 'We should probably be getting back to the polling station for the counting' came out as 'Nous devons partir maintenant—We must leave now.' 'We must' is an inappropriate way for a younger woman to speak to older women in the countries they were from.

Afterwards they complained about me—cette fille blanche, cette fille blanche. This white girl, this white girl, what was she up to? Coming from countries with complex colonial histories, the last thing these women needed was a young white woman telling them what to do. In Ghana younger women have a hard time too, the twin privileging of men and age making it hard for them to be taken seriously – and I had been acting in a way that a young woman ought not.

We want clear narratives of travel. To move forward, to change, requires most of all the development of a coherent narrative of the self. But in those moments away from home the 'self as victim' and the 'self as villain' sat strangely with each other. I'd been taught to be nice, to try to be liked above all else, as white girls are prone to do, but I was constantly face to face with how in someone else's story, in the larger story, I was the villain. An already unstable self slipped; a narrative would not hold.

I gave myself permission to go home from Ghana after 18 months on the proviso that I would leave again soon. Six months, one year, maybe two. It is now closer to four years and I'm unsure where I would go.

I left Ghana because I was losing myself and thought the best way to get back to how I used to feel was to go home. Lois Presser talks about our desire most of all for a consistent idea of the self, a central core holding you

together, even as you change and diverge. And so we tell stories about ourselves in order 'to tie together the more disparate strands of our lives, of our history'. But when I got back to Wellington I didn't know how to talk about Togo and Ghana; lingering anxiety and isolation hung like loose threads I could not find a way to tie into some greater whole. Even as over the years I shaped a new life around the edges of the one I had before, I still think often about returning to those places again. I cannot let them go.

When Lara Pawson, an English journalist, came back from Angola where she covered the civil war, an Angolan woman challenged her about the longing she had for that country which is not hers. She couldn't explain it. 'The only answer I've been able to come up with is that I was there during a war. It was an incredibly intense experience, one that influenced me radically. For a long time I tried to work out how I could retrieve it.' It's hard to leave behind the places that have unfolded you. There is always some part left behind in another country, in its place nostalgia for the promise of the type of person you would be in the world, long dissolved.

The first time I got back to Wellington after Timor-Leste, it was July, an abrupt change from a tropical summer to New Zealand winter. Since then, whenever I notice the first change from autumn to winter I feel like something is coming; all those times arriving from hot countries back to a New Zealand winter and the promise that it held. And so years later, whenever it becomes cold, I start to think about the leafy roundabouts and the dusty streets and the hot power-cut nights lying in bed and wondering what will happen, where the night will go.

Bombed

The little soul friskily asked her accompanying angel: but how could God tell I was from Iraq without even asking me?

The angel gently wiped the soul's cheek with his hand,

He then put his finger in front of her eyes, and said: By the soot my little one ... the soot.

(Translated from the original prose poem of Iraqi poet Maitham Rodhi.)

One Long Puff

Death doesn't go back home right away

He takes a rest along the road as we do when we travel

He puts down the sack full of souls he's been carrying, stretches out his legs and lights a cigarette

The time taken to finish smoking his roll is when we feel the dead are still here.

(Translated from the original prose poem of Iraqi poet Maitham Rodhi.)

The Hotel Theresa

I have strolled down the brownstones of Harlem
with a heart full of salt peanuts and jazz.

Looking for soul food and a place to eat
as I try to find the Hotel Theresa.

Right across the road from the Apollo
made famous for a walk on the wild side.

Where Louis Armstrong blew his golden horn
but was refused entry to hear his friends.

Where Castro stayed to be with the people
down on one hundred and twenty fifth street.

Where elderly ladies wear their Sunday best
dancing in the aisles of the Baptist Church.

In the place where Malcolm X was transformed
from a two-bit hustler into a saint.

Hoki Mai

She kisses him goodbye with her eyes still wet and alight from their last swim in the Awatere River. At the train station celebration she leads the kapa haka but her voice keeps breaking under and over itself like waves. Like last night, on the riverbank, between the moss and baby's-breath, where he had kissed her sticky until she cried out from her swelling chest. And she was thinking about the rolls of white fabric her sister kept in the shed and how she would make a dress pressed with shiny bits of shell. She could even fix a veil from the weave of fishing net or wear knots of pale hydrangeas like a crown upon her head. And together they would move to the empty plot of ancestral land forgotten by the sea and have little brown babies that she would make sure to stuff fat with potatoes and wobbly mutton. And they would slurp kina in the summer, collect firewood from the beach on their way home from school. And their father would take up a good job in Gisborne, and return home with sacks of boiled sweets and powdery jam-filled treats, and maybe on special occasions a new perfume or European powder that she would keep but never use. And it was like she could already feel them growing and turning inside her, a sensation so violent and visceral she cried out from the dark in her gut but when the sun lit the day and the train started pulling away, with every funeral-wave farewell she felt the entire world changing, and the lump in her throat swelled like all the seas that would take him from her, but she promised that every day she would be the first to check the mail and this was the only vow she took.

Tuvalu

There are
islands
never far
from our hearts
but
deeply embedded
in the genetically encoded
tapa imprinted
tattooed
being
of our existence
where
treasured ancestors
guard
eternity and humanity
forever mindful
that our islands
are never alone
are never forgotten.

Island Girl

I once wore a shirt
That had 'island girl
fresh and sweet'

emblazoned
in bright yellow
across it

the words shaped
into a pineapple.

and I

who was neither
fresh nor sweet

enjoyed the irony.

Now I live
in Auckland

and in winter

I buy pineapples
all the way from the Philippines
for $3.78

and hope
the distance
they have travelled

hasn't soured them.

ALBERT WENDT

Discards

The search is always for balance between what is left
and what is discarded what is said and left unsaid
the meanings that spark and burn between the lines
for the reader to discover and sinew the poem with

Sometimes the poet trips over his discards
and he reconsiders if those are really unnecessary
That act will reshape the poem set it off in another direction
and another heap of discards

BOB ORR

A Palm Tree in Freemans Bay

It was in a bus stop
shelter.
Although not a wedding guest
he detains me thus
'… shipped out on a freighter
with a blue star on its funnel'.
And again I walk
those slum streets to the sea
where the derricks
of that freighter reflected in the tide
imperceptibly tilt faraway skies.
Whatever they lacked it wasn't laughter
those ribald barefooted weatherboarded seagull-shadowed
streets of ship jumpers ring bolters
pilfered cargo bookies sly grop shops and social visionaries.
Those streets where bread became contraband
have left a charter on the land.
The Freemans Bay he relates to me is a stamp
on a letter from a foreign country
formerly known as the republic of
the middle of last century.
I write poems
to those who've never dropped anchor.
Although the palm tree above me is moored to the pavement
its fronds extend wide like a frigate bird's wings.
In the lee of the Sky Tower's seedless stalk
I pluck lavender
growing wild through picket fences
in Freemans Bay.

I place a small sprig in my pocket
as if it were an invitation to a banquet.
In the hieroglyph of a
stormwater plate
I discern a ship slanting away from the moon.
The night sky above the palm tree
is a cruise ship to eternity.
'I once saw Heaven above the Suez Canal'
cries the old jack tar
bidding me
farewell
as he boards a bus that can find its way by the stars.

VAUGHAN RAPATAHANA

poet in his castle

(Bob Orr, 2017 poet-in-residence at Waikato University and living during
the week in the Nottingham Castle Hotel, Morrinsville)

the ahoy came from a c r o s s the road.
 up
we looked out and
& there he was
on the balustrade,
smiling
a sort of grimace,
waving like some l a g g a r d royal
& capped
in what appeared to be
an old captain's chapeau.

we went in to order
spicy pizza
& on our short jaunt back to the car
he called again,
gesticulating all the time:
rather like my wife's cousin
back in pampanga,
—a wary pointsman
warding off sinuous
waves of traffic.

we left him there
still standing high in the cockpit;
the poet in his castle,

ready to c h a r t
—I guess—
a laconic log
concerning
chance encounters
of the epical kind,
on a side street
in a slim waikato town.

BRIAN POTIKI

Rowley's Tangi—Down the Road

(Rowley Habib/Rore Hapipi: 24 April 1933—3 April 2016)

O-A-Tia, highest point above Oruanui. You reach it up the well-maintained hard-packed dirt road that leads to the old house where Rowley was born and to where he was taken by his whānau from Taupo, after being found, still warm, by his wife Birgitte. Dead of the heart attack he always expected would finish him.

They took him through the kitchen window, past the red table, the wood-fire stove, and into the front room; setting him hard up against the bay windows looking past a couple of distant houses, down the road to Te Waapu urupā where his mother and father lie together.

He and his whānau planned these things—the moving of the homestead from below (where his grandfather, then father, ran a store servicing the passing traffic and sawmill communities) and his final resting place on a small grassed ledge. The sort of space where we'd all like to have our end, facing north so the first sun awakens many tūī thriving in trees lining the road. As dawn broke I sat there—six hours before the burial—and saw the same rosy fingers that Homer described, appearing over the distant hills.

Hoani was the man. Rowley's close friend, shaven-headed (and ex-Vietnam he later told me) with loving memories of our mate—including Rowley's strong intuition. But it was Rowley's nephew Dean I spied first—standing outside the house watching us arrive, strumming one of the hardest-strung guitars I've ever played. Dean was one of Rowley's late touchstones: he'd read him one of his stories and if Dean said 'that's good, uncle', Rowley knew he'd nailed it.

There he was—our mate—or at least his shell. All bodies in coffins hold the merest trace of our loved ones (I first saw that with my mother, Jean). We—Jill and I with the others—were gathered to fulfil the most ancient contract, to ensure that wolves or enemies did not violate this remnant, this

case of mummified flesh, this palimpsest. And we were gathered to kōrero and sing to assuage this shared grief. House poroporoakī for a man who formerly loved the dangers of swimming in deep waters and who often strained the patience of his whānau with his whims, his stubbornness.

Candlelight flickered, firelight—a cold early-autumn night needing fires burning in this room, in the kitchen and outside. Older sister Rose and fond daughter Tangimoana by his head, on soft mattresses. His son Rere too. And sisters Evelyn and Joyce. And wider whānau. A rōpu from Hamilton arrived late (O-A-Tia is not easy to find) to tautoko Tangimoana, a doctor in their work practice. They couldn't stay and after their whaikōrero and waiata rich in harmony the man Hoani took the guitar and responded with a sweet ballad by Engelbert Humperdinck which was a bit more my—and Rowley's—style.

The cooks were up tending their fires early next morning (when I was enraptured at the urupā). Without electricity, it resembled a peasant scene from Bruegel. Laughter, women's voices and peeled vegetables, while below at nephew Greg and wife Nella's new house the men prepared the hangi.

Walking back from the urupā I got a bit lost in the bush seeking one giant rimu that can be glimpsed from the road. In a couple of letters, Rowley, you wrote of the close escape (you loved these phrases, ne?) you had when you once couldn't get your footing in Taupo's swift-flowing waters (where it rushes to the Huka Falls and where you loved to dive). You thought you were going to drown. I'd have written about this in my next letter and you'd have known exactly where that bush was and how close I'd been. Came out scratched and muddied ... you'd have understood, made a generous comment.

So ... no more exchange of letters, sharing of private adventures.

I was a pallbearer, solemnly helping to get you through the narrow doorway and out the window again, laying you tenderly on the verandah. The sun shone on you there and on your sisters and daughter by your side, the verandah of this old house, a paepae. It was 11am and there was now quite a crowd.

This is what we're going to do, said Hoani: a kāumatua's poroporoakī, a brief service, his son and daughter and sister Rose, Taupo's mayor (who brought condolences from the governor-general), then the rest of us could speak.

Jim Moriarty made the connection with Wellington theatre in the 1970s. I read from one of the hundreds of letters you'd sent me, Rowley, over more than thirty years, showing your deep love of literature and the pleasure you took in writing. Many speeches honoured you, creative, child-like, friendly man.

Then lifting you into the stationwagon and everyone following, most walking and chatting, the day clear and sunny. And up, up to the tiny old urupā. I'd never held the rope before—white, synthetic, thick. It bit into my hands as I—bird's eye view—saw you go deep. Into the ground.

Hoani led it all—the ceremony, the respect, the care taken.

And finally, a joyful feasting, the food most delicious. And the catching up, which happens more rarely now. Some singing. That guitar, though, metal strings unyielding like a medieval torture instrument. And Hoani was the man.

TONY BEYER

middle name

mine host at the Taupiri pub
no longer puts in an appearance

but leaves it to the excellent girl
to draw our pints of Waikato draught

cook our steak dinners
and show us to the bunkroom

up the steep Edwardian staircase
while a crass bunch in the corner

of the bar quaff and swear torpidly
and a group of women after work

juggle cellphones and ciders
separately under the garden awning

subtle riverine evening light
from orange to mauve to dusty purple

(hues listed on the back of Alfred Sharpe's
1876 watercolour view from the mountain)

then abruptly black as a bull
encountered on a railway siding

where the late freight shakes the joint
from roof to joists into the night

OWEN MARSHALL

Thistledown Farewell

Rome's Imperial Age was the final exam
then I went to Cheviot to spend a summer
working for a trucking firm. Mainly it was
carting hay and over weeks my townie hands
hardened beneath the gloves, the accustomed
focus of my eyes lengthened to the hills again.

On the day I finished there was a flight of thistle
down as we sprawled beneath some cockie's
poplars. Pale, silent, drifting insubstantial
multitudes as a ceaseless shoal of baby jellyfish
against the blue sea sky, or the lightest, trembling
foam balked along a hedge. Even the boss lifted
a brown arm to snatch. 'Bloody thistles,' he said.
'It's always the useless things that spread the best.'

JOANNA PRESTON

Town Planning *or* A Loose Roundelay in Answer to the People Who Keep Inviting Me to School Reunions

I come from Des Moines. Somebody had to.
—Bill Bryson, *The Lost Continent: Travels in small-town America*

There's just something about this place that turns my teeth to ice.
No main street should be quite so smug, so beige, so buttoned down.
And houses should be planned and built, not just improvised—
why would you take your architectural cues from sagging trousers?
This is a place to leave, if you want my advice.
This 'If-only-we-had-one' one-horse town.

Then there's the civic anthem—a badly improvised
larghetto for blocked bagpipe and a boy in too-tight trousers.
All down the street are rubber pleas for help from screeching tyres,
shop windows with displays to make commerce throw in the towel.
This is a place to leave, if you want my advice.
This 'There was-one-but-we-broke-it' one-horse town.

Beside the Caltex petrol station, walls of shredded tyres
make it look like Mad Max got this far and then threw in the towel.
And surely there's a message laid in the respective sizes
of the one-room public library and grand chambers for the council?
This is a place to leave, if you want my advice.
This 'We-sold-it-off-for-leather' one-horse town.

The brisk breeze every morning is the product of the sighs
of those who chose to stay despite admonishments of counsel.
The thought of even passing through there lines my veins with ice,
makes my jaw and fingers clench, my bosom batten down.
This is a place to leave, if you want my advice.
This 'We-had-one-but-it-scarpered' one-horse town.

RIEMKE ENSING

Volcano Country

for Elizabeth

That space you speak of
'that sheer cliff of sky
and stillness'
I know that longing
that irresistible language for solitude
and desire
in the bright fire of grass
where light burns
and in that roar an echo
of ourselves.

In that origin of place,
oceans boil. Flames surge
conscious of rapture. Winds
articulate exhilaration—the wild delight
of plains. Lightning strikes
and all the perplexities of our storms
enter deep into the habitat of poems
waiting to be touched.

On your desk
a jug of yellow marigolds.

JENNA PACKER

Paintings

1. *The Market Rallies*, 2017, 1116 x 1527 mm. Acrylic on canvas.
2. *Golden Calf*, 2017, 1117 x 1525 mm. Acrylic on canvas.
3. *New World*, 2017, 1112 x 1375 mm. Acrylic on canvas.
4. *Steam Hammer*, 2017, 1115 x 1372 mm. Acrylic on canvas.
5. *Conversion*, 2017, 1116 x 1527 mm. Acrylic on canvas.
6. *No Other Gods*, 2017, 1525 x 1116 mm. Acrylic on canvas.
7. *Folk Tale*, 2017, 1115 x 1374 mm. Acrylic on canvas.
8. *Furnace*, 2017, 1116 x 1370 mm. Acrylic on canvas.

With acknowledgements to Milford Galleries, Dunedin.

Jenna Packer is a painter of landscapes not as scenery but as contested territory, with possible environmental catastrophe imminent. Her current work is about the judgement of history, where nature versus commerce, and where culture involves negotiation between warring, hostile or collaborative groups over the same property. Her bovine deities stand for the edifice complexes of civilisation, the hubris of 'progress'. Her pictorial allegories and fables disinter historical memory. She finds in neo-colonial spectacle ghost images of colonial settlement; the future has the look of yesterday. For the masses, for ordinary people, after the end of the oil economy, the subsistence economy looms. The bankster bull asserts profit, and the control of profit. It asserts class consciousness and the privilege of the elite; it asserts the brute force of capital. Packer makes art that invites the ethical question: how should we live now? —David Eggleton, Art New Zealand 152

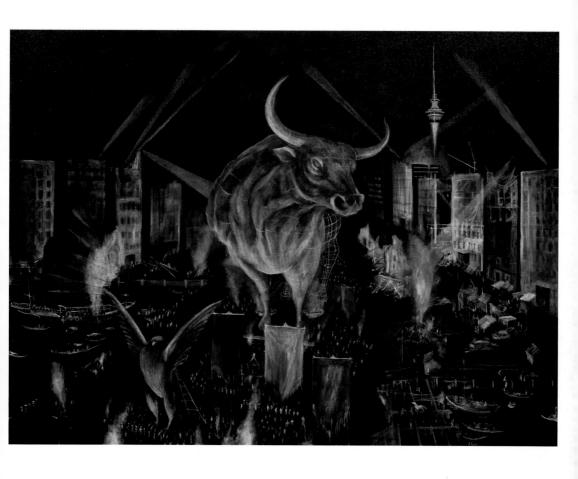

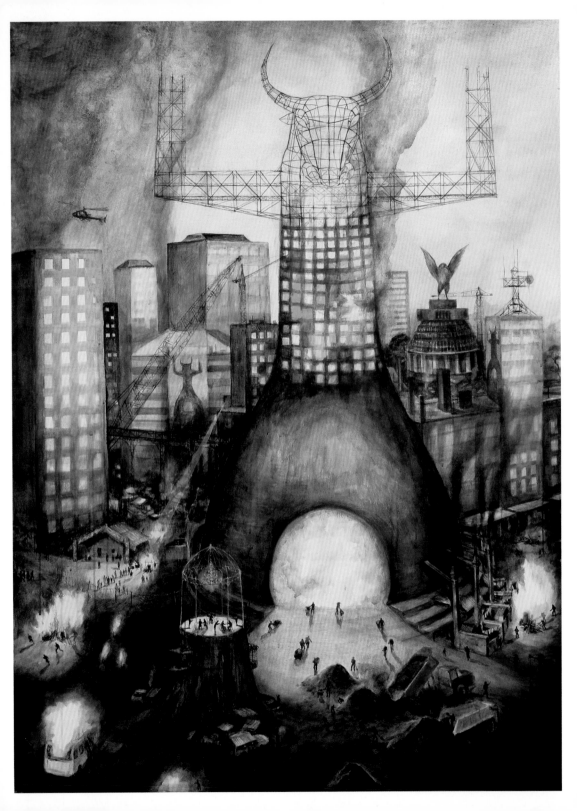

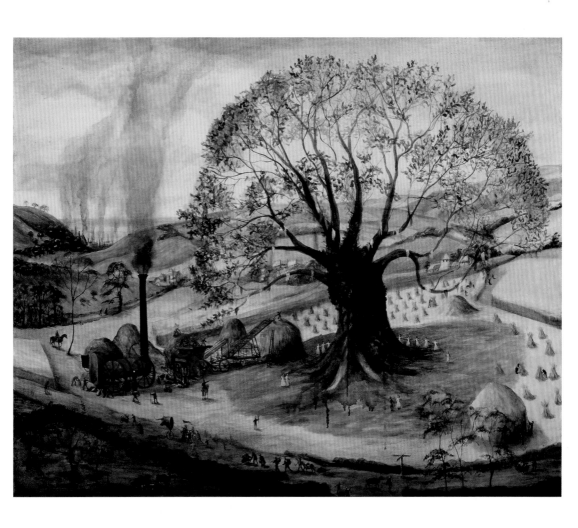

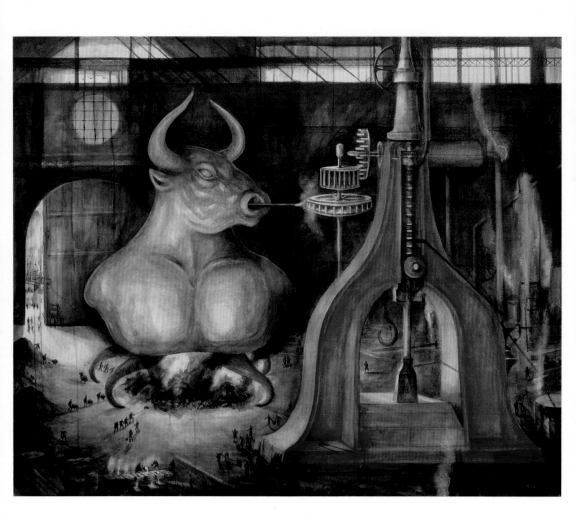

Expectation

A big lump of darkness sits over the world
just ahead.

Draw a line and it fits right through.

There's no escaping this darkness—it sits like clouds
just ahead.

Is this where the journey ends?

There's big weather brewing and it's not just clouds
but also desperation, mountains one
side, sea the other.

It sits like a lump just ahead.

I know I shouldn't be saying this because to speak of
darkness is to tempt fate.

This was drummed into me
but I don't seem to have learned my lesson.

Should I forgive the lump that sits,
this darkness, that
density?

It's getting complicated now darkness only exists in
counterpoint.

What's it like over the mountains?
How much more of this contrast can I take?

But this journey ends in darkness and I've been told
it lies just ahead.

STEPHANIE JOHNSON

A Personal Memoir of Dr Rosie Scott

On the fourth of May 2017, New Zealand/Australian writer Rosie Scott died in Hazelbrook, a small town in the Blue Mountains of New South Wales. It was the end of our thirty-five year friendship, begun when she was thirty-two and I was twenty. There are many other deep friendships that Rosie had, on both sides of the Tasman, older and longer or more recent. Rosie was a woman who treasured her friends and was cherished in return. 'You are made of love,' I told her the last time I saw her. I remember the smile she gave me in reply.

Like me, Rosie was born in New Zealand and married an Australian. She lived with him on Waiheke Island and in Auckland before moving to Australia when she was forty years old. We did it in reverse—I was a young mother in Sydney but now grow old in Auckland; she was a young mother in New Zealand and grew not-very-old in Sydney. When she died she was six weeks into her seventieth year, having turned sixty-nine on 22 March. Her death was long and protracted, the most punishing decline for a woman of letters. For eighteen months she had been often wordless and mostly bedridden, lovingly nursed by her husband and daughters at his house in the Blue Mountains.

For fourteen years, until she fell ill, Rosie had her own home in Cook Street, Glebe, a warm and sunny third-storey flat with a balcony groaning under a small forest of potted palms and cyclades. The birds came down for birdseed and honey at her call—rosellas, crows, cockatoos, parakeets. Flocking in at the door of her flat would be friends and visitors, most met in the twenty-eight years she had lived in Sydney after four years in Brisbane. They were predominantly writers, or associated with the literary world, and also people she met through her activism or contracts teaching at Long Bay Prison or University of Technology Sydney. A world of colour and light enveloped her—she completed a doctorate, taught, wrote, edited, chaired the Australian Society of Authors and mentored many of today's prominent Australian writers including Fiona MacGregor, Denise Leith, filmmaker Robin de Crespigny and the late Georgia Blaine.

Special mention has to go to writer and Afghani refugee Abdul Hekmat, who regarded Rosie as a second mother, just as she saw him as her son. Among her other treasured Australian friends that I met were Anita Heiss, Tom Keneally and Debra Adelaide. A very dear friend was feminist, writer and broadcaster Anne Deveson, whom I never did meet, but Rosie spoke of her often and fondly. Deveson died earlier this year, not long after her daughter, novelist Georgia Blaine. Friends from New Zealand would come to visit or stay—Helen Forlong, writer Sue McCauley and her husband Pat Hammond, my husband Tim and me. Nieces Zinzy and Malia would come from Auckland, as well as her sister, stepsister and cousins.

The flat was hers, rooms truly of her own. For the most part it was a contemplative and contented life. She had longed for a place of her own where she could write and think uninterrupted, where she had few domestic duties to perform. She had taken motherhood seriously with all that that entails, working as a social worker when her daughters were little and always keeping a warm and welcoming home for them. She adored her husband and daughters and, later, her grandchildren.

Throughout the years in Glebe, Rosie spent most weekends with her husband Danny, either at his apartment in Marrickville or, later, at his house in the Blue Mountains. It was, for all its unconventional living arrangements, a successful marriage. In their company I always had a sense of their great love and mutual respect. Through the weekdays they pursued their busy individual lives.

Rosie used to say to me that she and I were in some strange *pas de deux*, our lives mirroring each other. We had been the same age at the birth of our first child, twenty-seven; we had married Australians, we had published books in tandem, we had switched sides of the Tasman within a year of each other when she was forty and I was twenty-eight, we were playwrights, poets, feminists. What bound us on a deeper level was our shared experience of acute pain, which sounds gloomy but isn't. Rosie was born with hip dysplasia complicated by a deformity of the hip socket, and I was born with deformed feet, which meant I underwent many operations during my childhood and teenage years on bones that are now severely osteoporotic. In her fifties Rosie had an unsuccessful hip replacement which brought further problems. We both limped like bastards and swore like bastards too. The six short flights of

steps up to her otherwise perfect flat on the third floor sometimes seemed unconquerable, and I worried about her living there with no lift. We had an unspoken, or at least rarely referred to, understanding of what it is to have from birth a body that lets you down and gives you gyp.

But by far our deepest bond was in our talk of friends, our children and men, love and sex, the doing of it and the writing about it, and around that spinning talk about the whole world, politics, the universe, the worrying state of the environment, and everyone we knew. Three-hour phone conversations were not unusual, Rosie lying on her blue couch in Glebe, and me here at Rose Road, a Grey Lynn street she and her family had once lived in. Another step of the *pas de deux*. If we were together we would do the same, talk and laugh for hours. They were the most wonderful curling loving totally accepting conversations, the unpicking and weaving of ideas, books, films, scurrilous gossip, secrets and dirty talk, the two countries we love, and we would always say how we loved each other. Our friendship was an affair of the mind, both our hearts leaping at the prospect of time together. I have envelopes stuffed with letters from her from the days before email. I cannot bear to look at them. Not yet.

After Rosie got sick, Danny devoted himself to her care—he did nothing but nurse her, love her and treat her with compounds and supplements as well as conventional medicine. The family made sure someone was with her all the time, with Danny doing by far the lion's share. He was doing something right—she outlived the predictions by some months, which is a good thing. Rosie was not one to turn her back on life. She told me a couple of times in the last months that she wanted to die, and I agreed reluctantly that it was probably the right thing to do. But how impossible is it to say goodbye to someone like Rosie, who brims with life and a warm curiosity for all things? She was capable of real anger, but only in the face of injustice and destructive stupidity. Australia provided plenty of that for her during her last twenty-nine years on the planet, plenty of grist for her mill as activist, writer and editor.

If you are a stranger to Rosie's work as a novelist then I would recommend you start with *Glory Days* (1988), her first novel, which she wrote in Dryden Street, Grey Lynn. Danny built her a writing room on the garden level of their villa, sanctity away from the house, which often thronged with Bella's and

Josie's mates, friends from Waiheke, Auckland friends, fellow writers and theatrical types. There, her typewriter 'ran red hot', as her daughter Bella recalled. The novel was a huge success, here and in America, and made it on to the *New York Times* Best Sellers list. The heroine Glory is tough, resilient, wise and funny, not unlike a later heroine, Faith Singer, who stars in an eponymous novel published thirteen years later in 2001. The two novels are true sisters, set on either side of the Tasman, one in gritty Auckland and the other in gritty Kings Cross.

Among the novels written between *Glory Days* and *Faith Singer* are *Lives on Fire* (1993) and *Movie Dreams* (1995). The first drips with sex and jealousy and madness, steamy in the heat of Brisbane. It is a gothic, romantic heart-twister that deserves a far wider commercial readership. *Movie Dreams* is a deeply moving road trip in the company of a seventeen-year-old lad into the far northern tropical reaches of Australia. It is written in young Adan Loney's voice, intimate and amusing, reluctantly self-aware, true to its contemporaneous setting. It is my favourite of her novels.

Of Rosie's non-fiction, *The Red Heart* (1999) is a collection of essays. Some of these began life as commissioned talks, others are pieces developed from her treasured journal that she kept from the age of nine. Some are musings on writers, some on writing itself, or life in Australia for a New Zealander becoming Australian, or on love, motherhood and friendship. In her essay 'Friends' she writes, 'For most of us, adulthood brings the full-bodied joys of genuine friendship, relationships tempered with consideration and tolerance, the comfortable state of trust, love and mutual inspiration between two people, without which life would be a boring, hazardous and barren wasteland.'

Rosie worked in the capacity of initiator and co-editor for her last three books. The first two were *Another Country* (2004) and *A Country Too Far* (2013), edited with Tom Keneally, which combined fiction, poetry and political pieces on the asylum seekers question. After each publication, Rosie travelled around Australia speaking on the tragedy and encouraging discussion around immigration policy. She threw herself into the issue heart and soul.

The third, co-edited with Aboriginal writer Anita Heiss, was on the intervention and everything that spins out from that in terms of the parlous attitude of government to Aboriginal rights. Contributors to *The Intervention*

(2015) came from all over Australia, from Aboriginal and non-Aboriginal writers.

In her obituary for the *Sydney Morning Herald*, Rosie's friend and UTS colleague, writer Debra Adelaide, wrote about how Rosie would gently persuade friends to join her on whichever cause she was espousing. She recalled how these phone calls would always begin with the sound of Rosie's gentle voice saying, 'Hello, love, I was just wondering ...' Among the many issues Rosie confronted was that of the Stolen Generations, for which she co-founded Women for Wik. In 2016, the year before she died, Rosie was awarded the Order of Australia in recognition of her 'significant service to literature as an author and to human rights and inter-cultural understanding'.

Dr Rosie Scott had a honed, rare instinct for sniffing out injustice and a consuming desire to shine the brightest light on the darkest cruelty. Overwhelmingly compassionate, practical, political, loving and articulate, she was an activist and story-spinner possessed of profound insight into human existence. Rosie leaves behind her devoted family—Danny Vendramini, daughters Josie and Bella, granddaughters Siona and Sabela—and legions of trans-Tasman friends and admirers.

RIEMKE ENSING

Caselberg Trust International Poetry Prize 2017 Judge's Report

It was an exceptionally long and bitter winter, during which world events only added to a prevailing mood of despair and disbelief. Perhaps that is why so many of the 135 poems entered in this competition seemed to deal with death, pain, illness, mortality and loss. There were political poems triggered by 'Trump talk' and fear of another Cold War. There were poems addressing pollution, the refugee crises, homelessness and migration. Many more dealt with personal relationships, family, isolation, memory, the possessed and dispossessed. A kind of grimness pervaded.

From all the poems on offer, which were judged blind, I chose as the winner 'Road to Murdering Beach' by **Majella Cullinane**. I liked the confident way it addresses the reader in a conversational, colloquial voice; the way a narrative is told with minimal detail, concentrating instead on imagery to convey the 'feel' of the story as we plunge through 'the charcoal sky of dusk beneath the sea'. The poet steers us away from the obvious and concentrates on the imaginative —on 'the shadow' of what lies behind. We can 'hear the last murmurs of the dead' or be like the kāhu, the harrier hawk, gliding high and free above the 'tide's exhalation' rather than dwelling in the gruesome details of what happened here 'in the skitter of grey-pink clouds polishing waves' so many years ago.

There was very little humour in any of the entries, so I was delighted to come across **Ruth Arnison**'s 'Finding Billy Collins in the Fiction Shelves'. If you don't know Billy Collins, look him up and have a chuckle. Certainly here is the very opposite of '[tying] the poem to a chair with rope and tortur[ing] a confession out of it'. I liked the humour, the snappy, conversational style imitating Billy Collins, the way you are invited to go back and read that poet— and Emily Dickinson, who, someone said somewhere, would have kicked his

arse. Suddenly you are reading more than the poem in front of you. You've embarked on a journey of exploration.

I chose four Highly Commended poems: 'Lumb Bank' by **Sarah Grout**, 'Notes from a Refugee' by **Ruth Hanover**, 'Bridge' by **Carolyn McCurdie** and 'Cambodia (A Deconstructed Country)' by **Susan Howard**.

'Lumb Bank' took me on a virtual journey. I visited the Ted Hughes Arvon Centre, a writers' retreat in Yorkshire, and saw the 'red tulips wave to no-one above Sylvia Plath's grave' in Heptonstall. I was reacquainted with the American poet Sharon Olds. Sarah Grout's poem seemed to centre, almost unwillingly, on death. 'I have been forced to wrack / through words recalling / the death of my father.' A painful business, like the writing process itself, where the poet confronts her own 'wound that will not heal'.

Often a poem—or even just a line—lingers in the mind. It might not be a very sophisticated poem, but something about the way it offers a picture arrests one's attention. That's why I liked 'Notes from a Refugee'. This poem comes straight at you, forcing you to 'Look at me' and engage with loss, poverty and homelessness. It is plain and straightforward and demands your attention.

'Bridge' has that little frisson of delight at the end when a vague childhood memory 'I never trusted as true' suddenly materialises after sixty-four years and becomes a reality. It is the sort of experience we may all have had when we revisit an old haunt, not quite knowing what we may find. The memory of 'being lifted to a window / to watch a train go by' but really having nothing firm on which to base this possible 'myth' becomes almost electric when we are suddenly confronted with the stark—almost frightening—reality.

In 'Cambodia (A Deconstructed Country)' we're presented with 'a paradox for brave visitors'. We see an 'unlayered country' that 'still waits for justice'. Poems like this need to be written to remind us to resist.

Winner: 'Road to Murdering Beach' by **Majella Cullinane**
Runner-up: 'Finding Billy Collins in the Fiction Shelves' by **Ruth Arnison**
Highly Commended: 'Lump Bank' by **Sarah Grout**; 'Notes from a Refugee' by **Ruth Hanover**; 'Bridge' by **Carolyn McCurdie**; 'Cambodia (A Deconstructed Country) by **Susan Howard**.

The winning and runner-up poems appear on the following pages.
This report has been edited. A full version can be found on the Caselberg Trust website.

MAJELLA CULLINANE

Road to Murdering Beach

I'll let you in on something—
I've never dreamt of being a bird,
see only the shape of myself plunging through water,
a fish flecking its tail, fins stroking waves
in the charcoal sky of dusk beneath the sea.
Nights I have dreamt this, and come up to breathe
in a room curtained in darkness. By a window

I have watched headlights stream down the road,
sunlight hide behind the old villa next to us,
heard the pledge of autumn in the sigh of another leaf,
the wind sashay the green orange pines on the hill
and in the skitter of grey-pink clouds polishing waves
I remember what you said to me once—

there are few who can feel the shadow
of the murdered behind them at twilight,
can hear the swing of hatchets, the thrust of spears,
the last murmurs of the dead. There are others
who listen hard, like a child holding a conch shell
to their ear, but hear only the tide's exhalation,
the plaintive kāhu, the flap glide flap of wings.

RUTH ARNISON

Finding Billy Collins in the Fiction Shelves

He was leaning
against Jackie Collins with
Tamara Cohen peeping over his shoulder.

I whipped him
off the shelf hissing,
you've taken Aimless Love too far.

There's no point
in going ballistic, said the assistant,
we've always had trouble with poetry.

Billy, I said,
shelving him next to Emily, you've got to
stop this sailing alone around the room.

I think he got my message.
Next week he was still there,
Taking Off Emily Dickinson's Clothes.

Landfall Review Online

www.landfallreview.com

Reviews posted since April 2017
(reviewer's name in brackets)

April 2017

Strip, Sue Wootton (Tina Shaw)

Billy Bird, Emma Neale (Emily Brookes)

The Wish Child, Catherine Chidgey (Maggie Rainey-Smith)

Mansfield & Me: A graphic memoir, Sarah Laing (Claire Mabey)

New Sea Land, Tim Jones (Kay McKenzie Cooke)

I am Minerva, Karen Zelas (Kay McKenzie Cooke)

Acknowledge No Frontier: The creation and demise of New Zealand's provinces, 1853–76, André Brett (Jane McCabe)

May 2017

A History of New Zealand Literature, ed. Mark Williams (Lawrence Jones)

Goneville: A memoir, Nick Bollinger (Garth Cartwright)

Nothing for it but to Sing, Michael Harlow (Charlotte Graham)

Back with the Human Condition, Nick Ascroft (Charlotte Graham)

The Name on the Door is not Mine: Stories new and selected, C.K. Stead (Andrew Paul Wood)

A Briefcase, Two Pies and a Penthouse, Brannavan Gnanalingam (Nicholas Reid)

A Surfeit of Sunsets, Dulcie Castree (Gillian Ranstead)

June 2017

Jay to Bee: Janet Frame's letters to William Theophilus Brown, ed. Denis Harold (David Herkt)

The Broken Decade: Prosperity, depression and recovery in New Zealand, 1928–39, Malcolm McKinnon (Cybèle Locke)

Lifting, Damien Wilkins (Felicity Murray)

Black Ice Matter, Gina Cole (Tulia Thompson)

Stories on the Four Winds: Ngā Hau e Whā, eds Brian Bargh and Robyn Bargh (Vaughan Rapatahana)

Butades, T.P. Sweeney (Ted Jenner)

July 2017

The Straight Banana, Tim Wilson (Michael Morrissey)

The March of the Foxgloves, Karyn Hay (Nicholas Reid)

Enclosures 2, Bill Direen (Lindsay Rabbitt)

Fully Clothed and So Forgetful, Hannah Mettner (Helen Lehndorf)

The Internet of Things, Kate Camp (Helen Lehndorf)

Everything is Here, Rob Hack (Erena Shingade)

Red Woman Poems: Two poems after paintings by Dean Buchanan, Denys Trussell (Erena Shingade)

Songs of the City, MaryJane Thomson (Erena Shingade)

Night Fishing, Brian Turner (Piet Nieuwland)

Visions of Valhalla: A poetic tribute to Richard Wagner, John Davidson (Piet Nieuwland)

Koel, Jen Crawford (Piet Nieuwland)

August 2017

Notes from the Margins: The West Coast's Peter Hooper, Pat White (Denys Trussell)

The Stolen Island: Searching for `Ata, Scott Hamilton (Michael O'Leary)

Best Playwriting Book Ever, Roger Hall (Helen Watson White)

Shift: Three plays, Alison Quigan, Vivienne Plumb and Lynda Chanwai-Earle (Helen Watson White)

Tom Hutchins: Seen in China 1956, ed. John B. Turner (Max Oettli)

The Shops, Steve Braunias and Peter Black (Max Oettli)

The Walking Stick Tree, Trish Harris (Johanna Emeney)

The Case of the Missing Body, Jenny Powell (Johanna Emeney)

City of Circles, Jess Richards (Antony Millen)

September 2017

Manifesto Aotearoa: 101 political poems, eds Phillip Temple and Emma Neale (Michalia Arathimos)

Blood Ties: New and selected poems 1963–2016, Jeffrey Paparoa Holman (Robert McLean)

Tender Girl, Lisa Samuels (Robert McLean)

As Much Gold as an Ass Could Carry, Vivienne Plumb, illus. Glenn Otto (Christine Johnston)

Keel & Drift, Adrienne Jansen (Lynn Davidson)

Star Sailors, James McNaughton (Tim Jones)

Breaking Ranks, James McNeish (Andrew Paul Wood)

The Landfall Review

The Observing, Remembering, Recording Self

by Martin Edmond

Charles Brasch: Journals 1945–1957,
Selected with an Introduction and Notes by
Peter Simpson (Otago University Press, 2017),
686pp, $59.95

Charles Orwell Brasch, born 1909, was an heir to the Hallenstein fortune. The progenitor of the line, Reuben Hallenstein, operated a textile mill in Brunswick, Germany. Brasch's great-grandfather, Bendix Hallenstein, Reuben's youngest child, followed his two older brothers to Manchester, England, where they all learned to speak the language; and then to the Australian goldfields, where they opened a store at Daylesford, Victoria. There, it is said, all three fell in love with their housekeeper, Mary Mountain, who had come out to the colonies on the trail of a sea-faring brother. She chose Bendix and, after their wedding at the Mountain family seat at Thurlby, Lincolnshire, they moved, in 1863, to Invercargill in the South Island of New Zealand to open another store.

Relocating to Queenstown, Bendix sold groceries, wines and spirits, drapery and ironmongery. He opened more shops on the Otago goldfields and began to act as an agent for sheep farmers, selling their wool in Dunedin, Melbourne and London. He became a flour miller and a farmer himself, and built a large house near Queenstown, calling the property Thurlby Domain after his wife's home in England. Because he had difficulty in obtaining men's clothes to sell, Bendix Hallenstein started manufacturing his own, and opened a retail outlet for them in Dunedin's Octagon. By the turn of the twentieth century there were thirty-four Hallenstein Brothers shops throughout the country and they included the DIC (Drapery and Importing Company) in Christchurch and another in Wellington.

Charles Brasch was descended from Reuben Hallenstein through two of his four grandparents. His maternal grandfather, Willi Fels, was the son of Bendix's sister Käthchen; his maternal grandmother, Sara, the eldest of Bendix's four daughters (he had no sons); they were thus first cousins. The extended family was also connected to the Michaelis family, business people in Melbourne, and to the de Beers—not the South African diamond trading firm but the Dunedin family of scholar, collector, bibliophile and philanthropist Esmond de Beer, son of Dutch migrant Isadore. The Hallensteins combined commercial acumen with a dedication, both philanthropic and performative, to the arts.

Charles was his father Henry Brasch's only son. His mother Helene died in childbirth when he was four years old and his much-loved younger sister, Lesley, when she was 28. There were no other

siblings. He went to Waitaki Boys' High School in Oamaru and then his father sent him to Oxford, expecting him to return home and take over the family business. Charles did come back, in 1931, and made an attempt to do so. It failed, however, and, much to his father's disappointment, he returned to England, spending the rest of the decade travelling in Europe, Russia, the Middle East and America, working as an archaeologist in Egypt, teaching 'problem' children, writing poetry. He (and his father) were in Hawai`i, on their way to New Zealand, when the Second World War broke out. Charles went back to England and did fire-watching in London, and intelligence work at Bletchley Park, until 1945, after which he returned, by ship, to his own country.

It is at that point, on the *Themistocles*, on 11 December 1945, that this, the second volume of Brasch's *Journals*, begins: *Ireland visible in the morning, a misty steel blue.* He is returning home as a man with a mission: to invent, to provoke, to nurture, to sustain, a robust literary and artistic culture in New Zealand. The main forum for this creation was to be the magazine he founded, with others, in 1947: *Landfall.* Brasch had been involved with the periodical *Phoenix* in the early 1930s; its four issues were anticipatory of *Landfall* and some of the same people—James Bertram, Allen Curnow, Brasch himself—worked in both enterprises. Brasch had met printer-poet Denis Glover in London during the war and

Glover, with his connection to the Caxton Press in Christchurch, was a crucial if somewhat ambivalent figure in the early days of *Landfall*. The tragi-comic vagaries of the alcoholic Glover, poignant and exasperating, become one of the leit-motifs of the first third of this volume.

When Brasch returned home he had concerns other than the founding of a literary quarterly. Can I live in this place? he repeatedly asked himself. An independently wealthy man, he wasn't talking about getting and spending. He meant could he find the kind of sustenance he needed as a person to survive? Could he find intimacy with other human beings on a level that would sustain his intellect, his emotional stability and, we might say, his soul? Some of that sustenance actually came from the land itself, and the *Journals* are notable for their magnificent descriptions of landscapes, mostly (but not solely) those of the Southern Alps, Central Otago, the lakes, Fiordland and other parts of the wild south. Brasch, along with others in his circle, would go tramping in these wildernesses every summer and his accounts of these excursions make a kind of spine for the book as a whole: reliably grand, structurally stern, spiritually both exacting and fulfilling.

The human world is more complex. Brasch craved an intimacy that he rarely enjoyed, as if he were too sensitive to bear the incursion of another into his privacy, while at the same time ardently desiring it to occur. He was attracted in

this way to both men and women: he fell in love, on the *Themistocles*, with Rose Archdall, a young woman who had lost her husband in the war and was travelling home with their daughter. This relationship consumed Brasch's emotional energies in the aftermath of his homecoming, until it was supplanted by another love affair; but it returned in the 1950s, when the question of marriage, it seems, was broached and then successfully (and probably for the best) avoided—by both parties. They remained good friends.

His other great love endured throughout the years covered by this selection and followed the same arc: intense, passionate, emotional involvement succeeded by a gradual alteration towards something more like friendship. Harry Scott was a young scholar when Brasch first met him— disturbed, indeed fractured, by wartime experiences as a conscientious objector. Brasch, a sympathetic older man, helped Harry put himself back together again until such time as he was able to resume the full range of the scholarly and literary activities he was capable of pursuing. Brasch lived in Dunedin but *Landfall* was published out of Christchurch, to which city he would travel to stay for extended periods as each issue of the quarterly approached completion. In the early days of these sojourns he shared a flat with Harry Scott. Meanwhile, in Dunedin, over a much longer period, he lived with another close male friend, Rodney Kennedy.

The question naturally arises: were either of these love affairs in the sense we understand the term today? In other words, were they reciprocal? It is impossible to know. Brasch excised many of the journal entries that referred to events in his relationship with Harry. About Rodney, he is often irritable and unkind (and then remorseful); yet it is clear he continued to feel a strong affection for him. When Harry falls in love with a young woman called Margaret Bennett, Brasch, in the throes of an emotional crisis, is strong enough to become a friend, supporter and ally of the young couple and to forge an enduring friendship with them and with their children. Indeed, it is Margaret Scott who transcribed the *Journals*, and her daughter Rachel who has published them. Harry, meanwhile, a mountaineer, was killed in a fall on Aorangi in February 1960: a death eerily prefigured in entries in the *Journals* a decade before it happened.

So much for intimacy. In the wider literary and artistic circles of 1940s and 1950s New Zealand, Brasch was ubiquitous. As editor of *Landfall* he was a nexus for all sorts of exchanges in the arts. He was certain from the start of the need to make a magazine that took a broad approach to matters cultural: publishing not just fiction and poetry, but social and political commentary as well as reviews of the visual arts, of theatre, music, dance, architecture. It would reproduce paintings and drawings too. He travelled incessantly, often in

order to meet potential contributors and to discuss with them what they might offer the magazine. The notion of a literary editor taking a bus from Dargaville north, say, in order to visit Eric Lee-Johnson in the Hokianga, may seem bizarre now; for Brasch, then, it was de rigueur. He must have covered thousands of miles in this way, on planes, boats, trains, in buses and in cars.

Or people came to him. One of the fruits of these engagements is a series of pen-portraits of those whom Brasch met. He was visually acute and his observations do bring his subjects before the eye. He was particularly responsive to male beauty and liked to reproduce not just faces and voices but hands, torsos, physiques, gestures, clothes and the indefinables that animate them. His descriptions of the young Alistair Campbell are a standout, as are the half-dozen portraits of James K Baxter. And of composer Douglas Lilburn. Ruth Dallas, a close friend, too. Douglas Stewart, and others whom he met in Sydney. They appear before you as they were. He will often, on further acquaintance, revise a character study; as he does, for instance, with Allen Curnow, who strikes him at first as *coarse* and only later reveals the refinement that was, for Brasch, an essential quality in any friend or colleague.

Brasch was a poet, too, and another theme of the *Journals* is his struggle with his craft and sullen art: he was frequently in despair of his ability to write poetry and sometimes wavered in his commitment to doing so. Yet he continued to believe that, without poetry, his life was meaningless. His private discontents, however, went well beyond the writing (or not) of poems. There were family matters to consider. Upon his return to Dunedin he nursed his much-loved grandfather, mentor and guide, the collector and philanthropist Willi Fels, through his last illness. Subsequently his relationship with his father became a central concern. This continued until Henry's own death in 1956, after which a kind of liberation occurred, allowing Brasch to embark upon his (unfinished) memoir, *Indirections*. Nevertheless, given that *Indirections* covers the years 1909 to 1947, when *Landfall* began, in some respects this present volume may be read as a sequel to it. The third, which is in preparation, will presumably complete what will come to be seen as one of the indispensible autobiographies of our time.

The book is old-fashioned in look and feel, like an artefact from the era out of which it arose: a robust hardback, with a drawing of Brasch by Eric Lee-Johnson on the pale blue cover, a black ribbon, thick white shiny pages, a good selection of photographs and an impressive armature of scholarship assembled by editor Peter Simpson. There is a chronology, a family tree, a comprehensive introduction, a Dramatis Personae (415 entries!), a bibliography and an index. The journal entries are footnoted, where necessary, to supply context or detail; and yet you still quite

often feel yourself to be looking down upon the pool of light on the desk where Brasch scratches out his thoughts and feelings and sends them into the darkness beyond the page. It is skilfully structured: beginning with Brasch's return on the *Themistocles* and ending with his second return, by air, after he had revisited England and his beloved Italy, in 1957. In London, emblematically, he has seen and admired Francis Bacon's homages to the paintings Vincent van Gogh made of the artist on the road to Tarascon.

I wondered if, at nearly 700 pages long, it might be a difficult read, but that is emphatically not the case. For two reasons: Simpson's selection is both economical and judicious; and Brasch was a fluent writer, with a lively mind and an engaging voice. Truthful, too, so far as you can tell. He is also a consummate self-portraitist. Herewith, his own reflection upon the process:

> So many selves jostle for place within me, & get the upper hand by turns, that when I write about myself I seem to be writing about different people at different times. I do not present a unified consistent picture of myself; yet 'myself' really exists, & I can trace the thread that unites my various selves. It is the observing, remembering, recording self.

Those selves are indeed various: there is the discerning, often fierce critic, especially where painters and painting are concerned (Rita Angus, McCahon and Woollaston are all taken to task); the refined, snobbish aesthete who feels physical pain at the crudities of others; the uncertain, sensitive man who doubts himself on every level except perhaps the most basic, where God is as a rock inside of him; the tough editor/business person (but only in the arts) who has an almost infallible instinct for what will or will not work; the generous soul who extends vital support to others without expecting anything in return; the mortal who worries about the regularity of his bowels and, on one occasion, dreams he has two penises; the wanderer of upland roads; and more. But it is, as he says, the observing, remembering self that unites all of the others.

To end with a coincidence: Susan Sontag, whose journals have also been published in three volumes, had this to say on New Year's Eve, 1957 (the day after Simpson's selection ends):

> The journal is a vehicle for my sense of selfhood. It represents me as emotionally and spiritually independent. Therefore (alas) it does not simply record my actual, daily life but rather—in many cases—offers an alternative to it.

Elsewhere Sontag remarks that had she not been homosexual, she would not have needed to write her diaries. Whatever the true nature of Charles Brasch's sexuality—and it is a matter he seemed to wish to render as opaque as possible—there can be no doubt that his *Journals*, like Sontag's, constitute both a record of daily life, and offer an alternative to it. Like her, too, he knew this to be the case.

This selection thus bears witness to a secret life which, once the thirty-year embargo passed, was meant to see the

light of day. You might read it as a letter to the future; like the Constantin Cavafy poem—which Brasch surely knew—called 'Hidden Things', which concludes: 'Later, in a more perfect society, / someone else made just like me / is certain to appear and act freely.' The book also constitutes an incomparable, sometimes heart-breaking, testament to a wilder, simpler, cruder but also more generous, kindly and egalitarian New Zealand; one that has largely disappeared but which may, courtesy of accounts like this one, come again. We are fortunate to have it.

How to Write About Something While Writing About Everything

by Iain Sharp

Selected Poems by Ian Wedde (Auckland University Press, 2017), 336pp, $39.99

Let's begin by talking about everything. In an early poem Ian Wedde strikingly refers to his birth as the moment 'when I first gaped my gums to receive the world'. Every poem ever written deals in one way or another with the reception of the world. The interesting question is, how much of that continual, ineluctable bombardment of the senses does the poet want to include? For Wedde, it has always been the whole chaotic, sometimes glorious, often hideous, light-and-dark shebang. Or, as he puts it in a famous passage from his mid-1970s 'Sonnets for Carlos':

> Diesel trucks past the Scrovegni chapel
> Catherine Deneuve farting onion fritters
> The world's greedy anarchy, I love it!

In the characteristically savvy and generous-spirited foreword that he contributed to sociologist Nick Perry's 2011 book Ruling Passions: Essays on just about everything, Wedde cites one of Perry's earlier discourses (on the Apple computer television advertisement) as

his 'touchstone for how to write about something while writing about everything'. That's rather a peculiar phrase but a useful one, I think, when negotiating Wedde's *Selected Poems*. Poets of any ambition will surely want the themes, details and language they choose to resonate beyond the specific context, but Wedde seems to work from the other end of the telescope. Rather than going from here to eternity he comes from eternity to here, in search of a serviceable receptacle to hold an amorphous swirl of thoughts. He already has 'everything'; it's the 'something' he needs to locate. With *Ruling Passions* in view, I'll also help myself to the lovely question that Perry (channelling George Bernard Shaw) uses as the subtitle for the introductory chapter to his book: 'Is everything enough?'

First, however, there's the not-unrelated question of how to select from a poet who resolutely writes about everything. What one immediately notices about the Selected Wedde (along with John Reynolds' cover design, which inscribes the author's name in big hand-drawn block capitals, the 'IAN' recalling the massive 'I AM' of McCahon's *Victory Over Death 2*), is its sheer heft. Stretching to 336 pages, the Selected Wedde is forty pages longer than the 2010 Selected Baxter, even though Hemi was notoriously prolific. It's more than 100 pages longer than the 2016 Selected Bornholdt and twice the size of the 2012 Selected Manhire. Besides much else, we're given all the 'Sonnets for Carlos',

all the 'Commonplace Odes', all fifty-seven stanzas of 'A Hymn to Beauty', all 385 couplets of 'The Lifeguard'.

Asking for more smacks not only of greed and ingratitude but a fundamental stupidity about how the Selected genre operates. I'm happy to proclaim the Selected Wedde not just one of the best New Zealand books of 2017 but one of the best of any year. Yet there are poems not included that I miss: 'Gulf Letters', 'Losing the Straight Way', 'Angel', 'A Short History of Rock 'n' Roll', 'Beautiful Golden Girl of the Sixties', 'Two Odes to Desire', 'Two Affections', 'Seven Dreams', 'Three Regrets', 'Three Elegies'. In my heart I wish Auckland University Press had let the project swell to another volume or two and called it a Collected. For the committed fan, there's always that niggling hunger for more.

Having dropped the guise of impartiality and disclosed myself as a Wedde fan, I'm obliged to say what it is in his work—besides the obvious response of 'everything'—that I admire. Primarily, it's his ability to make me think harder. There's a strain of oafish reductivism in New Zealand culture towards which I often incline and against which Wedde stands as a kind of corrective. His subtle, inquisitive intellect gives him an appetite, unusual on these shores, for complexity and complication. Dissatisfied with pat answers, he likes to open up possibilities and investigate options. Yet he's by no means a drily cerebral poet. He can be very funny, making us laugh as well as think. He

frequently greets family and friends in his poems. He gets emotional at times, nostalgic, even a bit sentimental.

He has always resisted tidy categorisation. I recently revisited C.K. Stead's 1979 essay 'From Wystan to Carlos', still a valuable critique of local poetics nearly forty years on. I have no quarrel (does anyone nowadays?) with Stead's contention that New Zealand poets of the baby-boom generation were generally far more excited by the American strain of Modernism than by British models; I agree with him about Wedde's pre-eminence among the boomers and I enjoy the cleverness of his title, which draws on Allen Curnow's first-born child sharing a name with W.H. Auden and, thirty-odd years later, Wedde's first-born child sharing a name with W.C. Williams.

In February 2013, in the course of an interview with Angela Crompton of the *Marlborough Express* (the newspaper for which his father once worked as an accountant), during a return to Blenheim (his birthplace), Wedde said what he had learned from William Carlos Williams was that 'very small, ordinary things in the world in one's life can be as important as huge events, if not more so'. Since the mechanics and dynamics of the workaday world are part of the 'everything' Wedde wants to write about, then Williams, who depended so much on his keenly observed wheelbarrow, is, of course, an exemplar.

Yet I've always felt chary of identifying Wedde as one pole in the binary opposition that Stead's 'From Wystan to Carlos' title suggests. In tone and texture Wedde's poetry—erudite, witty, sociable, fond of formal challenges (I'm thinking not just of the scrupulous syllabic count in 'Sonnets for Carlos' but also the careful alternation of iambic tetrameter and iambic trimeter in 'Katrina's Ballad'), confident in its own linguistic resourcefulness, content at times just to take those resources for a test-drive with no clear end in sight—generally seems closer, to my eye and ear, to Auden than to Williams.

But that's not all. As he recalls in 'The Commonplace Odes', Wedde spent part of his childhood on the banks of the corpse-strewn, cholera-infested Karnaphuli River in the Chittagong region of what was then East Pakistan and is now Bangladesh. In his early twenties he lived for a year in Jordan, translating verses from the great contemporary Palestinian poet Mahmoud Darwish. All his writing life Wedde has been aware of poetic traditions outside the British/American axis and the grasp of most New Zealanders. It's noticeable too that the Modernist whom Wedde salutes in the first poem in the chronologically arranged *Selected* is not an American or British or Kiwi or Arabic poet but a French painter (Matisse).

Influence is a strange and mutable thing. Ian Wedde also spent part of his childhood and adolescence at a boarding school in Bruton, Somerset, which was simultaneously avant-garde enough to have a film club that screened French

new wave and Kurosawa movies, yet old-fashioned enough to insist on Latin as a core subject. Listing poets who have influenced Wedde, I would begin with Horace (tutelary spirit for 'The Commonplace Odes'), then Virgil (boss ghost for 'Georgicon'), then Ovid and Theocritus of Syracuse (who underlie 'The Lifeguard'). But they would just be the beginning.

Wedde opened his 1980 collection *Castaly* with quotes from ten different authors: Captain Joshua Slocum, Gertrude Stein, Sir Walter Raleigh, Bertolt Brecht, A.R. Ammons, Ross McDonald, Ishmael Reed, John Wieners, Jackson Browne and Thomas Pynchon. Americans predominate in that dectet, but they are a quirky bunch. Few readers would have been able to predict all the choices, and Wedde himself would probably have chosen differently at any time other than that particular moment in 1980.

Wedde's masterpiece from the first decade of the twenty-first century, 'A Hymn to Beauty', is a collage of quotes from a dizzying range of sources: everything from Johnny Cash to Sir Joseph Addison, from Emmylou Harris to the Book of Zephaniah, from Ruskin at his most hi-falutin' to Barbara Mandrell being 'almost persuaded' to strip herself of her pride in some southern honkytonk. The poem is subtitled 'Days of a Year', but actually we get only one sixth of a year and are left to imagine the rest. Each stanza contains a birthday greeting to a celebrity who either was once considered an outstanding beauty (Cindy Crawford, Ursula Andress, the Fijian banded iguana), or else is thought to have added to the beauty of the world through art, music or writing (Handel, Renoir, Wilhelm Grimm, Lou Reed et al.). The birthdays run sequentially (with a few wobbles) from 20 February to 17 April, except that the salutation in the first stanza is to 1950s screen star Montgomery Clift, who shares Wedde's own birth-date of 17 October.

If there's a PhD student out there in search of a meaty literary topic, may I suggest a detailed exegesis of all the references in 'A Hymn to Beauty'? Here's a small sample from near the beginning of the poem. A birthday greeting to Auden (who claimed Icelandic descent) segues into a quote from Ruskin's 1846 essay 'Of Vital Beauty in Plants' that refers to 'dead ice' and the seventh verse of Psalm 51: 'Wash me and I will be whiter than snow.' A new stanza then begins with a brief blast from Californian singer-songwriter Beck about a 'beautiful way' to break the heart, followed by these mysterious lines:

> You are resourceful and clever
> but your retrieving skills leave something to
> be desired

Their source, demonstrating that nothing is beneath Wedde's notice, is the 'dog horoscope' section from a 2007 book of cutesy photos called *Little Dogs* that includes an introductory essay by Auckland-born fashion guru Tim Blanks (a contributor to the world's beauty in his

way, as are the diminutive canines). Specifically, Wedde quotes the horoscope for his own star sign, Libra.

Wedde titles his preface to the Selected 'Enjoyment'. Although moods vary not just from poem to poem but from line to line, a key concept running through Wedde's whole oeuvre is that the world, in all its messy variety, is there to be enjoyed.

By way of conclusion, I want to thank him for a lifetime of reading pleasure. Thanks for the diesel trucks, the onion fritters, Matisse's *Still Life With Oysters*, Tony's Tyre Service, the pathway to the sea, the relocation of railway hut 49, the juxtaposition of Rob Muldoon's brooding hypocrisy and Grant Batty's brilliant intercept try in 'Don't Listen', the raw-necked Chittagong vultures that 'stuck their heads up the arses of the carrion', the confusion of 'Car Tune' and 'Khartoum' in 'Shadow Stands Up', the myriad definitions of beauty, the doggy horoscopes. Thanks for everything.

Life Story of a Publisher, Poet, Novelist, Performer

by Jenny Powell

Die Bibel by Michael O'Leary (Steele Roberts, 2016), 304pp, $34.99; **Collected Poems 1981–2016** by Michael O'Leary (HeadworX, 2017), 260pp, $35

History, memoir, autobiography or biblical creation; by the end of chapter one it's a struggle to categorise *Die Bibel*. This parallels the life and times of Dr Michael John O'Leary, Earl of Seacliff and roaming resident of Aotearoa New Zealand. Or perhaps not so roaming now. Having lived mainly at Paekakariki from 1997 onwards, O'Leary seems to have found a permanent earldom; a place to settle and be settled. Publisher, poet, novelist and performer in English and Māori, Michael O'Leary is also a renowned bookshop proprietor. *Die Bibel* is his life history.

The choice of a biblical setting reflects the impact of Catholicism on the writer, and provides the reader with an underlying structural stability. The 'Old' and 'New Testaments' are divided into books, each delving into a decade. The books are further divided by numbered paragraphs, akin to biblical verses. These episodes are often packed with people and purpose, along with acute

observation of places, and personal reflections. The white space between the numbered sections allows a visual pause for the processing of information.

Proverbs I and II provide a break between Testaments. An epilogue, the Book of Acts, and Psalms: Spiritus Mundi conclude the second section. A scattering of images and poems accompanies the Testaments, although the Book of Psalms contains a separate collection of poems, with their context usefully provided in the Testaments. The power of poetry to speak its own intense language is irresistible for O'Leary.

What is missing in O'Leary's introductory section is any discussion of process or accuracy of memory. Were there gaps filled by supposition? Do any of the entries have deliberate fictional elements? Did the writer diarise events as they occurred?

Die Bibel tells of a time when the mix of New Zealand's social and economic cross-currents was on public display. Poverty, such as that of the O'Learys, was obvious. And it was a time when family origins formed a bedrock of identity, but some of the gospels according to O'Leary anecdote began to unwind. The first was the hint of German ancestry, and the second was the assumption of a Māori background. To dismantle core elements of self, while attempting to stand on already shaky ground, must present a substantial challenge.

In addition to satisfying our reality-TV fascination with early goings-on of key literary and artistic figures in New Zealand, *Die Bibel* leads us on an often solitary search for a place to be, both internally and externally. The impact of personal difference, and multiple episodes of childhood suffering, gouge a deep pit of yearning for acceptance by others. O'Leary was born with cerebral palsy and a mild hearing defect, the consequence of which, as he notes early on, 'caused me much misery and has given me something of an inferiority complex'.

His first significant memory is of falling off a train at Tamaki Station in Auckland. Difficulty with balance, and getting ahead of his mother, as little boys do, led to him fall between the steps of the train and the platform. 'The guard had given the whistle for the train to go and I was only saved by my mother's screams for help.'

The consequences were profound— for many years O'Leary had a tremendous fear of trains. Later his fear was, he says, overcome by working for New Zealand Railways. Perhaps it was overcome, or perhaps it was transferred into a preoccupation. Whatever the case, O'Leary allows us to trace strands of his life as they tangle and untangle and find expression in writing, art and music.

Michael O'Leary was born in 1950, before the benefits of cohesive health interventions and mainstream schooling. His family did the best they could, with more than their share of tragedy in the midst of the usual developmental ups and downs.

Bob Dylan, the discovery of art and the

premature removal of his teeth were major adolescent influences. However, they faded into insignificance when, in 1968, both his parents died. This painful phase is faithfully recorded. There is a sense that O'Leary felt that if he were to omit any detail, his own life would become incomplete. The effort to prove he is somebody would be in vain.

O'Leary penetrates the nomadic existence of writers, artists and second-hand book dealers. The flipside of O'Leary's adult coin is his employment at manual labour. His restlessness brings surprises in unexpected quarters and accounts for his wide range of friends and acquaintances.

Die Bibel plays a record of time where notable creative careers have their unique beginnings in the swift 1970s current of artistic individualism. They were the shakers and makers of cultural history who weren't afraid to live their dreams and ideals. David Eggleton met O'Leary during an Auckland production of a satirical/anarchic extravaganza called 'Stomach Cabaret'. They lived in an Auckland cul-de-sac, where 'Bob Dylan's "Desolation Row" played all day and night' and 'became an anthem for the way we lived'. In the same flat was Graham Hennings, a viola player who was the flat's butler (in lieu of paying rent) and who later became a professional musician. Artist Tony Fomison came to stay until he could find somewhere permanent. At times, *Die Bibel* reads like a 'who's who' of many of Aotearoa's aristocratic bohemians.

Dunedin was O'Leary's next port of call, and in 1977 the Captain Cook and Robbie Burns hotels featured prominently, along with the array of artists and academics who gathered there. O'Leary found accommodation in Seacliff, an 'eccentric' coastal village, to which he would return some years later.

He has a talent for recording people and places without off-putting sentimentality, yet with enough detail and respect to be (presumably) historically informative. Managing moral decency while including personal revelations is a difficult balancing act but it is one O'Leary seems to have conquered.

Die Bibel's Testaments are separated by Proverbs I and II. These are a series of quotes that have made an impact on the author, 'Proverbs I' being those from others and 'Proverbs II' from his own writing. Despite the structural element they fulfil, I wasn't sure they were necessary. How much do they add to the book? He might have achieved more impact by placing one proverb on each page, prompting the reader into deeper consideration. Similarly, the 'Book of Acts', a very full curriculum vitae, has been largely covered already in the two Testaments.

Influential places and people never completely disappear. Like the lovers in O'Leary's life they are given their emotional connection in the poems of the Psalms. 'Psalms: Spiritus Mundi' offers a seamless communion with the Testaments. The beat of O'Leary's poet's

heart spins memories into a lyricism that can reach beyond the straight shape of prose, as in 'Elegy for Diana Parsons':

> on the bus coming home
> from Dunedin, the Coast Road
>
> radiant, sullen and dark
> depending on its mood
> like your husband

It is in the poems that lovers lift from the page, their 'soft words / like fingers half-touching' ('Kia Aroha—toru'). O'Leary manages to grasp the unusual essence of memorable moments. In 'He Waiatanui Kia Aroha' he writes: 'then we did kiss / holding our mouths together like beaks / but sweet, ambiguous even / and I shuddered with emotion'. There is the splash of mother's milk: 'your farewell gift to me, / a koha that stayed all day on my tongue' ('In North East Valley').

There is also the splash of that other mother's milk: alcohol. At the forefront of many wild escapades through the years, O'Leary has often used alcohol as a shield from sharp personal reality. In the Testaments, accounts of excess are calmly documented and placed in the context of the rebellious subculture of the times. As decades roll on this becomes habitual consumption and, to his credit, O'Leary includes details of its effects.

A major connection with poet Mark Pirie (managing editor of HeadworX publishers) was cemented in the mid-2000s. Since then the two have worked in tandem, resulting in a prolific output. HeadworX is the publisher of O'Leary's *Collected Poems 1981–2016* in which five sections of poems cover an array of forms, sequences, songs and themes, including most of the poems from *Die Bibel*.

The poet's gaze ranges from devoutly satirical to respectfully serious. In this collection poetry is often a filter for life. It explores darkness and leaves it to rest on the page. Frequently poems are a gift or acknowledgement. What is there to give but words? How else can we grapple with death? That topic is addressed in 'Mortality Sonnet (for Patrick O'Leary)':

> Once again I turn my collar of words
> To the bitter winds of life
>
> Knowing all the while that no matter
> How many words I say or write
>
> Beneath them I stand alone and naked

Words bathe in tenderness and frolic in joy. Poems are easy and literal, or language and focus can tighten, as in 'Otara—Have a Banana' and the southern-based 'Storm Warning'. In the longer 'Station to Station', with its David Bowie influence, O'Leary returns to the topic of trains with their inbuilt order and regularity. Over this he places the window view of a journey from Paekakariki to, eventually, Clarks Junction. Underlying is an echo of the spiritual pilgrimage in Stations of the Cross. 'Appendix' follows on; waiata of forgotten stations and translated meanings: 'Clickety clack, Karakiti karakati'. The train travels in chant to its destination on every second line. In between, history and journey dominate.

Such works are testament to O'Leary's ability to infuse the everyday with sensory wealth and a multi-cultural context. The station poems are a junction that link *Die Bibel* and *Collected Poems* together. They both travel the same highly identifiable lifeline, and are heading towards the next decade's testament.

Beauty Held Between Head and Heart
by Johanna Emeney

The Arrow that Missed by Ted Jenner (Cold Hub Press, 2017), 52 pp, $19.95; **The Ones Who Keep Quiet** by David Howard (Otago University Press, 2017) 96pp, $25

The Arrow that Missed by Ted Jenner is a 51-page collection that mixes the modern and the classical. The book ranges from a 'Sappho triptych' to poems that contemplate windchimes in Meadowbank (47). There is also poetry, prose-poetry, and prose that mixes past and present. In a section called 'Genius loci', for example, the spirits of various places are explored via different media. Jenner is an expert scene-setter, imbuing the landscapes with brief moments of movement that the reader observes for a minute, and is left feeling for a long while afterwards:

> Playing against the southern façade of the
> War Memorial
> Museum in Parnell, the horses at Anzac Cove
> are swishing their
> tails under the olive trees, oblivious to the
> slaughter taking
> place around them. (47)

David Howard's collection is twice the size of Jenner's. It has several long poems in the voices of dead people—the famous and the lesser-known. Robert Louis Stevenson narrates the final hours

of his life in 'The Speak House'. Ian Milner, implicated in the Petrov affair of 1954, 'writes from his sickbed' in 'Prague Casebook' (66). Howard appears to be a poet just as concerned as Jenner with memory and doubt, with reconstruction and preservation.

In both of these collections, then, figures from history, ancient and more recent, populate the poems. The dead are memorialised. The poets are keen to ensure that important events—and the feelings surrounding these events—are preserved in some way. In Jenner's 'A Ceremony of Innocence', occasioned by the Hagley Park Memorial Service of 22 February 2012, there is silence from the natural world, still in mourning, a year after the Christchurch earthquake's devastation:

> ... not even
>
> a cricket chirps for
> the one hundred and eighty-five
> monarch butterflies
>
> released in a
> fading nimbus to ghost
> our lost souls. (49)

Howard, whose collection has been put together over four residencies (2013–16), has mined some wonderful material in order to bring diverse characters back to life. Being in the midst of the characters' contexts seems to have imbued the poems with a credibility and heartiness that writing at a distance could not have produced.

James Williamson, from the first poem in the book, was one of the colonial period's wealthiest property developers. Having founded the New Zealand Insurance Company and the Bank of New Zealand, he became insolvent when one of his other companies failed in 1887, and died suddenly the next year. In 'The Ghost of James Williamson 1814–2014' Howard takes on his persona and tells of his life in shipping, as a publican, speculator, husband, businessman, bankrupt and presiding spirit of his one-time home, the Pah Homestead. Howard's Williamson is full of fabulous aphorisms: 'No one behaves / well if their family curtails / choices' (12); 'Portraits fade from more than the sun. / What we conceal reveals / the most about us' (15).

Another fascinating character is Austrian taxidermist Andreas Reischek, who established collections in the Canterbury and Auckland museums between 1877 and 1889. In the poem 'Because Love is Something Left' Howard explores ideas of loss, love and time. Particularly admirable is the section called 'II apostrophe', in which a taxidermist's work to make something dead or extinct emulate a lifelike state is described, its interplay of light and shade, life and death quite astonishing:

> ... When the museum
> backlights our divine evolving
> then a child's eyes widen
> sizing up the swamp hen
> under the moa's shadow. String
> and scissors deliver God's kingdom
>
> for one Sunday afternoon. (79)

In many ways this is what Howard and Jenner both do in their collections. On

the page, here are characters, dead or mythical, for us to enjoy in their speech and performance. As Howard says later in 'II apostrophe', still addressing Reischeck, as the title suggests:

> ... You show
> love is what taxidermy sews
>
> shut, the guts of the matter removed
> so beauty is lasting, it's held
> between the head and heart
> by memory, the part
> you lose through age ... (79)

Howard's use of sound to stitch his words over lines, over stanza-gaps, is glorious. His ability to give us the unadorned 'guts' and then those prettier parts— 'head', 'heart'—in the same poem, making an elegy, a love song, for the taxidermist, is remarkable.

The concentration upon capturing the ephemeral and holding it tenderly on the page for the reader to appreciate is also very clear in 'A Black Butterfly in a Tongan Café' by Jenner. The five-line poem is positioned almost in the centre of the page, but slightly higher. The poem reads, in full:

> A strip of burnt paper
> folded against the ceiling
> the powder of your wing
> is still on my napkin
> this shadow of your soul (37)

There is no punctuation, nothing holding the poem—or its butterfly— down on the page. There is a haiku-like quality to the concertinas of image in this poem. The light touch of the poet as he observes the butterfly (which may have rested on his lap, or on his table-setting),

on the ceiling, the scales from the delicate wings left on his napkin, is so deft, so graceful, it is in itself no more than the shadow of something otherworldly.

Jenner uses this shadowy effect again in a poem that features 'a bronze Zeus' and 'Patission St', 'early on Sunday morning', suggesting that it is perhaps set in the National Archaeological Museum, which houses the famous Artemesion Bronze. The poem is written in a shape resembling an extended muscular arm (the typesetting has been arranged carefully to this end), and it is one scene-setting sentence:

> *The Shadow of the Lord Zeus' Arm*
>
> early on
> Sunday morning
> when only
> the cafés
> and the pastry shops
> are open
> the shadow
> of the bronze
> outstretched
> arm of the
> Lord Zeus
> reaches even
> Patission St.
> where a
> little old
> woman
> in black
> shuffles
> sweeping
> up leaves
> in the hollow
> of his armpit (29)

It is up to us to decide whether Zeus is protector or unkind god. It is autumn; the woman is dressed in black; she is old

and shuffling. The statue has no thunderbolt to send down; just an extended arm that overshadows the woman. The shadow, though, complemented by all of the darkness in the poem, is troubling. I cannot help but feel that even if he is a bronze god who no longer bears weapons, he is still a god who has made many widows, and whose long shadow is still felt more in fear than in solace. Does Jenner suggest that we are always in the shadow of a greater power, and always sweeping away the traces of decay and death just as a new curse is coming for us, or does he simply imply the immemorial reach of an ancient figure, casting shadows after millennia?

Certainly, Jenner is a poet who has great tenderness and admiration for his classical subjects. Take Jenner's Sappho, so poignant in her use of a pun to downplay what is a desperate wish for a deserved permanence:

Do not give me
a mask of clay
which loses face.
Someone in some
future time will
remember me. ('Sappho Triptych', 14)

It is easy therefore to read his Zeus poem as a paean to the father of the gods, great figure from classical mythology, enduring in his ability to pull crowds to galleries and museums, his power to inspire students of literature and art, and to move writers and artists, still.

These collections are a pleasure to read in tandem. The poets' efforts to memorialise and to (re)animate are extraordinary. Both Jenner and Howard are poets of the ear as well as the eye. Their writing is musical and layered, enjoyable on the first and fifth reading. I cannot decide which book I esteem more. They are both very satisfying, offering crafted, thoughtful pieces that enlarge the reader's knowledge of history and of contemporary poetic practice.

A Special Kind of Sickness

by Denis Harold

The New Animals by Pip Adams (Victoria University Press, 2017), 223pp, $30

The New Animals is a novel with an ambitious structure that dominates the characters. Several major themes animate the text: the fashion industry in present-day Auckland, the significance of digital technology in communication, growing socioeconomic malaise and the pollution of the environment. It's a book you can argue with, that you can sometimes feel like tossing across the room, but you read on because the author is a persistently crafty explorer, mapping—athough sometimes only sketching—a recognisable world.

There are no chapters, only a flow of text interrupted by single line breaks, a presentation that belies the fact that the novel divides into two parts. The first two-thirds of the book is written in a kind of literary cubism, a style of multiple points of view that does not privilege one perspective, similar to the multi-faceted build-up of a cubist painting. Gertrude Stein in some of her works, John Berger in his novel *G*, and a few more recent writers have worked in a similar mode.

The alternating points of view of the characters result in a picture of a complex social landscape. There is an occasional feminist subtext that skewers male posturing. Adams shows a lot of skill in crafting dialogue and action so that the shifts in perspective are lucid. The accretion of details forms a network, a web, not unlike the digital media that mediate the characters' lives. Sometimes they loathe their devices and apps:

> It was automatic, [Carla] was looking at it before she knew she'd opened the application, she used it like she used cigarettes—to numb something with a feeling of nausea.

> [Sharona] flicked back to Twitter. It gave her a special kind of sickness. It felt like watching too much porn.

> It was like [Tommy's] phone was keeping him fooled. He had been thinking about getting rid of it, for good.'

The main plot of the first section of the book is the characters' preparation for a photoshoot of their next collection of male corporate wear. The three owners/designers, Tommy, Cal and Kurt, are in their mid-twenties. Their parents are rich. They are contrasted with their hired help, three women in their mid-forties, Carla, Sharona and Duey. Elodie, at twenty the youngest main character, acts as an intermediary between the middle-aged female trio who are of 'Generation X: tired, cynical and sick of being used', according to the novel's back-cover blurb, and Tommy, Cal and Kurt who are, as the blurb describes them, 'millennials'.

In preparation for the photoshoot, Tommy shows the team risqué

photographs of women in various stages of nudity and bondage. Some of the women 'had babies' heads'. Tommy had assumed this was why the title had 'tot' in it, then he found out it meant 'dead' in German. Kurt asks Clara, the hairdresser, to cut the models' hair very short, though he thinks to himself that he 'didn't want them to actually look like the victims of genocide. He wanted them to have style.'

Brutal details like this depict, and occasionally satirise, the fashionistas, but there are also more gentle descriptions of the inner workings of hairdressing salons and dressmaking studios. Sometimes these descriptions read as supplements rather than integral. One shocking intervention is the dog Doug, which Clara begrudgingly looks after because no one else wants to. The relationship between Clara and Doug, who is actually female, is terrifying. Clara locks Doug up in her apartment, which the dog gradually tears apart.

The New Animals is intermittently a social comedy:

> Tommy's mother Rachel felt proud. She said that a lot. A creative in the family was something to be nurtured. Not everyone had one ... Tommy knew that in her heart his mother hoped he was still queer.

Illustrative of Adam's patient build-up of detail, almost fifty pages intervene before a related facet is added to this comic portrait: 'It had been a hard time for her, a mother saying goodbye to her rainbow parent status. She was still on the Trust, though.'

Before the novel gets to the photoshoot it veers in another direction. The style changes, becomes more metaphorical, arguably less digital and more analogue. All the characters except Elodie are left dangling in their often angry and frustrated states. The multiple points of view have created a glittering picture but there is no sense of a core. Even if the author wanted to render three-dimensional characters, the style of narration undermines that possibility.

The shallow pomposity of the Tommy character, his dependency on digital media, his fear of 'depths', is conveyed during his ride on a ferry:

> He'd lived by the beach his whole life and never liked the sea, being in it, under it, with all that was on top of him, the pressure, the water, the fish. He liked the ferry.

This foreshadows the second part of the novel when Elodie, a 'manic pixie dream girl' who 'didn't have any social media accounts ... she preferred meeting people in real life', breaks out into another dimension and becomes, perhaps, The New Animal.

Elodie is the only character whom all the other characters regard as genuinely nice. She has a sexual relationship with three of them, Tommy, Kurt—and Carla, who 'felt like a predatory old lesbian. She never used that word about herself. Never.' Clara the hairdresser has more gravitas than any of the other characters. She had left her Auckland milieu for a ten-year period. It is not clear what happened, though it seems to have begun with her swimming out into the ocean in what may have been a failed

suicide attempt. Anyways, she thereby made some discoveries: 'As soon as [Elodie] met Carla she knew she had the way, locked up inside.' One important discovery Clara has made is that '[a]ll of them thought they had free will, that they were really walking for themselves, stepping out, but Carla knew. Everyone was just responding to stimulus.'

The new direction begins with Elodie freeing Doug from Carla's flat and heading for the 'ocean and the island'. She 'imagined Carla had left from a beach, the sand in her feet, letting herself leave the ground gradually'. Elodie goes through a number of cycles of swimming then submerging, of thinking then feeling, of sinking into a kind of phantasmagoria: 'She wanted to be away from her mind. She wanted to be in her body.'

Elodie begins to ruminate in a tone reminiscent of Carla: 'The body is stronger than the mind. The mind is a result of the machinery of the brain. The by-product of it running. The extra energy.' A dualism of mind and body, and attempts to resolve this, recur throughout Elodie's watery adventure.

Though there are passages of visceral acuity detailing bodily, and perhaps mental, dissolution, the text often tends towards the mystical/mystifying. For Elodie, the

> mind was her friend ... There was an animal deep inside her, growing at the same time as the animal Elodie dragged around her terrestrial life ... Her body knew what to do, it held on to what it needed for centuries—hundreds of millions of years.

Nevertheless, Elodie's musing is sometimes a bit scientific: 'She didn't believe in anything but fate and natural selection.'

She gets on and off a boat, finds a wetsuit and puts it on, sees corpses floating about, comes into close contact with an octopus. Her body begins to break down:

> She relied less and less on her eyes. There was really no need for them. Her face, so ruined now by all the elements, felt everything ... Confusion. Confusion was going to get her.

Now and then she surfaces into seeming rationality: 'She'd been crazy to get in the water. Maybe she did want to die?'

Elodie makes for the island Clara had seen but it turns out to be an island of plastic rubbish. She thinks she can settle on it but it is 'nothing solid. Nothing enough to stand on. There was no island ... There was nowhere to stand. It was a mess. This was her new home.'

Adams says in her Acknowledgements that Janet Frame's *Intensive Care* 'became very important to me as I wrote', and that Frame's *A State of Siege* 'helped me to write the last part of the book'. The satiric parable of the Human Delineation Act in the last section of *Intensive Care* likely influenced Adam in her ecological parable, which attempts a redefinition of human/animal. (Maybe there is also an echo of Frame's 'Is-land' in Adam's 'island'?) A contrast between the two authors is that the texture of Frame's writing is deeply imbued with poetry,

whereas Adams' writing, particularly in the first section, is an agile prose served up in sharp, often short, sentences that abut and overlap in an exploratory structure. Adams' second section's more poetic style is sometimes effective but is at other times repetitive and nebulous. One convincing comparison, though, with Frame, who considered her long fictions as explorations rather than novels, is that *The New Animals* is an intriguing exploration.

Twenty-Somethings with Old Souls

by Charlotte Graham

The Suicide Club by Sarah Quigley (Penguin Random House, 2017), 416pp, $38

At the beginning of this novel a promising writer stands on a ledge, surrounded by ghosts from his past. A beautiful woman runs out of an older man's bedroom after sex, and sees a body fall past the window. And a genius inventor, beleaguered by a co-dependent life with his unpleasant parents, parks his newspaper cart in the street at night, only to have the promising writer land on it when he leaps—or is pushed—from the top of a building.

And so three desperately sad people in an anonymous English city collide, their stories now connected as they try to work out how to live in a world that seems too painful for any of them to tolerate. It takes the trio to a kind of mental health camp in an old house in Bavaria, where they attempt to address the tragedies that have brought them to this point.

Sarah Quigley's novel is an ambitious premise, and patchy in its delivery. The first problem comes when you know that the names of the three main characters are Bright, Gibby and Lace. One character with an unbearably quirky name is believable, but naming all three in this vein establishes the challenge at

the heart of Quigley's book, to do with how untruthful the emotional arc of the story seems. A constant nagging question that disrupted my reading experience was whether, in this novel, truthfulness is supposed to matter.

Look almost anywhere in film, young adult fiction and the news media at present and you will see there is much ado about suicide. The treatment of the emotional and psychic pain befalling—usually—the young is trendy and highly contested terrain. Some have argued that recent films like *To the Bone* and *Feed*, and the TV series *Thirteen Reasons Why*, tackle mental health in almost the same way every time. If the brutal reality of mental illness is that it is everywhere, the brutal reality of mental illness within popular culture is that it largely afflicts the beautiful, talented, white, and youthful. Quigley's novel, for all its ambition and energy, falls into the same pattern: bright young things whose suicidal inclinations are a tragedy because of how promising they are, rather than for any other reason. It is an easy, but lazy, way of framing mental illness in a socially palatable way.

The three main players in *The Suicide Club* are all old souls, but they are nominally twenty years old. Yet there is almost nothing in their characterisation to make them feel that young. Bright has already written a bestselling novel; Lace has had any number of affairs with much older men; and Gibby has invented numerous gadgets. They think, speak and act like people in their mid-thirties, and I wondered why the writer had decided to make them twenty at all.

It's hard to avoid the conclusion that by drawing them at age twenty, Quigley is attempting to heighten the sense of pathos because of their youth. It is an uncomfortable idea on which the book rests: that only the pain of extraordinary people could possibly be interesting. Lace is a show-stopping, radiant beauty. Her blondeness and thinness are described many times and, despite the thinness coming courtesy of an untreated long-term mental health issue, every man she meets falls in love with her. She is so funny she's literally a stand-up comedian—and she's only twenty! It feels as though Quigley thinks she needs to be young to ensure the reader regards Lace's pain—which is genuine and understandable—as tragic. It's the same with Bright, the erudite and witty bestselling novelist. Even Gibby the inventor—who is not described as attractive—is already semi-famous.

Gibby is by far the most interesting of the three, and it is no coincidence that he is the most robust figure with the most ordinary story. When the reasons for his trauma are exposed, the quietness of his suicidality revealed, Quigley's writing is painfully vulnerable. It is frustrating to have these lovely glimpses in an otherwise uneven book: Gibby's story at times so beautifully, realistically rendered; a truly hilarious fight scene in a kitchen that showcases the best of the book's flip and absurdist tendencies. A novel written in the vein of either of those styles might have worked, as would a

story that knitted the two together in a way that inspired more trust in the reader that the novelist was in control of her narrative.

The one standout trait of the book, allowing some sentences to linger and repeat long after I finished reading, is the lyrical quality of Quigley's descriptive prose. She can write a sunset, a room, a city, in terms that perfectly illustrate and satisfy.

But the lure of an artistic, romantic view of suicide seems, at times, too strong for the author to resist. That means the book is somehow more enjoyable if read as Gothic, where you try to detach what would be the pressing real-world concerns of these characters, and see them as floating in a surreal, slightly overblown world where two-dimensional characters can be a cipher for something allegorical.

Equally often, though, Quigley inserts real-world elements into the plot, or suddenly writes about a panic attack or a suicide attempt in a clear-eyed, utterly down-to-earth fashion. It leaves the reader wondering whether the book is meant as a surreal portrait of two-dimensional characters—the suicidal impulses a beautiful, literary conceit—or the grittily realistic stories of three extraordinarily damaged young people in extraordinary pain. The book's two sides bump uncomfortably together, each contradicting the other's narrative.

Of course it is acceptable for a story to be complicated, but some of the more artistic refrains about suicide would seem egregiously offensive in a realistic book, and the main characters are not rounded enough for the realistic parts to land. Quigley seems to want to have it both ways, and so sometimes characters are shaken and traumatised by the thought of suicide, and at another point a character rushing in to save another from self-inflicted death pauses to acknowledge how beautiful and tranquil she looks. It's disconcerting, and perhaps it was supposed to be, but it creates whiplash in the reading experience that can make finishing the book a difficult task.

I don't believe creators have an obligation to treat an issue realistically or seriously, and Quigley does not have to give a public service announcement about suicide here. It's an adult book. The problem I have with her treatment of mental health speaks to the credibility and trustworthiness of the story on an emotional level. The swings between flip and serious when it comes to mental illness do not seem intentional. Instead, they give the impression that Quigley doesn't have a firm hand on what she is saying about suicide, trauma, or the young people who suffer it. Given it is a fairly long novel this does get exhausting, and that is compounded in the first few chapters by a narrative style of addressing the reader directly.

'Does it strike you as odd, the rises and falls that have occurred in just a few pages?' Quigley writes. Fortunately, she stops using the technique about a third of the way through the book—

notwithstanding a baffling chapter where two of the main characters are written about in a mysterious tone, without names, even though we know from the preceding chapters exactly who they are—because the selfconscious asides to the reader make for a cumbersome reading experience.

Towards the book's end, when a suicide does take place, the characters are swarmed by buzzing journalists in a series of scenes that illustrate the misfire at the centre of the book. For days the journalists chase the story of a suicidal young person; one reporter even wonders if the story will make their career. I have covered crime and tragedy as a reporter and I know that coverage of suicide merits nothing of this kind of excited frenzy; in fact a possible murder that the police have rendered a suicide is enough to send all the journalists home. That is only partly due to New Zealand's stringent suicide reporting guidelines; it's also because suicide is utterly, tragically common and there is nothing romantic about it.

Quigley's journalists pursue the story of a twenty-year-old's suicide as though it were a rare and exotic act. In the real world, statistics show us it is anything but. Quigley's desire to dig into the feelings and meaning at the heart of a suicide is admirable but ultimately misguided. She is looking to depict something grand and meaningful in an act that is usually neither.

A Brutal and Disturbing History
by Katie Pickles

The Great War for New Zealand: Waikato 1800–2000 by Vincent O'Malley (Bridget Williams Books, 2016), 690pp, $79.99

The 1865 words of Wiremu Tamihana, key player in the founding of the Māori King movement, provide the touchpoint for historian Vincent O'Malley's latest book on the origins and aftermath of the 1863–64 war in the Waikato. Tamihana prophesied that:

> No te taenga ki te kohuru Rangiaohia, katahi au ka mohio he tino pakanga nui tenei, no Niu Tireni. When it came to the (time of the) murder at Rangiaohia, then I knew, for the first time, that this was a great war for New Zealand.

It is timely to propose that the Waikato war was more significant than Gallipoli or the Western Front as the key conflict in New Zealand's history. Amid the current rush of scholarship on the widely considered 'real' Great War, World War I, O'Malley complexifies the place of that war from a New Zealand-centred perspective.

He argues that the terrible loss of life for New Zealand during World War I 'may have been eclipsed by the casualty rate suffered by Waikato Māori in 1863 and 1864' (370). He also points to the confiscation of large tracts of land and massive socioeconomic impacts,

including the loss of flourishing tribal economies. More generally, O'Malley argues that the war shaped the future of the nation in ways both obvious and subtle: there was large debt from the war, and Māori and Pākehā race relations were set back for generations. After the war, colonial policies of assimilation got into full swing, as evidenced through the introduction of the 1865 Native Land Court and the 1867 native school system. The war also secured Auckland's future and growth in the Pākehā settlement of the North Island.

This is brutal and disturbing history. The sometime myth of New Zealand having 'the best race relations in the world' is disrupted through these pages. Taken generally, the death, dispossession and loss of culture as a result of war are similar to those experienced in invasions and colonisations elsewhere around the world at the same time. O'Malley has a comprehensive historical understanding and writes with deep authority, drawing comparisons with elsewhere. He indicates transnational connections, such as the application to New Zealand of policies tried by the British in Ireland (367). O'Malley is thoroughly versed in the historiography: James Cowan's 1922 narrative of the war, Alan Ward's 1974 *A Show of Justice*, James Belich's 1986 revision of the New Zealand Wars work, and Chris Maclean and Jock Phillips's work on memorialisation are just a few of the many sources drawn upon. The primary and secondary bibliographies are truly impressive.

With the primary research for the book having its origins in two reports written for the Waitangi Tribunal's Te Rohe Pōtae inquiry in 2010 (based on research that began in 2006), this is an excellent example of thoroughly researched treaty history made accessible for a general audience. The depth of understanding is immense and masterful. The book does not claim to be a military history, but it does provide much detail on specific battles. O'Malley is centrally concerned with the impacts on people, and writes what might broadly be construed as socio-political history. Is a conventional source-driven narrative, rather than a work from oral history or alternative sources.

The first two chapters set out and justify O'Malley's 'Great War for New Zealand' thesis. They are aptly and provocatively titled 'Owning Our History' and 'Remembering (and Forgetting) the Waikato War'. There is mention of popular retellings of the war, as in Rudall Hayward's 1925 silent movie, remade in 1940, *Rewi's Last Stand*, on the battle of Ōrākau.

The rest of the book is divided into four parts. Starting in 1800, part one concerns the pre-Waikato war context. It examines the fluid and contested tribal affiliation in the Waikato region. A 'flourishing economy' and 'close and symbiotic relationship with the settlement of Auckland' are foregrounded (59). The 1852 Constitution Act is introduced, as is the emergence of the King movement, and the 1860–01 war in the Taranaki.

Part two details the Waikato war itself. It

covers the invasion, the battle for Rangiriri, including confusion over the meaning of a white flag. Cultural collision and misunderstanding, a theme in O'Malley's previous work, continues within these pages. He foreshadows future grievances in examining key figures and their beliefs on both sides. The occupation of Ngāruawāhia and the battles of Rangiaowhia, Hairini and Ōrākau are outlined and critiqued.

Part three concerns the aftermath of conflict. It is a story of enduring unease, confiscation and eventual compensation. O'Malley examines military newcomers and their settlements whose presence required protection, with some anxious to leave the region. He details and analyses settler legal processes such as the Compensation Court. King Tawhiao features. The tone is mournful and contemplative.

Part four concerns the long search for justice. It covers Māori engagement with the legal system and the complex and ongoing protests, petitions, appeals, legal challenges and deputations, political negotiations and movement towards a settlement. Deputations to Queen Victoria and Parihaka fall within the scope of the section, as O'Malley paints a grim picture of race relations by the end of the nineteenth century. The twentieth century emerges as a long battle against inadequate commissions and settlements, until the 1995 Raupatu settlement.

Particularly impressive is the way O'Malley locates specific details within complex contexts. He has succeeded in writing a work that will be useful for both the introductory and advanced/specialised reader, which is no mean feat. He also manages to write in a sensitive tone, and to avoid sensationalising. He subtly highlights what he considers to be major themes, such as confident and flourishing cultural contact in the Waikato world, and manages to move beyond notions of fatal impact to convey complexity.

The text is clear and the chapters flow, with succinct introductions. The book is enhanced by many high-quality images including maps, diagrams, photographs and artefacts. These work in harmony with the text and contribute to a magisterial work that draws the reader in and through the impressive 688 pages.

In an age of defining moments and a search for turning points, the thesis of the 'Great War for New Zealand' invites scepticism and will hopefully encourage informed debate. This book operates beyond the level of key moments to demonstrate definitively that the Waikato war was of enormous and enduring significance.

Akin to the scholarship on World War I, it evokes tragedy and an ongoing legacy of loss, retelling the shocking and disturbing realities of colonisation as a strong antidote to celebratory nationalism. This is accessible and compelling history that is rich in research and interpretation.

Overall, it is a beautifully produced, important, thought-provoking and soul-searching book that deserves a wide readership.

Clergyman, Politician, Magistrate, Farmer, Missionary

by Edmund Bohan

The World, the Flesh and the Devil: The life and opinions of Samuel Marsden in England and the Antipodes 1765–1838 by Andrew Sharp (Auckland University Press, 2016), 948pp, $75

Samuel Marsden, the most resolute and formidable of West Riding Yorkshiremen, was lauded by New Zealand's nineteenth- and early twentieth-century historians as one of our nation's most cherished founders. In stark contrast, however, perhaps the majority of Australia's historians— including even his descendant the great Manning Clark—and all those who have elevated Governor Lachlan Macquarie to the status of enlightened national hero, have condemned Marsden as the intolerant 'flogging parson' of early New South Wales, and Macquarie's mortal enemy.

Perhaps few in our history have suffered such swings of reputational fortune. Marsden's admiring English contemporary, William Woolls, compared him to Martin Luther; the later admiring generation of popular evangelical writers such as J.R. Elder, the prolific Reed uncle and nephew (whom

Sharp surprisingly and wrongly describes as brothers) saw him uncritically as an apostle of civilisation and a pioneer of empire. So did the influential William Pember Reeves.

Then the tide turned, with writers like Robert Hughes and a generation of novelists; while our postwar historians— from Sir Keith Sinclair to Dame Judith Binney, James Belich and Michael King— have been cool when not simply dismissive. For them Marsden had, indeed, become an equivocal minor character in our national story and of lesser significance than Thomas Kendall, whom Marsden condemned so bitterly. Many of those determined to recast our national history solely in terms of their own currently fashionable beliefs and ideas might even question why a scholar of Andrew Sharp's reputation has taken the trouble to produce such a monumental volume of sustained and meticulous scholarship—and take a decade in doing so.

Yet, whatever our preconceived opinions might be, Marsden the man is surely overdue for impartial and wide-ranging reassessment. When one considers the sheer scope for detailed study that Marsden's long life provides, the author's reasons for embarking on the task become much clearer, and justifiable when one compiles even a bare list of what is relevant for a comprehensive biography: evangelical Anglicanism; the founding, politics and social structure of New South Wales; the development of its farming, and

especially its wool industry; Christian missions to the Pacific Islands; the first New Zealand missions and the founding of European settlement in the Bay of Islands and Northland; the philosophic bases of England's late eighteenth-century and early nineteenth-century society, and the place of the Anglican clergy within its hierarchical structure.

In every respect Andrew Sharp is the ideal scholar to deal with this multi-faceted life. He is the University of Auckland's Emeritus Professor of Political Studies and among New Zealand's most distinguished scholars: a historian of ideas, renowned especially for his work on the political ideas of the seventeenth-century English Civil War. Among his other books are *Justice and the Māori: The philosophy and practice of Māori claims in New Zealand since the 1970s* (Oxford University Press, 1990 and 1997); and (as editor with Paul McHugh) the excellent *Histories, Power and Loss: Uses of the past—A New Zealand commentary* (Bridget Williams Books, 2001).

This book is basically organised topically, though with an over-arching chronology, and its introduction provides a quite superb overview of Marsden's life, as Sharp emphasises that his aim is to write as a historian rather than as a moralist or philosopher who passes judgement. In his own words:

> But even if Marsden is to be judged, to be praised and condemned, and used to embellish a moral other than thoughtlessly, he must first be understood in his own terms. Imperfection in acting according to professed ideals is to be expected in any human being,

and so it is worth asking, in the first place, what his ideals were, and then, secondly, why his imperfections as well as his achievements have seemed to matter so much from so many points of view; and have been described so differently.

There follows the first section, 'Freight from England 1765–93'. Its opening chapter, 'A West Riding man's place in the social and economic world of England', is followed by chapters entitled 'The gospel c. 1780–93' and 'The callings, duties, trials and mission of an evangelical minister c. 1780–93', before Marsden and his young wife Elizabeth are dispatched to Botany Bay. The very detailed chapters on Anglican evangelical thought and opinions are crucial in understanding Marsden's lifelong and unshakeable convictions about the absolute truth of the Bible, the salvation of the Elect, his abhorrence of Roman Catholicism, his belief in the existence of evil as proof that the Devil is forever abroad, and the fundamental wickedness of fallen mankind. Accompanying those theological opinions went the political and social dogma that authority in a stratified society must be obeyed because it was ordained by God. It is absolutely essential to know all this, but these chapters are, I fear, where the book's problems begin.

In an admirable and remarkably frank radio interview with the ever-astute and probing Kim Hill, Andrew Sharp admitted that this section is probably too hard for most general readers. It is. It is so packed with often repetitive quotations that many readers,

unfortunately, are likely to be deterred from reading any further. That is a great pity. The author also made the point that it would be difficult to read this book in the usual linear fashion from beginning to end. Rather, he suggested, it is a book to consult, or dip into selectively. I would agree whole-heartedly. As a source book for all the many facets of Marsden's life and work that are of real interest and significance it is, in fact, superb.

The section 'A Rising Man in New South Wales 1794–1807' consists of eight chapters that examine Marsden's role and status as an Anglican clergyman; the beginnings of his missionary ambitions in the Pacific; the nature of the chaotic convict, emancipist and free sections of a society dominated and administered by the military; his position as a magistrate; and his pioneering efforts as a farmer. The short section 'At Work in England 1807–1809' traces his efforts as a temporary expatriate to achieve some measure of colonial social reform, along with his campaign to promote further missionary work in the Pacific.

There follows a long fourth section entitled 'Tribulations and Triumphs in the Antipodes, 1810–c. 1828', which, through another nine chapters, delves (amid so much else) into the tortuous progress of his long and increasingly bitter ideological warfare with Governor Macquarie. That lasted for over sixteen years and ended only with Macquarie's death. Sharp describes it as a 'fight to the reputational death' generated by the prevalent contemporary concept of

amour-propre, on which he discourses interestingly at some length. This might also be described as a matter of status or gentlemanly honour that drove men in that period (especially military men) to fight duels. Their personal struggle reached its climax—or rather nadir—in the notorious Philo Free libel case, which Marsden eventually won after having been libelled by Sydney's *Gazette*.

This major section also deals with Marsden's continuing part in the missions to the Society Islands and, especially, his ambitions for the fundamentally weak New Zealand mission in the Bay of Islands, There, the growing dissensions among his chosen missionary families were exacerbated by the problems of musket trading and the rising military power of Ngā Puhi war leaders such as Hongi Hika, once Marsden's protégé.

The titles of the five chapters in the last section, 'Towards a More Peaceful End, Until 1838', are self-explanatory: 'The routines of colonial life, c. 1821–30'; 'Civilisation and the Prince of Darkness: New Zealanders, their civilisation and evangelisation, 1814–30'; 'Law, government, settlement and empire in New Zealand, 1814–38'; 'Final years, c. 1830–38'; 'The last judgement'. There follows, finally, 'Appendix: Marsden's character in the hands of others, 1838–2014'. This latter, like the introduction, is admirable: a concise, considered and perceptive summation of two centuries of spectacularly changing opinion.

Andrew Sharp certainly goes some way to restore something of Marsden's diminished reputation, but as he does so at such very great length it is unfortunately likely that many potential readers may not have the patience or intellectual stamina to fully appreciate the author's achievement. This inevitably, I think, must provoke some debate about the need for publishers to exercise editorial influence over even the most eminent academic author.

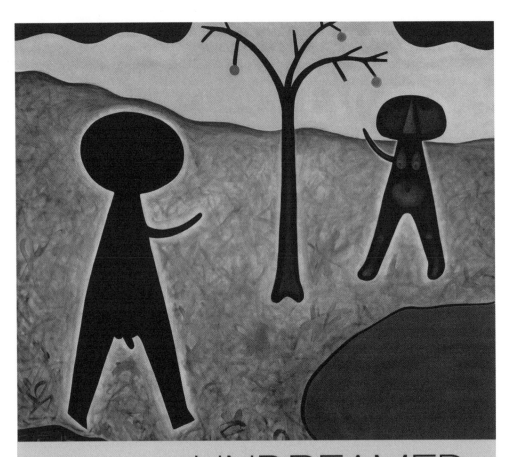

UNDREAMED OF...50 YEARS
OF THE FRANCES HODGKINS FELLOWSHIP
Priscilla Pitts and Andrea Hotere

A new book from Otago University Press celebrates 50 years of the Frances Hodgkins Fellowship

The University of Otago is proud of its five arts fellowships: the Frances Hodgkins Fellowship, the Robert Burns Fellowship, the Mozart Fellowship, the Caroline Plummer Fellowship in Community Dance and the Creative NZ University of Otago College of Education Children's Writer in Residence.

future Landfall editor swots up

NEW BOOKS FROM
OTAGO

UNDREAMED OF ... 50 YEARS OF THE FRANCES HODGKINS FELLOWSHIP

PRISCILLA PITTS & ANDREA HOTERE

This sumptuous, full colour book brings together the art and the stories of half a century of Frances Hodgkins fellows. The result is a vibrant celebration of talent fostered through New Zealand's foremost visual arts residency, showing how the artistic wealth created has flowed back into the culture of the small country that nurtured it.

ISBN 978-0-947522-56-8, hardback, $59.95

CASTING OFF: A MEMOIR

ELSPETH SANDYS

In the second volume of her memoirs, Elspeth Sandys' refreshing honesty and her skill as a writer of fiction and drama propel the reader through an absorbing life story that is equally a commentary on the meaning of memoir and the peculiarities of memory.

ISBN 978-0-947522-55-1, paperback, $35

PHONEY WARS: NEW ZEALAND SOCIETY IN THE SECOND WORLD WAR

STEVAN ELDRED-GRIGG WITH HUGH ELDRED-GRIGG

Phoney Wars looks at the lives of New Zealanders during the greatest armed struggle the world has ever seen. Lively and controversial, it is not a political, economic or military history; rather it explores in fascinating detail what life was like during the war years for ordinary people living under the New Zealand flag.

ISBN 978-0-947522-23-0, paperback, $49.95

THE FACE OF NATURE: AN ENVIRONMENTAL HISTORY OF THE OTAGO PENINSULA

JONATHAN WEST

Lavishly illustrated and wonderfully readable, The Face of Nature explores what people and place made of one another, from the arrival of the first Polynesians until the end of the nineteenth century in the remarkable and unique environment of the Otago Peninsula.

ISBN 978-1-927322-38-3, paperback, $49.95

Otago University Press
From good booksellers or www.otago.ac.nz/press/

CONTRIBUTORS

Ruth Arnison is the afternoon administrator at Knox College, a residential college affiliated to the University of Otago. She is the editor of *Poems in the Waiting Room* (NZ).

Alie Benge is a writer and copy-editor living in Wellington. Her work has been published in *Headland* and *Geometry*. She is working on a novel about her childhood in Ethiopia.

Marianne Bevan is a Wellington-based researcher. Her work has focused on women, security and justice in a range of countries including Timor-Leste, Togo, Ghana, Liberia and Aotearoa New Zealand.

Tony Beyer has recent or forthcoming work in *Hamilton Stone Review*, *Otoliths*, *Poetry NZ* and *Poetry Pacific*. His new collection, *Anchor Stone*, will be published this year by Cold Hub Press.

Edmund Bohan is a Christchurch historian, biographer and historical novelist. His latest historical mystery novel in the Inspector O'Rorke series, *A Suitable Time for Vengeance*, is due for publication in October.

Owen Bullock is a New Zealand poet who has been resident in Australia while completing a PhD in creative writing at the University of Canberra. His exegesis discusses the poetry of Alistair Paterson, Alan Loney and Michele Leggott, and his creative project, *Semi*, was recently published by Puncher & Wattmann. A second collection, *Work & Play* (Recent Work Press), is forthcoming.

Kate Camp is the author of six volumes of poetry from Victoria University Press, most recently *The Internet of Things* (2017). This essay was written during her time as the Katherine Mansfield Menton Fellow in 2017.

Medb Charleton lives and writes between Ireland and New Zealand. Her poems have appeared in *Sport*, *JAAM*, *Poetry NZ*, *Landfall* and online.

H.E. Crampton is from Nelson and studied chemical engineering and classics at the University of Canterbury. 'The Boatman', a thesis for an MA at the IIML at Victoria University in 2015, was shortlisted in the manuscript category of the Queensland Literary Awards. She lives in Cairns and Golden Bay.

Majella Cullinane is a PhD candidate in creative practice at the Centre for Irish and Scottish Studies at Otago University. In 2011 she published her first poetry collection, *Guarding the Flame*, with Salmon Poetry, Ireland. In 2014 she was awarded the Robert Burns Fellowship. Her second poetry collection will be published by Salmon Poetry and Otago University Press in 2018.

John Dennison's first collection of poems, *Otherwise* (Carcanet/AUP 2015), was long-listed for the 2016 New Zealand Book Awards, and short-listed for the 2016 Seamus Heaney Centre for Poetry First Collection Poetry Prize. Dennison is

also the author of *Seamus Heaney and the Adequacy of Poetry* (Oxford, 2015), and is the recipient of the 2016 CNZ Louis Johnson New Writer's Bursary.

Doc Drumheller was born in Charleston, South Carolina, and has lived in New Zealand for more than half his life. He has published ten collections of poetry, his poems have been translated into more than twenty languages, and he has performed in many countries. He lives in Oxford, where he edits and publishes the literary journal *Catalyst*.

Breton Dukes is working on his third collection of short stories. His previous two were published by VUP. He lives in Dunedin with his wife and two sons.

Lynley Edmeades recently completed her PhD at the University of Otago. Her thesis looked at sound in avant-garde poetics. Her first book of poetry, *As the Verb Tenses*, was published in 2016 (OUP) and she is currently working on her second. Lynley lives in Dunedin.

Martin Edmond was born in Ohakune and lives in Sydney. His next book, *The Expatriates*, is due from Bridget Williams Books in October 2017.

Ben Egerton is a poet from Wellington. He's currently studying for a creative PhD at the IIML at Victoria University, where his interests lie in contemporary religious poetry.

Johanna Emeney is an Auckland teacher and writer. Her second book of poetry, *Family History*, was published this year by Mākaro Press. She works as a tutor of creative writing at Massey University, and at the Michael King Writers' Centre, co-facilitating the Young Writers Programme with Ros Ali.

Riemke Ensing's next small book of poems entitled *If Only* is currently being hand-set and printed by Tara McLeod of The Pear Tree Press. Riemke is also researching the life and work of painter Anna Caselberg and would welcome any information readers may have to share: r.ensing@ensing.co.nz

Sisilia Eteuati is a writer and poet. She has a master's of creative writing with honours from the University of Auckland (where she was awarded the Sir James Wallace Master's of Creative Writing Scholarship). She makes ends meet by practising law.

Laurence Fearnley is a Dunedin writer of fiction and non-fiction. In 2016 she received the Janet Frame Memorial Award and the NZSA/Auckland Museum National Research Grant to work on a collection of essays and short fiction about approaching landscape and environment through scent.

Rachel J. Fenton lives in Auckland. Her poems have appeared in *The Rialto* and *Overland Journal*, and she was runner-up in the Ambit 2016 Summer Competition.

Rhian Gallagher's first collection, *Salt Water Creek* (Enitharmon Press, 2003), was shortlisted for the Forward Prize for First Collection. Her second collection, *Shift*

(AUP, 2011; Enitharmon Press, 2012) won the 2012 New Zealand Post Book Award for Poetry. Gallagher's most recent work is *Freda: Freda Du Faur, Southern Alps, 1909–1913* (Otakou Press, 2016). Rhian is Otago's Burns Fellow for 2018.

Charlotte Graham is a journalist and broadcaster who lives in Wellington. Her work has appeared in the *New York Times*, on the Spinoff and on Radio New Zealand.

Denis Harold is a researcher and editor who lives near Dunedin.

René Harrison's work is informed by blind epistemology and Crip poetics. His poems have appeared in *Wordgathering, Literary Orphans, Takahē, Poetry NZ, Shot Glass Journal, Blackmail Press* and *Brief*. He malingers in Auckland.

Ingrid Horrocks is a Wellington writer. Her publications include two poetry collections, a travel book and, most recently, a scholarly work, *Women Wanderers and the Writing of Mobility* (Cambridge University Press, 2017). She also co-edited (with Cherie Lacey), *Extraordinary Anywhere: Essays on place from Aotearoa New Zealand* (VUP, 2016). She teaches at Massey University.

Mark Anthony Houlahan teaches in the English programme at the University of Waikato, Hamilton. He plans never to own a racehorse.

Stephanie Johnson is an Auckland writer. She is the author of around a dozen novels, many plays and several volumes of short stories. Her most recent novel is *Jarulan by the River* (HarperCollins Australia), published under her pseudonym, Lily Woodhouse.

Judith Lofley lives on the Kapiti Coast. Her poetry and short stories have appeared in anthologies and been placed in competitions. She has two novels nearing completion.

Owen Marshall, CNZM, has published three collections of poems. He is an adjunct professor at the University of Canterbury, and in 2013 received the Prime Minister's Award for fiction.

Andrew McLeod is an Auckland-based artist, printmaker and musician. He is represented by Ivan Anthony Gallery in Auckland and Robert Heald Gallery in Wellington.

Samantha Montgomerie is a poet and teacher who lives in Macandrew Bay, Dunedin. Her work has been published in the newspaper and the recent NZ Poetry Society anthology. She was placed third in the national Poems in the Waiting Room Competition this year.

Claire Orchard's first book of poetry, *Cold Water Cure*, was published by Victoria University Press in 2016. Her website is claireorchardpoet.com

Bob Orr has published seven books of poetry, the most recent being *Odysseus in Woolloomooloo* (Steele Roberts, 2014). He is 2017 Writer in Residence at the University of Waikato.

Jenna Packer is an artist living and working in Waitati, on the coast just north of Dunedin. Painting is how she attempts to make sense of the issues that concern her most.

Kiri Piahana-Wong is a poet and editor and the publisher at Anahera Press. Her first poetry collection, *Night Swimming*, was published in 2013, and she is currently working on her second book, 'Tidelines'.

Katie Pickles is associate dean of postgraduate research, and professor and head of history at the University of Canterbury. She teaches New Zealand and women's history and her research ranges from gender and empire to Christchurch history. She is most recently the author of *Christchurch Ruptures* (BWB, 2016).

Brian Potiki and Rowley Habib were co-workers at the dawn of Māori theatre. Both writers kept in close contact, writing letters regularly, often weekly: Rowley from Taupo, Brian from just up the road at Lake Rotoehu.

Jenny Powell is a Dunedin writer. Her recent memoir, *The Case of the Missing Body*, was published by Otago University Press in 2016. Her new collection of poetry, *South D Poet Lorikeet*, is due in November 2017 from Cold Hub Press.

Joanna Preston is a Tasmanaut poet and freelance creative writing tutor who lives in semi-rural Canterbury with a flock of chooks, an overgrown garden, and a Very Understanding Husband.

Vaughan Rapatahana is a writer, poet and critic and a Māori language activist; his books include *English Language as Hydra* (Multilingual Matters, 2012). Rapatahana's poetry collection, *Atonement*, was nominated for a National Book Award in the Philippines in 2016, and he won the inaugural Proverse Poetry prize in the same year. His most recent poetry collection is *ternion* (erbacce-press, 2017). He has a PhD in existential philosophy from Auckland University.

Rebecca Reader is studying for an MA in creative writing at the International Institute of Modern Letters in Wellington, and writing a collection of poems inspired by all things Mexican.

Sue Reidy has had three novels published internationally, as well as a NZ collection of short stories. She is a former Buddle Findlay Sargeson literary fellow and a former BNZ Katherine Mansfield short story competition winner. Her poetry has been published in *Landfall*, the *Listener*, *JAAM*, *Takahē*, *Bravado* and *International Literary Quarterly*.

James Robinson has been a practising artist since 1989. Born in Christchurch, he sees his art as a form of 'reconciling self and the world'. Robinson paints and draws 'in a experimental way as part of an "ancient and new story" of human imaginative culture': www.jamesrobinson.nz

Ali Shakir is an Iraqi-born New Zealand architect and author of *A Muslim on the*

Bridge (Signal 8 Press, 2013) and *Café Fayrouz* (Arab Scientific Press, 2015). Maitham Radhi is a poet and cartoonist. A collection of his prose poems, *Kalimat Radi'a* (Distorted Words), was published in 2015 by Almutawassit Books, Italy.

Iain Sharp is an Auckland-based writer, poet and reviewer.

Kerrin P. Sharpe has published three collections of poetry with Victoria University Press: *Three Days in a Wishing Well* (2012); *There's a Medical Name for This* (2014); and *Rabbit Rabbit* (2015). Her fourth collection, *Louder*, is imminent. Kerrin's poems have been published in a wide range of journals, including *Oxford Poets 13* (Carcanet).

Sarah Shirley is a doctor living in Hamilton with her husband and two children. Her poems have appeared or are forthcoming in *Poetry NZ*, *Takahē*, *Atlas*, *Pedestal*, *Intima*, *The Healing Muse* and elsewhere.

Carin Smeaton lives in Tāmaki Makaurau with her kids, Kazma and Yuga. Her first collection of Auckland poetry, *Tales of the Waihorotiu*, is out from Titus books.

Ruby Mae Hinepunui Solly is a Ngāi Tahu writer and musician. Her writing has been published in *Minarets*, *Brief* and *Redraft*. She often writes about themes of cultural identity and lives in Wellington with her partner and a pet chicken.

Michael Steven was born in 1977. *Walking to Jutland Street* is forthcoming from Otago University Press in 2018. He lives

in West Auckland with his partner and newborn son.

Rev. Mua Strickson-Pua: whakapapa Gafa Ngati Hamoa Saina Irish French; Strickson Peterborough London England; Pua PapaSataua Savaii Samoa; Purcell Malaela Upolu Samoa; Laiman Canton China. He is the co-founder of Street Poets Black, an ordained Presbyterian minister and a community development worker and Tuatua for Māori and Pasifika nations communities in Aotearoa. He writes Aiga Tupulaga poetry of Fa`atuatuaga (hope). He acknowledges his wife of 35 years, Linda Strickson-Pua, who guided him into the realm of poetry writing. Alofa Aroha Agape.

Tayi Tibble is a Māori writer based in Wellington (Ngāti Porou/Te Whānau-ā-Apanui). She is currently completing an MA in creative writing at Victoria University's IIML. Her work has previously been published in *Starling*, *Mana Magazine* and *Sweet Mammalian*.

Maualaivao Albert Wendt is acknowledged internationally as one of New Zealand and the Pacific's foremost novelists and poets. He has published many novels, collections of poetry and stories, and edited numerous anthologies. He has received many literary prizes and awards, including the Commonwealth Book Prize (twice), and the Order of New Zealand. He lives with his partner Reina Whaitiri in Auckland, and continues to write and paint full time.

Tom **Weston**'s most recent collection is *What is Left Behind* (Steele Roberts, 2017).

Sue Wootton is a writer and former physiotherapist, and a PhD candidate at the University of Otago, looking at how illness and healing are represented in literature. Her most recent publications are the novel *Strip* (Mākaro, 2016) and the poetry collection *The Yield* (OUP, 2017). She co-edits the health humanities blog Corpus: Conversations about Medicine and Life, found at http://corpus.nz.

Phoebe Wright is a writer and teacher based in Christchurch and in Gulu, Uganda. She writes poetry and prose, and is working on a novel. This year she is enjoying participating in the Hagley Writers' Course and teaching English at St Andrew's College.

CONTRIBUTIONS

Landfall publishes poems, essays, short stories, excerpts from works of fiction and non-fiction in progress, reviews, articles on the arts, and portfolios by artists. Written submissions must be typed. Email to landfall@otago.ac.nz with 'Landfall submission' in the subject line, or post to the address below.

Visit our website www.otago.ac.nz/press/landfall/index.html for further information.

SUBSCRIPTIONS

Landfall is published in May and November. The subscription rates for 2017 (two issues) are: New Zealand $55 (including GST); Australia $NZ65; rest of the world $NZ70. Sustaining subscriptions help to support New Zealand's longest running journal of arts and letters, and the writers and artists it showcases. These are in two categories: Friend: between $NZ75 and $NZ125 per year. Patron: $NZ250 and above.

Send subscriptions to Otago University Press, PO Box 56, Dunedin, New Zealand. For enquiries, email landfall@otago.ac.nz or call 64 3 479 8807.

Print ISBN: 978-1-98-853115-1
ePDF ISBN: 978-1-98-853116-8
ISSN 00–23–7930

Published by Otago University Press, Level 1, 398 Cumberland Street, Dunedin, New Zealand.

Typeset by Otago University Press. Printed in New Zealand by Printlink Ltd.

ARTS COUNCIL OF NEW ZEALAND TOI AOTEAROA